Bernheimer Family

‖‖‖‖‖‖‖‖‖‖‖‖‖‖‖‖‖‖‖‖‖‖
D1492390

Samuel ∞ Clara
Guttmann Behrendt
(PRIVY COUNCILLOR) 1808–1901
1850–1921

Otto
Bernheimer
(CONSUL)
1877–1960
∞ Carlotta (Lotte)
Guttmann
1883–1943

Ernst
Guttmann
1886–1918

Daniel ∞ Maria
Uzcátegui Rodriguez
1877–1954 Febres
*?–1925

Ludwig
Bernheimer
1906–1967
∞ Elizabeth
Hirsch
1910–1991

Kurt
Bernheimer
1911–1954
∞ Mercedes
Uzcátegui
*1923

8 siblings

Emmeram ∞ Anna
Schaeffer Vaas
1915–1979 1918–2001

Francisca
Bernheimer
*1952
∞ Kurt
Garlich
1948–2005

Maria Sol
Bernheimer-
Brey
1945–2010
2.∞ Jobst Brey
*1948

Iris
Bernheimer-
Goodwin
*1953
∞ Dale
Goodwin
*1952

Konrad O.
Bernheimer
*1950
∞ Barbara
Schaeffer
*1950

2 siblings

1.
Nicolas
Wolf
*1972

1.
Daniela
Wolf
*1975
∞ Tobias
Guethner
*1974

Daniel
Goodwin
*1990

Teresa
Bernheimer
*1978
∞ Kaspar
Pflueger
*1977

Isabel
Bernheimer
*1979

Blanca
Bernheimer
*1982
∞ Mark
Buenger
*1980

Benjamin
Buenger
*2014

Felicia
Bernheimer
*1991

Jasmin
Oeller
*1997

Jonas
Guethner
*2009

Emma
Guethner
*2012

Samuel
Pflueger
*2011

Elias
Pflueger
*†2013

Fausta
Pflueger
*2014

£4.19
/21

Konrad O. Bernheimer

Great Masters
and
Unicorns

*

The Story of an
Art Dealer Dynasty

Translations: Susanne Meyer-Abich
Copyediting: Aaron Bogart
Typesetting: Dörlemann Satz, Lemförde
Typeface: Bodoni
Production: Agnes Krolik, Hatje Cantz
Paper: Munken Premium Cream, 90 g/m²
Printing and binding: C. H. Beck, Nördlingen

2013 © by Hoffmann und Campe Verlag, Hamburg
2015 © Hatje Cantz Verlag, Ostfildern, and author

Published by
Hatje Cantz Verlag
Zeppelinstrasse 32
73760 Ostfildern
Germany
Tel. +49 711 4405-200
Fax +49 711 4405-220
www.hatjecantz.com
A Ganske Publishing Group company

Hatje Cantz books are available internationally at selected bookstores.
For more information about our distribution partners, please visit our website at
www.hatjecantz.com.

ISBN 978-3-7757-4069-2

Printed in Germany

Contents

*

Introduction
'A man is always prey to his truths.'
11

*

Part I

1864
'So far out of town – that's not good for business!'
21

Family Relics
'Every decent household should have a narwhal tusk.'
37

The End of the Golden Years
'A global firm of substance.' or:
'Could you possibly be a person of Mosaic faith?'
47

The Nazi Era and Life in Exile
'It was only Hitler who turned us into Jews.'
61

*

Part II

*

Part III

Two Galleries, One Castle
'Ars non habet inimicum nisi ignorantem.'
171

London: Becoming a Picture Dealer
'A handsome tallboy, on ball-and-claw feet, of slightly curved shape,
with a bombé *front, half German oak and half South American mahogany ...'*
185

Sourcing, Buying, Cataloguing and Selling
'Mr Bernheimer, how exactly can you tell that the painting is not
by the hand of the master?'
203

Colnaghi
'If we want things to stay as they are, things will have to change.'
213

Maastricht and TEFAF
'In the middle of nowhere.'
223

Art Dealers vs Auction Houses
'We are all prima donnas*!'*
235

Dealers and Collectors
'I have never bought with my ears, only with my eyes.'
245

*

Part IV

*

Finale – for Now!
'Exceptional things never happen in comfort zones.'
311

*

Appendix

Chronology

Acknowledgements

*

Introduction

*

'A man is always prey to his truths.'

(Albert Camus)

Christie's London auction room is packed to bursting point. The young auctioneer concentrates on the next page from the auctioneer's book, which he has laid on the rostrum in front of him. The date is 3 July 2012 and the occasion is the Evening Sale in King Street, the seasonal highlight in the calendar for Old Master paintings. And the highlight of the evening is about to be called: John Constable's *The Lock*, from the collection of Carmen Thyssen-Bornemisza is the night's most expensive lot. Before the sale it had caused controversy, since the picture, which Baron Heinrich von Thyssen had bought in 1990 for the considerable sum of ten million pounds, had previously hung in the Thyssen-Bornemisza Museum in Madrid. Both Francesca von Habsburg, the Baron's daughter, and Norman Rosenthal, legendary curator and former Exhibitions Secretary of the Royal Academy of Arts in London, had resigned from their positions as museum trustees in protest. The dispute is resolved, the Baroness prevailed, and the painting hangs on the wall of the auction room behind one of the long benches with Christie's staff. Almost all of them have telephones pressed to their ears, and there is an air of tremendous activity.

Will the high expectations of the firm be realised? The estimate is set at twenty to twenty-five million pounds, potentially a record for a work by Constable.

The young auctioneer leans forward over the rostrum with folded arms. 'Lot 37: *The Lock*, Constable's *Lock*, at seventeen million

pounds – to open it ... at seventeen million pounds ...', and after a short time: 'and five hundred thousand ... seventeen million five-hundred thousand ...' 'Bidding, sir', calls one of his colleagues from the telephone bench on the left, and the auctioneer calls the next increment. 'Nineteen million ... at nineteen million, nineteen million pounds ... nineteen million five hundred thousand ...' There is another bid from the opposite telephone bench. 'Twenty million ... now, twenty million pounds ... against you, madam, it's here [points to the left telephone bench] at twenty million pounds ... it's here ... not yours ... selling for twenty million pounds ... and selling it, fair warning, at twenty million pounds'! The auctioneer's gavel comes down on the rostrum. Sold. 'And sold, to paddle 851 for twenty million pounds. Sold to the telephone bidder on the left.' Visibly relieved the young auctioneer reaches for the next page.

He was to bring the firm's Evening Sale to a very successful conclusion; at a total of over eighty-five million pounds including the buyer's premium it was the most successful overall result for any Old Masters auction yet.

The seating plan for the first rows in the room was as usual. In the first row on the left there was Simon Dickinson with partners and staff, and behind him in the second row our firm, Bernheimer and Colnaghi, has taken up the position we have occupied for many years. My seat is nearest the aisle, with my London Sales Director, Tim Warner Johnson, next to me, followed by Jeremy Howard, our Head of Research. Directly behind me is my London colleague Johnny van Haeften with his entourage, and behind him Otto Naumann from New York, in front of David Koetser from Zurich.

On the right-hand side of the central aisle the front row is shared by Fabrizio Moretti from Florence and Adam Williams from New York, in the second row behind them, and therefore opposite myself, there are the sons of the London firm of Richard Green, based in Bond Street. Further at the back there are the private collectors, the

other dealers, many agents and members of the public, if they have been able to secure a seat. At the very back there are several rows of standing spectators. It seems as if the main dealers still rule the roost in the auction room; the seating plan certainly gives this impression. But is it really still the case?

A few days later I am back in my office in Munich and reviewing the auction week with the sales catalogues on my desk before me. I have the most beautiful view of the Wittelsbacherplatz, a wonderful neo-classical square surrounded by all the great palaces built by Leo von Klenze, with the figure of Elector Maximilian in the centre with an outstretched hand in greeting. As usual, papers and catalogues are piled up high on the large desk. Am I going to succeed this time in tidying up before the summer holidays?

On the opposite side of the room there is the padded easel, a copy of the famous Colnaghi original, displaying a painting which was offered to me a couple of days ago. It is a still life, and I have a few days left to decide. It always works better for me to leave a picture for several days to allow it to make an impression. I was recently offered a Bellotto with complete paperwork and expertise documentation, for example, but the longer I had it in front of me the clearer it became that I did not want it. I have to be personally convinced, otherwise there is no point, and sometimes this conclusion takes time. There can be the *coup de foudre*, love at first sight. But this still life is taking almost too long for me to connect to, it still has not happened.

Behind me there is Franz von Stuck's *Amazon*, ready to throw her spear and always pointing at the nape of my neck. She keeps me alert. This is one of the many presents I received from my grandfather when I visited him. Of course he knew Franz von Stuck very well, as the artist was a client of the firm and had bought important tapestries from Bernheimer's for his magnificent villa in Prinzregen-

tenstrasse. This early cast of the Amazon was a personal gift from von Stuck to my grandfather. It is signed 'Franz Stuck' and not 'Franz von Stuck' as in many later versions, which are mostly late casts from the Nazi period. Stuck was only ennobled in 1905, but he created the Amazon already in 1897 (one of the many things my grandfather explained to me at the time).

Right opposite me there is the 'heritage corner', with a small copy of my great-grandfather Lehmann Bernheimer's portrait by Franz von Lenbach. The full-size original is at my home in Marquartstein. A bronze bust of my grandfather sits on a green marble plinth – he did not like it, and after his death we found it wrapped in a blanket at the bottom of a cupboard. There is also the earliest remaining newspaper advertisement of our firm from 1869, three years after my grandfather founded it.

In the centre of the room I keep one of my favourite carpets: a very rare octagonal, seventeenth-century Persian rug from the collection of my great-grandfather.

Once again I flick through Christie's auction catalogue. We dealers were rarely successful during the week. The auction houses increasingly manage to contact important collectors directly, especially the new buyers from Russia or China, who have begun to buy at auction with a fervour that we have yet to see in our parts.

The Executive Committee of the European Fine Art Foundation, which organises the Maastricht Art Fair TEFAF, also has legitimate concerns about the increase in the auction houses' Private Sales. How can we, the trade, assert ourselves against the ever-increasing dominance of the great auction houses?

I have in front of me a stack of documents from the estate of my late sister, as well as a pile of notes and records about the history of our family that I compiled over the last year. I have decided to write about the history of our art dealer dynasty, starting with my great-grandfather's beginnings in the middle of the nineteenth century

and ending in the present. I will speak of the great rise and success from the late nineteenth century to the First World War, of the short Weimar Republic between the wars, of the gradual increase in anti-Semitism, of the fate of my father and grandfather during the Nazi era, of concentration camps and of emigration to Venezuela. I must describe the coffee plantation where I was born, and the rebuilding of the firm in Munich after the war. I will have to write about my formative years in Munich with my revered grandfather, and about the tragic death of my father. And I will describe my own time, representing the family's fourth generation and trying to step out of the shadow of the past, no longer dealing in carpets, furniture and textiles, but instead becoming the first picture dealer in my family.

It is a long story with many ramifications. Now is the time to write it down, now that we have celebrated the 150th anniversary of the firm's founding by my great-grandfather in 1864. When my London gallery Colnaghi celebrated its anniversary in 2010, having been taken over by me in 2002, my part was much easier: I delegated the writing of a commemorative publication and contributed only a foreword. Over the past few years I have occasionally been contacted by journalists and writers who have wanted to write about the history of my family, but each time I declined. I always knew that I wanted to write about the Bernheimer history myself, as I am the one who knows it best after all.

During a recent visit to the author Hans Magnus Enzensberger the subject of my plan for this book came up. He encouraged me and helped me overcome my reservations, arguing that the history of my family was also contemporary history, a part of Germany's *Zeitgeschichte*. He also suggested ways of approaching the Bernheimer family 'saga'. Have dialogues, he told me, with yourself, have imaginary ones with your grandfather and your great-grandfather, and with friends, and in between you scatter stories about people and events. In this way you approach the story that you ac-

tually want to tell. He gave me his book on the history of the Hammerstein family, where he had used some of the same literary techniques.

However, I said to myself, I am not turning into an author only because I want to write my family history. What I took away from my conversation with Enzensberger was the importance of remembering and of writing down memories. This would not be a linear and chronological narrative, bearing in mind the changes in direction and the ruptures my family had to experience. It sounds simple, but memories and what we believe to be memories can slowly converge and overlap. Who can say what is exact historic truth and what the memories we believe in are? This must be what Camus meant when he said, 'man is always prey to his truths.'

Sometimes I think that as an art dealer I should have lived earlier. It is with a mixture of wistfulness and envy that I look through Colnaghi catalogues from the 1960s and see the abundance of great paintings. Maybe I was born too late for an art dealer, especially as a dealer in Old Master paintings. Still, as a Bernheimer I was lucky to have been born after the last World War. I am the first generation in my family who did not experience war, persecution, discrimination and emigration.

Looking at our family history I keep asking myself 'What if?' If there had been no anti-Semitism, would Hitler not have existed? Or would he have invented it, or whoever might have taken his place invented it? The question is moot, since anti-Semitism has existed for at least 2000 years. But would Hitler have existed had not so many Germans experienced the First World War's defeat as shameful? Could the First World War have been avoided if …? We can continue endlessly with these idle musings, and of course the theoretical rewriting of history is enjoyed not just by successful writers such as Philip Roth, who asked what if Charles Lindbergh had become the United States president, but also by reputable histori-

ans. Even painting can give rise to such thoughts: when looking at the magnificent Lepanto Cycle by Cy Twombly at the Brandhorst Museum in Munich we may wonder how history had developed had the Ottomans won the great naval battle? Or if the Ottomans had not been defeated before Vienna?

When reading Fritz Stern I found the phrase: 'There is no inevitability in history. We need to consider what could have happened if we want to understand what really happened.' What would have happened had my father not died so early? Would I still be sitting here, writing the family history of an art dealership? My father's early death in 1954, when I was only four, had a significant impact on my life, and also that of my mother and sisters. I am certain that my father would not have returned to Germany. I would have grown up in Venezuela and gone to school there, perhaps I would be working on our coffee plantation today and be hassled by Hugo Chávez's successors. I might have become disconnected from the Bernheimer family history, since I would not have come under the marked influence of my grandfather during my first years in Munich. My father, who wanted to shake off the past with such determination and thoroughness, would probably not have told me much about it.

'We need to consider what could have happened if we want to understand what really happened.'

When I recently looked out of the window of a plane approaching Munich I was startled. Suddenly, from above, I was looking at the Dachau concentration camp. The compound was clearly recognisable, with its fenced-in square perimeter and the rows of barracks. The entire camp has been conserved as a memorial. Many years ago I made the great mistake of visiting Dachau together with my mother. The experience was too much for both of us and each of us practically suffered a breakdown. I believe there are things we can never get over. To visit the place where my father had suffered so

much was not a good idea. It is not possible to keep a distance, to block off the terrible images developing in the mind.

One of my grandfather's most shocking memories was this: he and my father had already been in Dachau for several days, where they had been incarcerated after having been arrested and abducted in November 1938, after *Kristallnacht*. They knew nothing of each other's fate, since they had been arrested in different locations. But one day they realised during the roll-call on the Appellplatz that they were standing next to each other, my grandfather and my father, and they had not recognised each other at first in their prisoner suits and with shaved heads. My father was also in very bad shape, as he had been beaten up. I never found out what exactly happened to him during these days and weeks. My father never wanted to talk about Dachau.

Will we ever understand this? We Bernheimers were German, very patriotic, and of course we were monarchists. It was Hitler who turned us into Jews, said my grandfather. I have thought about this phrase often in my life.

For some time I have been thinking about a book that I read many years ago, probably as a student, and I believe was by Camus or Sartre. In addition to the protagonists it features their ancestors, who discuss the actions and character strengths and weaknesses of their living descendants. I would love to re-read it. Many times in my life have I imagined such conversations with my dead father and grandfather. So much of our history is incomprehensible or at least elusive. There are so many questions I would like to ask my father and grandfather. I would ask my father: 'Why would or could you not return to Germany?' And my grandfather: 'How could you return already in August 1945?' I often sat with the family portraits in Marquartstein and imagined this dialogue, but there are no answers. I have to respond myself.

Part I

1864

*

'So far out of town –
that's not good for business!'

(Prince Regent Luitpold to Lehmann Bernheimer)

W hile sitting at my desk I leaf through our two family chronicles. The first was compiled by my great-uncle Ernst Bernheimer while in exile in Cuba. He died in Havana in 1956. Then in 1957 my grandfather Otto Bernheimer wrote another family history on the occasion of his eightieth birthday, titled *Memories of an Old Man from Munich*.

1864 is considered the founding year for the house of Bernheimer. In America the Civil War raged on, and Abraham Lincoln was re-elected president of the United States. In Vienna Emperor Franz Joseph ruled, (as yet) happily married to Sisi, cousin of King Ludwig II of Bavaria, who in the same year ascended to the throne in Munich, aged eighteen. Prussia was ruled by King Wilhelm I and Otto von Bismarck, in France Napoleon III minted new gold coins and styled himself, as his uncle Napoleon had done, a descendant of the Roman emperors. Giuseppe Garibaldi had just united Italy and Vittorio Emanuele became its first king. Queen Victoria had been on the throne in London for thirty-seven years, her prime minister was Lord Palmerston. In 1864 Richard Strauss was born in Munich, Alois Alzheimer in Marktbreit in Franconia, and Henri de Toulouse-Lautrec in Albi in Southern France.

On 10 May 1864 Lehmann Bernheimer, aged twenty-two, opened his first shop in Munich at Salvatorplatz. He had taken over the former rooms of the firm Robert Warschauer on the corner of Salva-

torplatz next to the Archbishop's Palace. The predecessor had been one of a few existing shops at the time selling silks, fabrics and shawls. Lehmann Bernheimer's father with the nice traditional Jewish first name Meier (spelled differently from Mayer, as in Mayer Amschel Rothschild, founder of the Rothschild dynasty in Frankfurt) had been a citizen of the small town of Buttenhausen in the Swabian hills, about fifty kilometres southwest of the city of Ulm. Under one of the first *Judenschutzbrief* (letters guaranteeing protection of the Jews) in the region of Württemberg, the Bernheimers had lived in Buttenhausen since the Jewish community emerged in the eighteenth century. Like so many of his Jewish fellow citizens, my great-great-grandfather dealt in textiles. He imported fabrics mostly from France and Italy and brought them to the local markets, where he sold his fine cloth from a stall mainly to ladies of society. In the nineteenth century towns had very few shops, so the ladies bought their supplies from the travelling salesmen; then they passed the fabric to their dressmakers for processing. At the oldest fair in Munich, the Dult, Meier Bernheimer's stall was much sought after, not just for the evidently good quality of his fabrics, but also because of the famously charming stallholder, who was very popular with the ladies. Meier was accompanied by his son Lehmann, who had started to help his father when he was fourteen. He was also well liked by the ladies, and they loved it when he carried their purchases home for them. The Dult had its venue in what is today Maximilianplatz and Lenbachplatz. Bernheimer's stall must have been near today's site of the Wittelsbacher fountain, somewhere between the fountain and the Prannertor, one of the old city gates. Directly opposite there was the Englisches Café, a popular restaurant for day trips – at the time the Dult Square was outside the city wall perimeter. It had a pretty front garden, and my great-grandfather and his father liked going there for lunch. They usually ordered the cheapest item on the menu, which was steamed dumplings. One day

the landlord threw them out, saying, 'If you only ever order the cheapest stuff, you may as well stay away!' My grandfather often said that his father took good note of this. Many years later he bought the Englisches Café, tore it down and built his large *palais* in the same spot on Lenbachplatz.

In 1971, when I furnished my first student flat in the Schwabing quarter of Munich, I needed cutlery and my mother allowed me to rummage in the silver box. Several dessert forks came to light, completely blackened, and clearly not used for decades. When cleaned, there appeared an engraving: 'Engl. Café'. I assume, or rather I hope, that these were not the cause of my great-grandfather being banished, but that he bought them later together with the inventory of the café.

In September of 1864, when he opened his first shop on Salvatorplatz, Lehmann Bernheimer married my great-grandmother Fanny Haimann, who also came from a family of textile dealers. Together they built up the business, and from the very beginning they seem to have had great success. One year later they had already moved to the smartest shopping street in Munich, the Kaufingerstrasse.

Lehmann Bernheimer's new home and business premises were equipped with, for the time, very modern conveniences. Visitors especially admired the innovative bathroom, as there were few private dwellings with running hot and cold water. Grandfather remembered the so-called *Moscherabien* installed there – Moroccan wood lattices that can be found in pictures of a harem, permitting one to look out but not to look in.

In 1987, when we moved to the castle in Marquartstein and I cleared out the basement of the building in Lenbachplatz, I found a stack of these lattices bearing an early inventory number and clearly in the possession of the company since the nineteenth century. Some of them we installed at our castle, and once again in a bathroom.

Some time ago, when our daughter Blanca looked at the contents of the attic in search of furnishings for her new flat, she took two of the remaining lattices and they are now in her bedroom. She was very amused when I informed her that these were Lehmann Bernheimer's *Moscherabien*. The family circle closes.

Lehmann Bernheimer did so well in Kaufingerstrasse that he soon became one of the most respected businessmen in town. The economic expansion after the victory in the 1870–71 Franco-Prussian war, the so-called *Gründerzeit,* also contributed to the rise of my great-grandfather. Lehmann travelled to Paris to purchase 'novelties' as soon as the peace treaty with France was signed.

The clientele grew quickly, and soon the long-established families as well as the aristocracy and the artist community became Bernheimer's clients. His artist friends as well as the collectors who bought from him inspired an interest in fine and decorative arts, and especially in antiques. On his travels to Paris he now looked not just at fabrics, but also at East Asian objects and especially at antique oriental carpets.

One of my grandfather's favourite anecdotes about this time is this one: when Lehmann Bernheimer returned from London with his first twelve oriental carpets, he enthusiastically showed them to his artist friends Lorenz Gedon, Hermann von Kaulbach and Lenbach. Gedon, the sculptor, architect and inspired designer of artist parties and pageants, bought all of them on the spot. Gedon declared my grandfather to be an imbecile because he sold the carpets much too cheaply. The imbecile smiled however, and shortly afterwards travelled to Constantinople, as Istanbul was still called, to stock up. In the meantime he had discovered where the London dealers bought their carpets. This was the beginning of the fashion for oriental carpets, and the beginning of Bernheimer's rise as the first great dealer in oriental carpets in Germany.

Soon thereafter, in the early 1880s, the history of the company

Advertisement in the "Neueste Nachrichten"

took an important turn. Lehmann did not enjoy the dress fabric business, which had been Meier Bernheimer's sole occupation, and so without further ado he sold the entire stock to his brother Leopold, who had his own fabric shop in Ulm. Lehmann would now concentrate on the flourishing trade in decorative fabrics, carpets and art objects. He soon became a major supplier for the Bavarian Royal castles, obtaining a Royal Warrant from Ludwig II in 1882. He also won the contract to become exclusive outfitter for the Bavarian railway administration with regard to curtains and upholstery for both first and second-class carriages, and he maintained this contract for many decades. More and more important orders came in, interior decorations for castles and town houses of the aristocracy, beginning with the Dukes of Anhalt and the Grand Dukes of Baden.

Lehmann's greatest talent was the ability to internalise contemporary taste to a degree where he himself became a tastemaker. With his success grew the stock, and in spite of several extensions the building in Kaufingerstrasse became too small. Lehmann began to look for a piece of land.

When King Ludwig II died in 1886, my grandfather was nine years old. He heard the terrible news in the street and ran upstairs to tell his father. He told me what happened next, and it made a great impression on me. When he cried: 'Father, father, the King is dead!', his strict father slapped him in the face and told him: 'Son, you don't make jokes about this.' But it was no joke, the King

Advertisement Kaufingerstraße

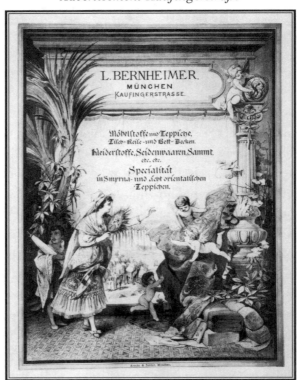

really was dead; he had drowned in Starnberg Lake. Many people refused to believe the official version of suicide at the time. Had the King been murdered? My great-grandfather, who held the Prince Regent in great esteem, is unlikely to have believed that there was a murder conspiracy, perhaps even hatched by the very House of Wittelsbach – even today I think there are only a few featherbrains who believe this.

A few days later my great-grandfather received a very large order indeed from the court administration: many, many metres of black velvet were needed to line the walls of the church, the Hofkirche, where the King was to be laid out, and for the catafalque and the burial procession.

After the tragic death of King Ludwig, who had been popular with the people but who had de facto not reigned for years and had withdrawn more and more into an imaginary world of his own, the period of economic growth in Bavaria received its own name: the Prince Regent's era. When Bavarians later referred to the good old days, they meant precisely this period of prosperity and economic upswing, beginning with Prince Luitpold's regency and ending with the First World War.

The Kaufingerstrasse years were very successful for Lehmann Bernheimer. The change in direction from a dealer in dress fabrics to one of the most important suppliers for the interior decoration of houses, castles, and railway carriages had been profitable, and he kept adding more and more antiques, Asian art objects and especially oriental carpets to his rich stock of decorating fabrics.

Large business premises were to be constructed, and in Munich terms my great-grandfather had in mind nothing less than an epochal project.

He had soon found the land, outside what was then the centre of town. It was in Maximiliansplatz, the former Dult site, where he had

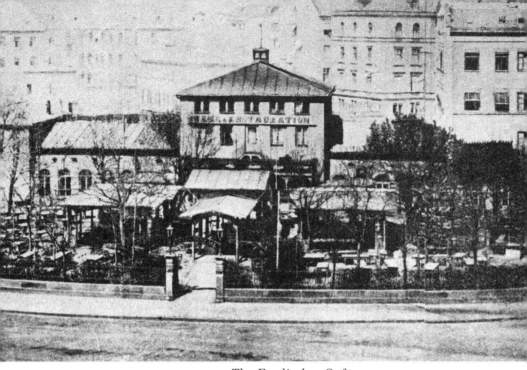

The Englisches Café

the stall with his father as a boy, selling dress fabrics to Munich society ladies. The Englisches Café with its front garden was still standing, and in 1887 Lehmann bought the grounds.

The planned business and living accommodation was to be the first representative building in this as yet underdeveloped quarter. Opposite there still ran a small brook, a grey apartment block occupied what later became Deutsche Bank, and a similar building took up space along the Karlsplatz nearby. The Palace of Justice was only built later, designed by the same architect who worked on the plans for the Palais Bernheimer, Friedrich von Thiersch.

Considerable doubts were raised in Munich as to whether such a formidable building could be realised at all by Lehmann Bernheimer, and whether such an ambitious business with retail premises would survive in this location outside the city centre. In

the end the Prince Regent himself gave my great-grandfather the building permission, but he warned him: 'I don't mind if you build there, Bernheimer, but so far outside town – that's not good for business!'

This concern soon proved to be unfounded, and visitors flocked to the new building. From the opening day onwards business was buoyant. People came even to admire the building, a grand and magnificent palatial construction, which was soon dubbed the biggest art dealer's building in the world.

Behind the imposing Neo-Baroque façade, the visitor's gaze fell on abundant halls, courtyards, galleries and flights of rooms with such a large selection of carpets, tapestries, antique fabrics, furniture, works of art, silk fabrics and embroideries as had never been seen before. The huge shop windows had been especially imported from Belgium on custom-made railway cars. In particular, visitors admired the beautiful and huge cast-iron staircase leading from the basement to the ground floor and then up to the mezzanine. Great-uncle Ernst described the grand opening on 10 December 1889 in his family chronicle. The entire royal court, the aristocracy, the directors of government agencies and the leading families of Munich were all assembled, and of course Prince Regent Luitpold himself declared the business open.

However, the building had also been planned as living accommodation. Even before completion the Princes Fugger-Babenhausen took the first floor, and my great-grandfather took up the entire second floor with a suite of twenty-eight rooms for himself. When my grandparents Otto and Carlotta were married later in 1905, they also moved here. Their flat took up just half of the third floor, with a respectable fourteen rooms.

One of the main reasons to build this big house, according to Uncle Ernst, had been to give his father's three sons a common base for activity. Together they should work to expand the firm. The first

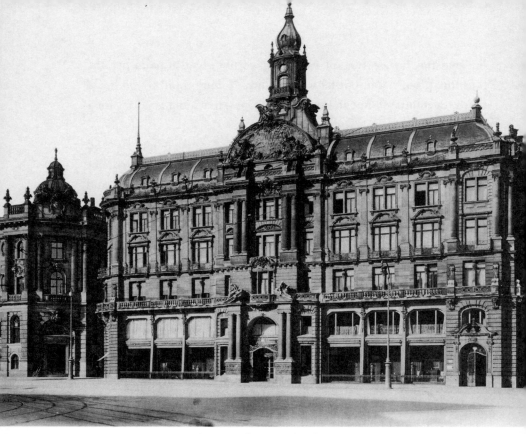

Palais Lenbachplatz

to join was Max in 1890, then Ernst and Otto followed in 1894 and 1896. At that time my grandfather Otto was nineteen years old.

Uncle Ernst notes how even shortly after completion at Lenbach-platz and the Prince Regent's inauguration in 1889, the vast expanse of space now available proved to be too small. It was therefore decided to acquire the adjoining land towards Ottostrasse.

The great fire in February 1897 all of a sudden threatened to destroy everything. A short circuit in the electric system caused a fire in the basement which raged through all floors. The stock and the building suffered enormous damage, and a collapse could only just be averted. But support from both local people and clients

must have been astonishing. Ernst Bernheimer gives the following examples: Baron Emil von Hirsch categorically refused to accept a replacement for the carpets we had stored for him, and declared that he had not paid storage costs anyway. Instead he immediately placed a new order. Baron Haniel Haimhausen had been sent a valuable tapestry for inspection, which he had not really intended to buy. After the fire he purchased it straight away.

The Prince Regent also helped. On the day after the fire he arrived to inspect the situation in person. He offered an empty garrison building near the Hofgarten as a temporary storage facility while the building was being repaired, and he had the keys delivered to my great-grandfather on the spot. Later, this garrison was replaced by the Army Museum, and today it houses the Bavarian State Chancellery with the prime minister's office.

After the fire, Lehmann and his sons continued to work on the meteoric rise of the firm at the end of the nineteenth century. Having previously travelled to London, Paris and Constantinople to buy merchandise, they now began to go to Italy more often. My grandfather focused increasingly on Italy, and later Spain, while the elder brother Max travelled to England, France and Turkey. Ernst, who suffered badly from a loss of hearing and soon had to carry a large wooden ear trumpet, looked after the office, the finances and the staff, but also after the arrangement of the so-called *Musterzimmer*, the customised showrooms, which were an amazing success. Almost the entire third floor of the building along Ottostrasse could be rearranged through a system of walls moving in tracks. Any room size could be set up and specific interiors displayed in a space that exactly matched those of the client's. Not just length, height and width were replicated but also the location of doors and windows. These rooms were then furnished with objects either chosen by Bernheimer's or by the client. Door frames were inserted, or panel-

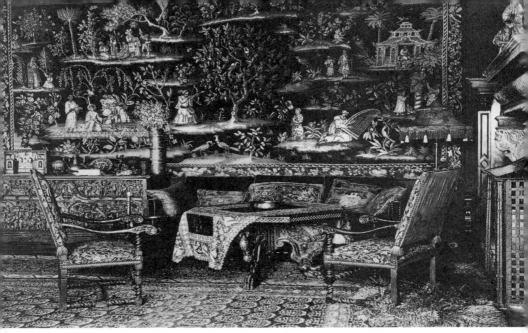

The grandparents' apartment at Lenbachplatz

ling, windows or terrace doors placed, wooden ceilings were hung and if necessary painted. Chandeliers were put up, cupboards put in, carpets put down and fireplaces installed. The client could have the perfect illusion of being in his own future home before deciding to buy.

The possibility of visually displaying a selection for the client played a key role in the firm's success.

I used to see these showrooms myself before the third floor was let out in the 1960s. This was also where art fair stalls were designed, so that it was possible to see exactly how the stall would look at the Munich Art Fair in Haus der Kunst.

An entire team of architects, draughtsmen, carpenters and upholsterers worked here. With their assistance, large houses and castles could be furnished completely without having to involve other suppliers. The firm of Bernheimer flourished greatly in those years, both as antique shop and interior decorators.

Otto, the youngest of Lehmann's three sons, began to travel to Italy even as a young man and bought chests, textiles, furniture, sculptures and stone chimneypieces. Even as an old man he was proud to remember that before he was twenty he had returned to Munich with a whole railway car full of chests. When his father asked him how much he had spent on each, Otto named the price. That was a lot more than he had spent on the last trip, responded my great-grandfather. Yes, Otto said, but these are full of antique fabrics and textiles. And so my great-grandfather was satisfied.

I am reading in the chronicles about the main clients around the turn of the twentieth century. My great-grandfather sold an important series of tapestries to the Krupp family for their house in Essen, the Villa Hügel. Randolph Hearst came to Munich only twice, but became one of the firm's best clients. My grandfather told me how

Otto and Lotte Bernheimer 1905

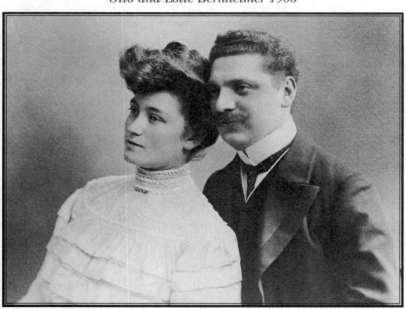

Hearst rushed through all floors of the building with his entourage, simply pointing at the objects he wanted to have. Behind him notes were taken furiously, and then crates and yet more crates were packed off to San Simeon in California, filled with tapestries, Renaissance furniture and sculptures to decorate Hearst Castle.

At the beginning of the twentieth century, the Barons Cramer-Klett developed Schloss Hohenaschau in grand style, and once again Bernheimer's were asked to supply tapestries and panelling. The Cramer-Kletts were one of the richest families in Bavaria at the time, due to their part in expanding the railway network, together with the Maffei family. They were also founders of MAN, large engineering works. They could afford the luxury of a private railway line from the Aschau Valley to Lake Chiemsee, which still runs today as the Chiemgau Line. It runs directly through our golf club in Prien, but I cannot imagine it is in any way profitable, since the trains are almost always empty.

Count Henckel von Donnersmarck was another client in those days – one of the richest magnates from Upper Silesia and probably one of the richest Germans of all at the time. He built Schloss Neu-deck with almost unimaginable expenditure. It was a huge building in French Neo-Baroque style and dubbed the Versailles of Upper Silesia. This was a major order for Bernheimer's. Very few of the firm's hand-written ledgers have survived, but there are some; for example those pertaining to 1902 and 1903, and there are pages and pages of deliveries to Neudeck.

The Princes Fürstenberg commissioned my great-grandfather to decorate Schloss Heiligenberg and others. We visited there a few years ago on the occasion of a trip with Hansi Hohenzollern, who at the time was director general of the Bavarian National Museum. Heinrich von Fürstenberg took us around the castle with its important sixteenth-century panelled ceiling, and he showed us the wing decorated by my great-grandfather. Afterwards we accompanied

Hansi Hohenzollern to his castle at Sigmaringen. He keeps saying that the Bernheimers only became rich after the fire at Sigmaringen in 1892, and he has a point, since we did not just get the commission to redecorate one of the wings, but got a very large commission from his brother, Karl. The subsequent order was even more important: for the prince's younger brother was to become King of Romania, and so Carol I of Romania commissioned Bernheimer's to decorate the castles in Bucharest and Peleş Castle in Sinaia. Sadly I have never been there, but it is said that the interiors remain the same to this very day.

In 1906 the foundation stone was laid for the Deutsches Museum in Munich. My great-grandfather's close friend Oskar von Miller founded this always-captivating, huge technical museum, which by its nature keeps changing with the times. The Bernheimers have a special relationship with the Deutsches Museum. The inauguration ceremony in 1906 took place in a hall that Bernheimer's was asked to decorate. Among other items we supplied the two thrones for the Emperor and the Prince Regent. When the two majesties were about to take their seats, the unspeakable happened: the Prince Regent's throne collapsed under him and he fell to the floor. My grandfather, aged twenty-nine, was responsible for furnishing the ceremony. He quickly abandoned the scene of the crime to report back to his father, who had remained in the office. The greatest disasters were anticipated, such as the loss of the Royal Bavarian Warrant, or that of the title of *Kommerzienrat*. When the Prince Regent announced his visit at Lenbachplatz for the following morning at 8am, anxiety levels rose even further.

On the next morning, my great-grandfather and his sons nervously stood in front of the building when the Prince Regent's carriage arrived. To everybody's surprise a beaming Prince Regent Luitpold emerged. With open arms he walked towards my great-

grandfather and exclaimed: 'Bernheimer, I cannot tell you how happy I am that it was my chair which collapsed and not that of the Kaiser!'

Unlike Kaiser Wilhelm II, the Prince Regent had a great sense of humour, and his mishap had contributed to a relaxed atmosphere at the initially very formal event. If the Kaiser had fallen, there could even have been a diplomatic incident between Prussia and Bavaria. My grandfather was quite convinced of it: 'A chair's broken leg could easily have caused a Prussian-Bavarian war!'

Another Bernheimer client was the great collector Professor Alfred Pringsheim, father-in-law of the author Thomas Mann. The editor of Thomas Mann's diaries, Peter de Mendelssohn, visited me twice in Munich at the end of the 1970s to discuss the relationship between Bernheimer and Thomas Mann, and the writer's Bernheimer desk.

It seems that Pringsheim did not really trust his young son-in-law to furnish the first flat of the newlywed couple, Thomas and Katja Mann, in appropriate style. When they moved into the flat in Franz-Joseph-Strasse in the Schwabing quarter in 1905, Pringsheim went to Bernheimer's with his daughter, where among many other things he bought a desk, which was to be Thomas Mann's desk all his life.

The desk accompanied the Manns into exile to Pacific Palisades and back to Switzerland to Kilchberg on Lake Zurich, where it stood in the study. When I saw a photo of the room I immediately recognised the Bernheimer Neo-Baroque model, which was produced at the time in the firm's own workshops on Lenbachplatz. I remember that the same model was in use by staff in several offices at Lenbachplatz. I always wanted to go and check if we had one such desk in the attic here in Burg Marquartstein.

My grandfather even made it into the pages of *Doctor Faustus*. There is a description of 'a very deep reading- and easy-chair covered with grey velvet, from Bernheimer's in Munich'.

Family Relics

*

'Every decent household should have a narwhal tusk!'
(Lehmann Bernheimer)

My favourite place at home in our castle at Marquartstein was the so-called *Herrenzimmer*. It was one of my habits to switch on every picture light in the room as soon as I came in. My ancestors should not be in darkness when I am in their company. My great-grandparents were here, my father and both pairs of great-great-grandparents. My grandfather looked over my shoulder from behind my leather armchair, in a delicate pencil drawing in profile by Olaf Gulbransson.

I remember the visits to Gulbransson very well. When I was a child we went to see him at his country house above Tegernsee Lake. One summer, it must have been in 1956 or 1957, the bald and rather portly Viking received us stark naked, with only a cooling damp cloth on his pate. When he saw my mother's horrified expression as she turned on her heels, he tied a leather loincloth around himself as scant cover for his front. He was quite a character, but a genius draughtsman.

Had my grandfather been more diplomatic in his dealings with another friend, we might have had an Oskar Kokoschka portrait hanging there. My grandfather and the artist knew each other well, but when Kokoschka suggested painting his portrait, my grandfather, who liked the man but not his art, said he'd rather not. Afterwards, he only ever referred to Oskar Kokoschka as the most conceited painter of all time, since he liked his own works so much that he always wrote 'OK' on them.

The Lenbach portraits of my great-grandparents from 1903 were hanging opposite me, painted one year before the death of the artist.

My great-grandmother, Fanny, looks both kind and severe, dressed entirely in black satin with a rose in her hand and her hair pulled back into a knot. My great-grandfather has the moustache he wore all his life and looks towards his wife on the left. He has a box of matches in one hand and the inevitable small cigar in the other. Lenbach insisted on painting him with these constant attributes. My grandfather said that his father only gave up smoking three days before his death. He called his sons into the room and told them that the end was near, since he had lost his taste for cigars. Three days later, in 1918, he died from a stroke, having been healthy all his life. He reached the age of seventy-seven, which for the time was quite old.

For years Lenbach had asked his friend Bernheimer to be allowed to paint his portrait, but my great-grandfather had always refused. When he finally gave in and arrived for his first sitting, the painter sent him home and told him to come back in two weeks, as his hair had been cut too short for Lenbach's taste. We know how much Lenbach was paid for the two portraits, twenty thousand gold marks, which would be around three hundred thousand euros today. It is a handsome price, but not as expensive as having one's portrait painted by Lucien Freud, which is rumoured to have cost five million dollars. I have also noticed that all Lucien Freud's sitters, including the Queen, look rather miserable. My great-grandparents may not have been very good-looking, but at least they have a friendly expression.

Opposite the great-grandparents were their parents, my great-great-grandfather Meier Bernheimer and his wife Sara, as well as Isaac and Jeannette Haimann, my great-grandmother Fanny's parents. The Haimanns were an important family in the textile trade, who had also settled in Munich in the 1870s. Like the Bernheimers they originated from Swabia.

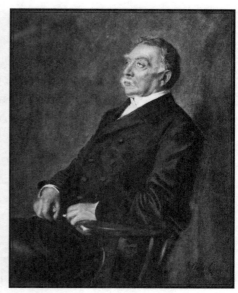

Lehmann and Fanny Bernheimer
Portraits by Franz von Lenbach

There is also an oval red chalk drawing of my great-uncle Max. This was the only portrait from this branch of the family in my *Herrenzimmer*. Sadly there are no existing portraits of great-uncle Ernst and his family.

My father's portrait by Corneille Max is held in special regard. It shows him in 1916, aged four, a blue-eyed blond boy on the terrace of the villa in Feldafing with a view of the Starnberg Lake. He is wearing the traditional Bavarian *lederhosen* and green cardigan, and his dog accompanies him. Was this what the Nazis imagined a German Jew to look like?

As a birthday present my wife Barbara had my grandmother Carlotta's portrait copied to add her to the gallery. My sister Iris has the original. It is a picture by an unknown artist of a fine, elegant lady in the fashion of the nineteen-twenties. The lovely blonde hair is slightly waved. My grandmother Carlotta, called Lotte by my grandfather, was the daughter of *Geheimrat* Samuel Guttmann and his wife

Clara, wealthy silk merchants from Nuremberg. (A *Geheimrat*, a Privy Councillor, was an important title in the Bavarian monarchy.)

In the portrait as well as in photographs, my grandmother appears to be a very beautiful and elegant woman. Curiously, we do not have any photos of her from her last years in Venezuela. My mother always said how elegant she had been at the hacienda. She continued in the tradition of her European lifestyle, having tea each afternoon and serving cakes made from German recipes to those she invited. But she had become very melancholy; I can easily imagine that she died of a broken heart, as my mother always maintained.

In front of my grandfather's portrait there was a narwhal tusk, quite a large specimen in an old cast-iron holder. This is one of our 'family relics', as my grandfather used to call it. It comes from my great-grandfather's first home, where it was installed in a corner of the dining room, and I remember it well from a corner of the drawing room in my grandfather's house. Lehmann Bernheimer used to declare that 'every decent household should have a narwhal tusk!' The tip of the long and slightly turning tusk is encased in brass, which indicates that the tip was lost at some point.

Narwhal tusks usually lost their tips during the Renaissance because it was believed that in powdered form the tip of the 'unicorn's horn', as it was thought to be, was considered an effective antidote against poison. Since death by poisoning was obviously rampant during the Italian Renaissance, every prince required a 'horn of the unicorn' among his possessions.

In the treasury of the Hofburg in Vienna, which is filled with the riches of the Habsburg dynasty, there are two so-called inalienable heirlooms of the house of Habsburg. One is an agate bowl, most likely fourth century Byzantine, which was thought to be the Holy Grail, and the other invaluable object is a narwhal tusk.

In our family the possession of a narwhal tusk was always regarded as an important good luck charm, even, it seems, in my

great-grandfather's time. Therefore we have another very nice speci-
men in our house in Munich, and a third one in my office in the gal-
lery at Brienner Strasse. I still need one for my London office, but
unfortunately I neglected to buy one when they were still affordable.
I recently saw two narwhal tusks at a London art fair, but I refrained
from a purchase when I heard the price. In fact, three narwhal tusks
should guarantee that one is armed 'to the teeth' against all evil
spirits, even if they are in separate locations.

Next to the narwhal tusk there usually stood the 'Holbein chair'; it
was missing for some time before it returned to its place underneath
my great-grandfather's portrait. I lent it to an exhibition at the Bav-
arian National Museum, where after many years of restoration one
particular carpet was being exhibited. It had been bought from
Bernheimer in 1911.

The chair is covered in a fragment of an early 'Holbein carpet', a
material that according to the most recent research dates back to the
late fifteenth century, around 1480. The name refers to a type of Tur-
kish carpet with rectangular medallions, which often appears in
paintings by Holbein. They were made in Anatolia around 1500, and
are among the most sought-after by carpet collectors. When I saw
the 'Bernheimer carpet' at the National Museum during a dinner for
the opening of our Highlights Art Fair at the Haus der Kunst, I spon-
taneously offered to lend our Holbein chair for the duration of the
exhibition to the director general, Renate Eikelmann.

There is a papal connection to our Holbein chair. In 1980, when
preparations were underway for John Paul II's visit to the Euchar-
istic World Congress in Munich, the arrival of Archbishop Paul
Marcinkus was announced at Lenbachplatz. He was a confidant of
the Pope, his banker, but also his travel organiser, and, it seemed,
bodyguard – a tall and powerfully built man fluent in any number of
languages, including German. He visited us and explained that the
archdiocese had referred him to us as he was looking for several

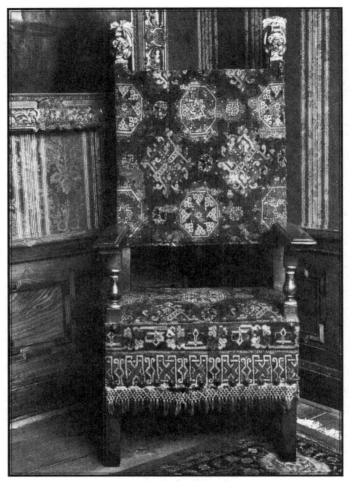

Holbein chair

pieces of furniture for the reception in the Hercules Room of the Munich Residence – classicist chairs for the Pope and his cardinals on the podium, one with armrests, the rest without (differences have to be made). Our dining chairs seemed to fit the bill, and we gladly put them at his disposal.

Much more important was the throne for the large altar on the

open square of Theresienwiese, where the Pontifical mass was to take place, in the same venue as the annual *Oktoberfest*. The critical glance of the cardinal fell, of all things, upon our Holbein chair. He sat on it, shifted his weight around and said: 'Yes, this will do, only I do not like the cover at all.' I refrained from telling him that this chair cover was a very valuable Holbein carpet fragment, and just nodded. 'Certainly, we will change the cover for the Pope.' So we went down to the fabric department and picked damask in the yellow and white of the Vatican to cover the chair. Actually, we simply pulled the fabric over the Holbein carpet. The archbishop approved, even though the organisational committee was slightly surprised that I wished to have the chair delivered by my own staff, comprising my janitor and my driver, and that both should be allowed to remain below the altar during the service. As soon as the Pope left, they snatched the chair and brought it back to safety until all the people were gone and the van could come and pick it up. Incidentally they also noticed a complete mobile operating theatre installed under the altar, in case of emergency. Barbara and I, however, sat in a place of honour at the front, in the same row as the very resplendently dressed grand masters of various Papal orders. This was part of the deal I had struck with Archbishop Marcinkus.

Like many Jewish collectors, my grandfather took a great interest in Christian art. This led to a collection of ecclesiastical garments, around four hundred in total. Then there were the ivory crucifixes, no fewer than forty of them were housed in a room on the second floor of Lenbachplatz. The textile curator of the Bavarian National Museum at the time, Saskia Durian-Ress, undertook the cataloguing of the chasubles. Our relationship with the museum goes back a long time; my grandfather had already been a supporter. I remember our visits to the former director in the Prinzregentenstrasse building, Theodor Müller, a friend of my grandfather's. During their long

conversations in the museum library I crept up the narrow cast-iron spiral staircases to reach the gallery. If I lay flat on the floor they could not see me anymore, but I could hear what they were talking about. Today I am a trustee of the museum, and sometimes during the meetings, which often take place in the same seemingly unchanged library, my thoughts wander up to the gallery where I went as a small boy.

One of the most important objects my grandfather contributed to the museum is the so-called Tattenbach Room, which will soon reopen after a long restoration. It is a closet with beautiful intarsia. As a gesture of appreciation and gratitude for the cataloguing of our chasubles, I gave the museum a group of Chinese costumes from our textile collection, before we moved out of Lenbachplatz and dissolved the old family firm.

Many years later, when I sold the ecclesiastical garments at auction with Christie's in London, the *Frankfurter Allgemeine Zeitung* covered the preview with the headline: 'As if a cathedral chapter lifted ...', which I found rather amusing at the time.

One of my great-grandfather's first purchases was a sitting Japanese Buddha in wood and lacquer. Family lore says it was the first antique object bought by Lehmann Bernheimer, and therefore it has always been part of the family relics.

My great-uncle Ernst wrote that during the inflation period the Buddha had been sold to a dealer in East Asian art without the knowledge of Ernst and Otto – at a time when, it seems, faster and faster transactions took place between art dealers – even though it had been agreed that great-grandfather's Buddha was never to be sold. When my grandfather found out on the day of the sale, he wanted to buy it back immediately, but it had already been sold on to the next dealer. My grandfather was forced to buy it back from the latter for a relatively high price. Henceforth the Buddha remained

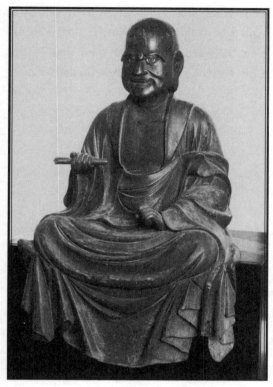

Japanese Buddha

in my grandfather's office until the family went into exile with it. As a child, I was afraid of it, as it sat in a swing chair in our house in Venezuela, almost life-size, and looked at me with large eyes. When my grandfather gave up the house in Rubio after my father's death and our return to Munich, the Buddha also returned to its former place at Lenbachplatz, in the office behind the desk. There it remained until my grandfather died.

In 1977, when I moved into this office, I brought the Buddha up from the basement where it had ended up and reinstalled it in the office. And then it sat in Marquartstein and guarded our castle.

Each of these objects that we consider to be 'family relics' has its own history, and I kept telling it to our children or to friends who came to see us at the *Burg*. Living with them and keeping memories alive through them gives me the greatest pleasure.

The End of the Golden Years

*

'A global firm of substance.'

(Ernst Bernheimer)

or:

'Could you possibly be a person of Mosaic faith?'

(A corporal during roll-call to Otto Bernheimer)

T he firm continued to expand during the early years of
the twentieth century. Stock grew inexorably, with Italian
and French furniture, carpets and tapestries, wall panels
and architectural fixtures accumulating in the large building on
Lenbachplatz, together with the ever-increasing range of furniture
from the firm's own workshops and a sizeable collection of stone
sculptures. The building could no longer accommodate them, and
Lehmann Bernheimer and his sons therefore decided to build an
even larger extension at the back, along Ottostrasse. It was to be
even more magnificent than the front building. In 1908 plans were
first discussed with the architects Friedrich von Thiersch and Mar-
tin Dülfer, and requirements for the building set out. There was to be
a beautiful tapestry hall to present the collection, which had greatly
increased in importance and needed an appropriate presentation.

Both parts of the building were to be connected by a courtyard mod-
elled on the Bargello Museum in Florence, with a flight of stairs
from the outside leading directly into the tapestry hall, just like in
the Florentine Renaissance. The courtyard would display part of the
sculpture collection, while the main part of stone pieces, chimney-

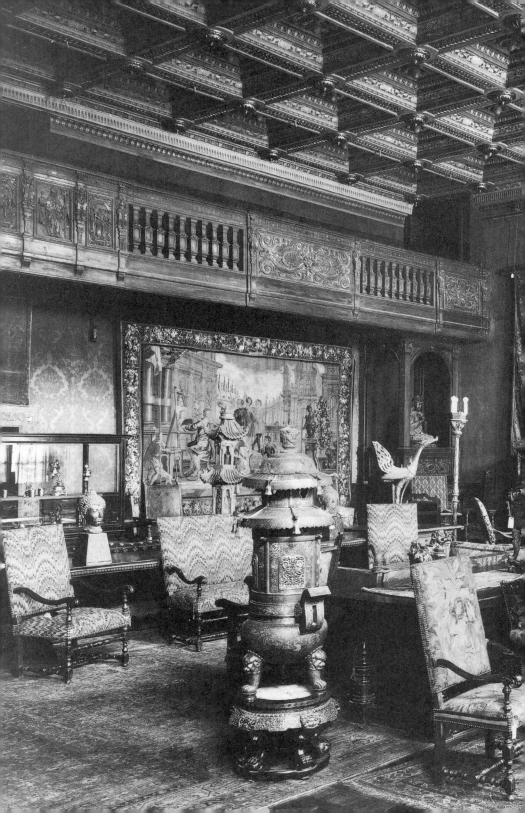

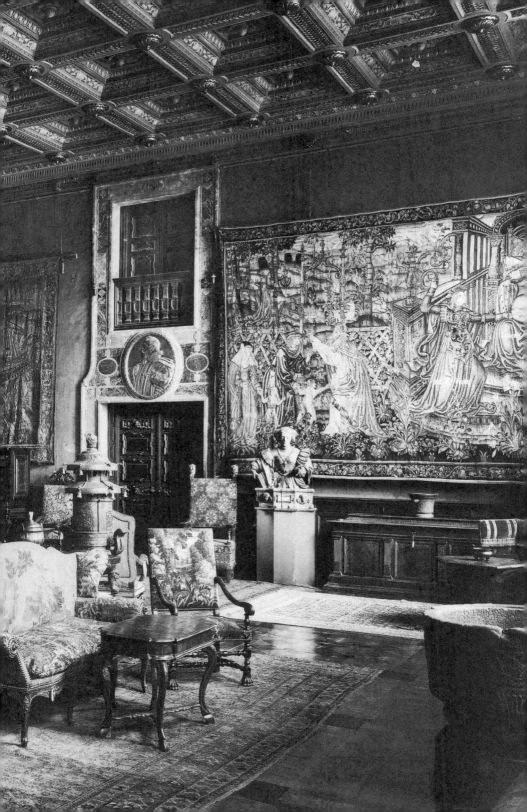

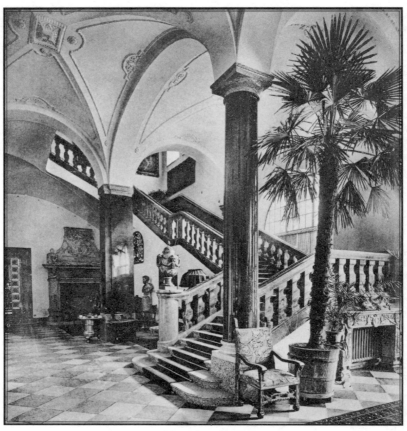

Entrance hall

pieces and panelling were to be housed in the basement, with a ceiling height of over four metres. The extension opened in 1910. In addition to extensive storage space, the basement also contained an independent engine room with large accumulators, capable of serving the entire block in the event of a power failure, as well as canteens, packing areas and crate rooms, as well as the perfectly equipped carpentry workshops. Several large lifts for people and goods connected the five floors.

The entrance hall on the ground floor was impressive, with a high ceiling and grand marble staircase. At the top of the stairs the visitor entered the double height tapestry hall, with a cantilevered ceiling cast in a single piece, below which a coffered ceiling had been hung, measuring fourteen by sixteen metres. Panelled niches hid a sophisticated and electricity-powered pulling system which allowed the raising of carpets and tapestries on each side of the room. Hidden behind a concealed door was the double height carpet strongroom, which had been lined with steel on the inside as a fire protection measure. The most valuable tapestries and the collection of carpets were stored here. On the second floor there were galleries for French, English and Italian eighteenth-century furniture, and the third floor was reserved for objects from the Italian Renaissance and German Baroque, as well as panelling, choir stalls and the sculpture department. Directly above the tapestry hall there was another large room housing the collection of antique textiles and embroideries, with fitted cupboards and showcases reaching up to the ceiling. On the fourth floor there were the offices of the draughtsmen, the sewing workshops, the rooms for upholstered furniture and a photo studio. And finally, there were the famous so-called *Musterzimmer*, the display rooms, which took up an entire flight of rooms.

In 1910, the new extension was inaugurated ceremoniously by the Prince Regent himself, who despite being ninety years old had insisted on appearing in person.

Uncle Ernst noted at the time: 'Bernheimer's had really become a global firm of substance. The treasure trove of tapestries, carpets and fabrics, furniture, antiques etc. is most likely unique in the world outside the main national museums and princely collections. Well-travelled connoisseurs maintained that our firm was not just the most beautiful and most important in Germany, but worldwide. This statement,' according to Uncle Ernst, 'is not meant to be self-praise, but simply records an often-expressed opinion. I have

Inauguration of the Italienischer Hof by Prince Regent Luitpold

noted it down to commemorate it for the younger members of the family.'

Bernheimer's now had over one hundred staff.

From the years after the completion of the extension until the beginning of the First World War Bernheimer's continued to be very successful. The firm took particular pride in orders from Lord

Curzon, Viceroy of India, for his palaces in Delhi and Calcutta. Lord and Lady Curzon, whose beauty my grandfather much admired, had come to Munich several times to make their considerable purchases. (One of my grandfather's favourite dishes was the turtle soup named after Lady Curzon.)

The beginning of the First World War meant the end of a successful era. The period of unusual economic prosperity and the happiest time for the assimilated and emancipated Jews in Germany and in all of Europe came to a close. The social advancement of the European Jews was complete, and their position in society seemed secure. The rise and success of Lehmann Bernheimer is a perfect example. He became a great merchant and was granted all the titles a merchant could obtain, such as *Königlicher Geheimrat* (Royal Privy Councillor) and *Kommerzienrat* (Councillor of Commerce), he only lacked a noble title. The Bernheimers saw themselves at eye

Lehmann, Max, Ernst and Otto and staff in 1914

– 53 –

level with the top echelons of society, which would have been impossible even one or two generations earlier. There were many important Jewish bankers, merchants, industrialists and professors; all of them respected members of society. Nobody wanted to acknowledge that there were anti-Semitic undercurrents during this felicitous time. Anti-Semitic statements were not take very seriously, although in Berlin, for example, the historian and deputy in the Reichstag Heinrich von Treitschke had said as early as 1873: 'The Jews are our downfall.' He demanded the expulsion of all Jews from their positions in society.

The social advancement of emancipated Jews almost seemed to feed a new anti-Semitism. Feeling German through and through, and in some cases not being religious at all, did not help either. In my family, as in most other German Jewish families, the impending danger was neither recognised nor acknowledged. When the First World War broke out, the Bernheimer family members considered it perfectly normal to immediately volunteer, as did members of so many other German Jewish families. My grandfather joined the *Schwere Reiter* of the cavalry. He was assigned to the Provisions Department in Munich and did not have to go to the front.

He loved telling the story of the roll-call on the first Sunday. After the orders: 'Catholics to the left and Protestants to the right, get to church!' he remained on his own in the middle. 'Bernheimer, what is the matter, are you not a Catholic or a Protestant? Could you possibly be a person of Mosaic faith?' When my grandfather nodded hesitantly, he got his order: 'Off with you to the synagogue!' My grandfather always added with great hilarity that he was sent to the synagogue on the wrong day. His brother-in-law and only brother of my grandmother, Ernst Guttmann, volunteered and fell 'for Kaiser and Reich' near Reims just before the end of the war in 1918. He is buried in the Jewish cemetery in Munich and his tomb is decorated with a steel helmet and the Iron Cross.

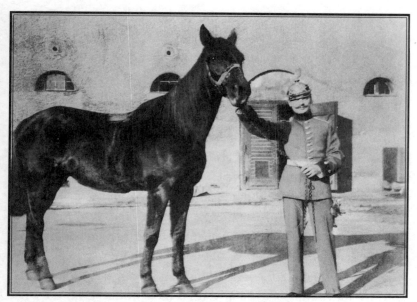

Otto in 1914 as Schwerer Reiter

My great-grandfather and founder Lehmann Bernheimer did not live to see the end of the First World War, as he died in May 1918. His sons were nearly grateful that their father had not witnessed the end of the war. 'The terrible outcome and the revolution which drove out the monarchy would have badly affected the royalist', wrote Uncle Ernst.

My grandfather always maintained that we Bernheimers were staunch monarchists. He had grown up under the monarchy and his connection to the house of Wittelsbach was especially close. The selection of photographs that he had on his bedside table is therefore perhaps not surprising. Firstly, there was a photo of Cardinal Faulhaber, the Archbishop of Munich for thirty-five years, with whom he cultivated a close friendship. Secondly, there was Prince Regent Luitpold together with my grandfather's friend Oskar von Miller, founder of the Deutsches Museum. Finally, there

was a picture of Crown Prince Rupprecht bearing a personal dedication.

My grandfather had probably hoped to be granted hereditary nobility as Baron von Bernheimer, but of course this was no longer possible when the 1918 revolution reached Bavaria as well as all other German monarchies and principalities.

Could this have been the root of the deep dislike which my grandfather harboured for the great art dealer Joseph Duveen? He always referred to his British competitor as 'the biggest scoundrel of all time', who for all his fraudulent activities had even been elevated to *Lord* Duveen by the British Crown. I suspect that my grandfather never really got over the ennoblement of his arch-rival, and the fact that the Bernheimers had missed their opportunity.

The revolution and the end of the monarchy was witnessed first hand by the Bernheimer family from their building on Lenbachplatz, since the square was a frequent scene of fighting between the 'Reds' and the 'Whites'. The turret allowed an excellent overview, from where one could see as far as the main station and the centre of town. On 1 May 1919 a general day of combat had been announced in the square. On that day my grandfather was positioned in the turret, from where he informed the white troops about the movements of the reds who were approaching from the main station. Both my grandfather and his older brother Max joined the militia.

Together with other citizens they kept watch over the neighbourhood. One evening after their briefing a police officer talked at length about the history of Munich. He described how in the fourteenth century the synagogue had been set on fire during a Jewish holiday. All doors were locked and the Jews inside burnt to death. As he spoke about this voices were heard in the room that this should be done again. When more and more swastika flags appeared during the militia's processions, the brothers Max and Otto realised that the time had come to withdraw.

Grandfather's bedside table

Slowly sales began to pick up again, but it was clear that the business had fundamentally changed. The previous clientele had largely come from the ranks of the European nobility and the reigning houses of Germany and Europe, which had all been swept away by the revolution and war. The economic crisis and the inflation were further factors. Surviving the difficult post-war years and the inflation was possible since the Bernheimers had decided to auction some of their carpets and tapestries at Christie's in London. During the spiralling inflation many wealthy clients sought refuge in tangible assets, and therefore business was not as bad as could have been expected. It was simply necessary to raise prices continuously, daily, and at the end even hourly, in order to maintain a balance with the ever-rising dollar value. In spite of this,

the most valuable objects were often sold below value, because it became impossible to permanently recalculate the dollar value. Many clients also deliberately paid late in order to get a cheaper price.

When the currency stabilised in 1923 after the introduction of the *Rentenmark*, at a rate of one to one billion (!), followed by the introduction of the *Reichsmark*, business came to a standstill at first. Everybody had been used to dealing in enormous sums, and now it became obvious that most of the supposed monetary value had been lost. It is hard to imagine today what it meant to take off twelve zeros when converting to the new stable currency.

There were hardly any clients left in Germany, and the exchange rate from abroad had suddenly changed for the worse.

When the turnover slowly began to rise again, taxes began to increase, and in addition, in 1929, the economic crisis hit in full force. The Golden Twenties, which had not actually been that golden, were finally coming to an end.

On Thursday, 24 October 1929 there had been a panic at the New York Stock Exchange, when the speculative bubbles had burst. The following day the bad news triggered the collapse of the European bourses, and it became known in history as Black Friday. This was the beginning of the Great Depression, which swept up the entire world and caused innumerable bankruptcies and an exponentially rising unemployment rate. Unfortunately, great-uncle Ernst's son-in-law, Richard Rheinstrom, who had married Ernst's daughter Lise, was also caught up in the wave of bankruptcies. The complete collapse of the banking firm of Rheinstrom forced the Bernheimers into a predicament, as many clients who had lost their money through Rheinstrom were also clients of Bernheimer's, including prominent members of the house of Wittelsbach. The family felt that it was their duty to cover their clients' losses, partly in response to the rise in vehement anti-Semitism. They wished to avoid an 'embarrass-

ing public relations controversy', and to protect their own clients from large losses. In the end, according to Uncle Ernst, nobody lost money apart from the Rheinstroms and the Bernheimers. The 'Rheinstrom affair' cost the family a lot of money.

The Nazi Era and Life in Exile

*

'It was only Hitler who turned us into Jews.'

(Otto Bernheimer)

With the beginning of the Third Reich in 1933, the family's concerns reached quite another dimension. Even in the early days, after Hitler had been appointed *Reichskanzler* on 30 January 1933, the family had to face the full force of the new regime's anti-Semitism. On 1 April 1933 there was a general appeal from the ruling powers to boycott all Jewish businesses. Like all Jewish firms, Bernheimer's had to close for the time being; the windows and the façade were covered in placards that said 'Jews'. Even when the shops could reopen, many clients stayed away out of fear of being seen as a friend of the Jews. In the meantime many Germans had joined the NSDAP, the Nazi party. In 1935, when another raid on Jewish businesses took place, assaults on Lenbachplatz could only be averted at the last minute because a staff member alerted the police that the Mexican Consulate was based in the building. Indeed, my grandfather had become the Mexican consul a few years before. A police force duly appeared to remove the rioters. However, they were released just behind the next street corner. Afterwards there were no more anti-Semitic attacks against the firm, probably because it was assumed that the Bernheimers were under special protection. The fact that many party functionaries, including Hermann Göring, bought from Bernheimer's, albeit through middlemen or architects, gave the family a sense of security and had led to an increase in turnover within a short period of time. At the time, many Jewish art dealer colleagues, some of them

immediate neighbours, decided to abandon their businesses. Among them were the Dreys and the Heinemanns, who were also based on Lenbachplatz but moved to New York, and Siegfried Lämmle, who emigrated to Los Angeles. But the Bernheimers stayed because, according to Uncle Ernst: 'You do not easily give up a firm with such a great tradition, and one built over three generations with so much hard work and effort.' They also did not anticipate that a buyer who could take over the firm would be found easily, on account of its sheer size alone. 'There was no solution.' So they continued, and hoped that nothing worse was to follow, although over time they were excluded from almost all aspects of everyday life. Travelling became difficult, since there were hardly any hotels who accepted Jews. My grandfather was struck from the list of honorary members of his cavalry regiment. Then he was excluded from the House of Artists association, the Künstlerhaus, where the Bernheimers had been founding members, and then even from the Rotary Club. But they stayed put, until 1938, the year 'when we were completely annihilated by the Nazis, emotionally and financially', as my grandfather later wrote.

My father Kurt Bernheimer was born in 1911, and when Hitler 'seized power' on 30 January 1933 he was not yet twenty-two years old. He had spent his sheltered childhood together with his older brother Ludwig, mostly in the family villa in Feldafing on Lake Starnberg. After his school days in Munich my father studied art history in Munich and Berlin. He wrote his doctoral dissertation on the influence of East Asian art on European decorative arts and the chinoiserie fashion in the seventeenth and eighteenth centuries, but it was no longer accepted. As a Jew he had to abandon his studies and leave university.

It was probably around 1935/36 when the younger generation of the family attempted to persuade their fathers to emigrate. My

father, and especially his cousin Paul, son of great-uncle Ernst took the initiative, but they were out of luck with their fathers. They were Germans, they declared, and surely nothing would happen to them. The Bernheimers were completely assimilated. For several generations they had not been religious in the orthodox sense. They felt German through and through, and saw themselves as full members of Munich society. Even though they were not very active in the local Jewish community, it did apparently matter to them to have the most beautiful and elaborate family grave on the Jewish Cemetery, probably as a status symbol.

To leave the their home country, to abandon the family firm and the great estate, that was out of the question. The Bernheimers probably acted like most of their fellow German citizens. They refused to recognise what was happening all around them. The Dachau concentration camp had existed since 1933, and Jews as well as opposition members had disappeared there. But that did not concern them. Or perhaps they felt secure because they thought they were protected by clients, by Göring for example.

My grandfather described one of his visits. It must have been between 1936 and summer 1938, when one day he stood in the hall on Lenbachplatz, having received a very short term notice from Göring's *aide-de-camp* Prince Philipp von Hessen. The president of the Reichstag wanted to look at carpets. He had several large size carpets brought out, and when shown an enormous blue and white Chinese carpet he said he wanted to come back to it. Then he wanted to see tapestries, and the procession continued into the tapestry hall, with my grandfather always followed by two SS officers with drawn pistols. When Göring was told the price of 180 000 marks he told my grandfather that he was insane, he had seen cheaper ones in Berlin. My grandfather responded that the quality was superior to anything available in Berlin, and that he would be able to pay in instalments. 'When I buy, I pay cash!' Göring replied. Then he

quickly left the building, since it was whispered to him that a crowd had gathered at the Lenbachplatz entrance. It had become known that Göring was in the building. Prince Philipp von Hessen rang my grandfather a few days later to say that the carpets and Gobelins were bought as viewed, probably for Göring's estate Carinhall in Brandenburg. The money arrived promptly a fortnight later. However, my grandfather said that people who later said that Göring had bought from Bernheimer's were arrested and accused of lying.

Was it the erroneous assumption that we were under Göring's protection, so to speak, or was it simply the inability to let go of the business, the home country and the (supposed) embeddedness in Munich society, which kept my family from leaving in time? To believe that the family had any kind of protection turned out to be a huge mistake.

In the course of events it was to become clear that Hermann Göring had an interest in the firm's collections, but he was certainly not interested in the wellbeing of the Bernheimer family. And that was the tragic error of judgement of my family, who were certainly not aware of the remark Göring supposedly made after the destruction of *Kristallnacht*: 'I wish you had killed 200 Jews and not destroyed such valuable property.'

Everything changed during *Kristallnacht*, on the ninth and tenth of November 1938. At Lenbachplatz some of the building's windows were smashed, but looting was largely prevented despite hundreds of Brown Shirts raging in the square. The main synagogue on Lenbachplatz had already been destroyed in June. It later became apparent that Göring had given instructions to protect our building in order to protect the collections from attacks. Obviously there were different plans afoot for the family collections.

The family members fared much worse. My father, his brother Ludwig and their cousins Paul and Franz were brought to Dachau on

the very same night. Uncle Ernst and his family were provisionally allowed to remain under house arrest at his small castle in Oberföhring, due to his advanced deafness. Fortunately Richard, the eldest son of Max and Karoline, was out of the country. The women were also spared and could remain at home. My grandparents heard the news in Baden-Baden where they were visiting the health spa. At his hotel my grandfather received a warning that the Gestapo had arrived to arrest him. Initially he was able to escape with a daring jump from the terrace into the park, but he was caught shortly afterwards, and on the following day he was also brought to Dachau. Neither he nor his sons knew about each other's arrest, as they had not been informed what had happened to the other family members.

When the sixty-one year old Otto Bernheimer arrived in Dachau, he had to stand half the night to wait for registration. When his head had been shaved he was finally allowed to lie down on a straw mattress. He said that during the early roll-call on the next morning

Kristallnacht: *Smashed windows at Lenbachplatz*

even those who had died during the night from abuses were dragged along, to ensure that the number of registrants was complete.

To my mind, the worst part of my grandfather's report comes next. A few days after their arrival he and his sons happened to stand next to each other during roll-call, but with their shaved heads and battered bodies they did not recognise each other. They only realised when they were called by name. It seems that my father had been treated especially roughly.

During the night of the ninth of November 1938 the family's belief in their Germanness and their inviolability was shattered. On *Kristallnacht*, my grandfather's expression: 'We were Germans and it was only Hitler who turned us into Jews' had become a bitter truth.

My grandmother had tried to ask for help from the owner of a Munich private bank who was also based on Lenbachplatz. The family were clients of the bank and had invested the greater part of their private assets there, since it had been known that the bank was connected 'to the very top'. But no help was forthcoming, and my grandmother was sent away.

Surprisingly, the miraculous rescue came from Mexico. My grandfather had become Mexican Honorary Consul in 1931, and the consulate secretary had wired a report to Mexico about what had happened. Four days later the office of the Mexican president Lázaro Cárdenas sent a telegram to the Dachau camp administration, copied to the Reich's Foreign Minister Joachim von Ribbentrop. If the Bernheimer family was not set free with immediate effect and allowed to emigrate, it said, twelve prominent Germans would be arrested in Mexico. My grandfather was indeed released from Dachau and allowed to return home. But the building on Lenbachplatz was no longer a home. Living there had become rather uncomfortable because of the frequent Nazi marches in the square. When the Brown Shirts took their formation it was every

citizen's duty to raise the swastika flag. Therefore my grandfather had decided to buy a villa in Herzogpark on Vilshofener Strasse, and the family had moved. My grandfather's secretary in the Mexican consulate had also moved the consulate to Vilshofener Strasse in order to convey diplomatic immunity on the building. However, when my grandfather returned from Dachau he found the villa rather empty. Shortly after his arrest the Gestapo had arrived, accompanied by several museum employees and art experts, to 'secure' the most valuable pieces. On the morning of the twelfth or thirteenth of November the Gestapo had also visited Uncle Ernst in his castle in Oberföhring. They came unannounced, he said, and were surprised to find him at home as they had also assumed him to be in Dachau. Ernst explained to them that he had been allowed to remain at home, due to his complete deafness. The men had brought along a well-known Munich art dealer, Xaver Scheidwimmer, who served as an expert for the Gestapo and pointed out the most important objects. 'All the tapestries, the embroideries, the best paintings, East Asian art, the collection of ancient silver, the best oriental carpets and other art objects and valuables were loaded onto a van which had been brought along for this purpose to be taken to so-called safety, never to be seen again.'

The jewellery had been confiscated, and every piece of furniture was rifled through for valuables. Both Uncle Ernst and, also a few days later, my grandfather had to present themselves at a notary's office in order to sign a declaration that gave the Nazi party full control of their entire private assets. They could no longer access their bank accounts. They were not allowed to enter the firm's premises, and the business was to be run jointly by one of the former general managers, Dr Egger, and by an emissary of the Nazi party who had risen in a short period of time from doing manual labour in the porcelain industry to becoming a professor at the academy. He must have been a particularly ardent Nazi since he had been awarded

the exclusive 'Blood Order' decoration. This was only bestowed by Hitler on those who had taken part in the 1923 coup, or on those party members who had excelled in the fight for National Socialism.

Otto tried to get his sons and nephews released from Dachau, but this took several weeks. Afterwards they were at first kept in solitary confinement in the notorious Gestapo cellars of the Wittelsbach Palais on Brienner Strasse.

The only remaining hope for the family was to emigrate. At that time however this had become increasingly difficult. Most countries had already restricted Jewish immigration quotas, and help was required from a citizen of the country to which one wished to emigrate. Another option was to prove ownership of real estate and a private income, demonstrating that one would not be a burden on the host country. But between 1933 and 1938 German Jews had been systematically stripped of all their assets.

At this point the Ministry of Economics alerted my grandfather that a certain Walter Rode and his wife Erica, a cousin of Hermann Göring, were interested in selling a coffee plantation in Venezuela. He went to Berlin at once to make contact with them. When my grandfather looked at the documentation provided he quickly realised that the property was run down and offered much too expensively. He appeared little inclined to close the deal and returned to Munich, where it was made clear to him by a senior official from the Ministry of Economics that he had no choice in the matter. He was told that Göring had said that 'no Bernheimer would leave the country alive if he did not sign the contract'. At that point his sons Ludwig and Kurt were still in the Gestapo prison, and his nephews were in Dachau. My grandfather thus returned to Berlin posthaste.

Göring presented him with several contracts. One was for the sale of all the family's immovable property. The business including the stock-in-trade and the collections was to be sold to a 'Fellowship of

Artists' led by Gauleiter Wagner. But even before Göring entered into the negotiations my grandfather had to hand over the gigantic sum of eight hundred thousand gold marks in cash. In order to establish the 'sale price' of the firm, the immovable property and the stock were valued deliberately low, at book values. However, money never actually changed hands, since the sum was held against an arbitrary tax demand, which included the Tax on Jews, the Tax on Flight from the Reich, etc.

A further contract was presented to my grandfather, concerning the purchase of the coffee plantation. The owners, Mr and Mrs Rode, had apparently tried several times to sell the hacienda but without success – not surprisingly, given the hacienda's dilapidated condition. They were determined to return to Germany, now that their cousin Hermann had become a great powerful figure in the Reich. With his help they had found a suitable victim. My grandfather had no choice but to agree to the unacceptable conditions. The contract further stipulated that my grandparents were to be accompanied to Venezuela by an unknown couple, for whom they would have to provide lodging on the hacienda and financial support for two years. They were Martin Hirsch and his wife: he was a Jewish stage actor in Berlin and his wife was an aunt of Göring's and of Erica Rode's. The *Reichsmarschall*'s Jewish uncle by marriage was thus elegantly disposed of. Göring's objective in the 'Bernheimer transaction' was not just the appropriation of the family's collections and business, which he could control with immediate effect through Gauleiter Wagner, but also to deal with some personal family issues.

Once my grandfather had returned to Munich, my father Kurt and my Uncle Ludwig were released from the dreaded Gestapo headquarters. As far as I am aware neither of them ever mentioned a single word about the weeks they had to spend there.

It took until spring 1939 to complete the lengthy emigration formalities. My grandfather's family were under house arrest at their villa in Herzogpark, his sister-in-law Karoline and her son Franz in their *palais* in Prannerstrasse. Uncle Ernst and his wife Berta were allowed to stay in their Oberföhring castle, together with their handicapped son Karli, who had Down's syndrome. Only Lise Rheinstrom, great-uncle Ernst's daughter, had to do forced labour in a Berlin ammunition factory. Finally, in April 1939 my grandparents and their sons Ludwig and Kurt were allowed to travel to England, from where they were supposed to continue on to Venezuela as soon as the visa arrived.

Aunt Karoline was the widow of my great-uncle Max, the oldest of the three brothers, who had died in 1933. In April 1939 she and her younger son Franz were also allowed to emigrate to the United States, where her elder son Richard had lived since 1934. Only Uncle Ernst and his family had to wait longer. It seemed almost impossible to find a country that would accept them together with their handicapped child. In spite of many attempts it was not possible to emigrate to the United States. They were adamant that they would not leave Karli behind as this would have meant certain death for him. In the end they were able to travel to Cuba in 1941, which seems to have cost a considerable sum, since the Batista regime expected to be well rewarded. For all those family members who wanted to travel to the United States, my distant cousin Phyllis Gordan was of key importance. She was a granddaughter of Adolph Bernheimer, the eldest brother of my grandfather Lehmann Bernheimer, who had emigrated to New York earlier in the nineteenth century. Phyllis Gordan produced all necessary affidavits for the Bernheimers, which was a prerequisite for immigration at the time. This means that she became a personal guarantor. In this way almost everybody managed to escape, except the branch of my great-grandfather's brother Leopold Bernheimer in Ulm, from whom nothing was ever heard again.

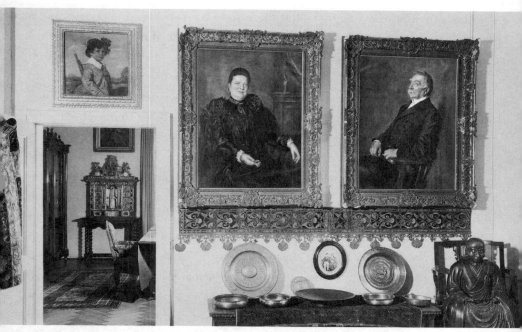

*The private rooms at Lenbachplatz with the Lenbach portraits
and the great Buddha*

Shortly before they left the country in April 1939 my grandfather
was allowed to enter the business premises for the last time. Accom-
panied by the Gestapo, he was allowed to say goodbye. When he
passed the Lenbach portraits of his parents he asked what was going
to happen to them. 'You can take these old Jews if you want, and
we also won't need the Buddha statues.' My grandparents received
the library from their private home, and they also took everything
needed to lay the table for the family: several dinner services of
Nymphenburg and Meissen porcelain, several sets of Baccarat
glasses, the monogrammed family silver, which surprisingly had not
been taken, and stacks of the most beautiful damask tablecloths,
mostly dating back to my grandmother's trousseau in the year of her
wedding in 1905. All of this later returned from Venezuela. In the

cellar of my mother's flat there were a few porcelain services and a large quantity of glasses in unopened boxes. When my sisters and I first opened these boxes in the 1990s, we were very much surprised to find glasses and porcelain wrapped in newspaper sheets from 1939, including the Nazi *Völkischer Beobachter*. These boxes had obviously never been unpacked after their arrival in Venezuela, and had returned to Munich untouched in the 1950s.

As soon as the Bernheimers had arrived in London in the summer of 1939, my grandfather received an unusual business proposition. The Reich's Foreign Ministry contacted him via the German Embassy with a commission to look for Aubusson carpets in London. He was to source these for Berlin on behalf of the 'Vereinigte Werkstätten', at the time a leading interior decorating firm often used by the government. Von Ribbentrop, the Foreign Minister, had expressed the view that 'Bernheimer was probably best suited for the task'. However, oriental carpets were not to be considered since 'inferior people' had produced these; they had to be French. My grandfather set to work and was soon in a position to organise a veritable Aubusson exhibition in a building he had rented for the purpose in Piccadilly. The buyers dispatched to London by the 'Vereinigte Werkstätten' were satisfied, and my grandfather received a commission of thirty-five thousand marks, which was a considerable sum at the time. The owner of a leading Bond Street carpet shop, Perez, offered to take my grandfather on as partner when he heard the name of Bernheimer and found out about the situation in Germany. But my grandfather declined, since he had to go to Venezuela to take over the coffee plantation, which he had after all bought with probably too much money, and it was the only property the family had now.

From today's perspective this seems bizarre: a Jewish family is driven out of the country, stripped of all its possessions, and the moment they are in exile they are employed to buy carpets. It is

understandable that my grandfather did not hesitate to take on the transaction, since every penny was needed for the emigration.

The carpets were loaded onto one of the last flights from London to Berlin before the war broke out at the end of August 1939. Otto and Ludwig could board a ship to Guadeloupe just in time; they had received their visa for Venezuela at the last minute. My father and my grandmother still had to wait for their visa in London. Then war broke out, and my father was interned as an enemy alien. It is unimaginable how he must have felt: he had hardly escaped from the concentration camp and the Gestapo, and had arrived in England as a stateless refugee, since the Nazis had withdrawn the entire Bernheimer family's German citizenship. Now he was considered an enemy German by the British and stuck in an internment camp. He shared this experience with many other Jewish emigrants.

He was to remain in the internment camp for almost a year, while my grandmother stayed in London. One and a half years after Otto and Ludwig, they also arrived on the coffee plantation.

Otto and Ludwig's sea voyage must have been quite adventurous. Having been stranded initially on the island of Guadeloupe, which was French sovereign territory at the time, they were taken to a prison 'full of black murderers', as my grandfather described it in graphic terms. Finally they were able to reach Trinidad on a circuitous route, where they were held for several more days, then to Cumaná, the first place on the Venezuelan mainland, and from there to Caracas's La Guaira harbour. There they were able to disembark with their entire luggage, which must have been substantial, considering the Lenbach paintings, buddhas, library and numerous boxes with porcelain, glass and silver cutlery. Afterwards they travelled over mountain passes through the Andes into the interior, since there were no motorways of course. After several weeks they reached their new home and took possession of the coffee plantation

'La Granja' above the small village of Rubio in the state of Táchira, close to the border with Colombia.

A cousin of my mother's, Maria Elena Uzcátegui, described in a very comical way the impression this 'caravan' made on her and the population of Rubio. The likes of *los Alemanes* and even *los Judíos* had never been seen before. They seemed to be very strange people, and nobody had seen so much luggage in living memory, let alone imagined anybody could have so much!

Los Alemanes moved into their new home, and Otto and Ludwig quickly began to learn about the entirely new business of growing coffee. The hacienda was rather dilapidated. However, they soon built a small water-driven electricity plant to put the coffee processing machines back into operation. They cleared the planting area of rampant weeds, installed new irrigation systems and obtained fertilizer. My grandfather also whipped the bookkeeping into shape, and within a short time the new owners had turned 'La Granja' into a model business.

One and a half years after Otto and Ludwig arrived in Rubio, my father and grandmother arrived in the spring of 1941. The family made the hacienda their home as much as possible. The run down house was turned into a veritable gem. It was redesigned in the Spanish Colonial style, with open verandas, several large courtyards and an entire suite of rooms. It soon became one of the finest and loveliest houses in the region. It was furnished with considerable taste, and the extensive gardens were filled with tropical plants with lavish blooms. A long road lined with palm trees led towards the house, ending in front of the main building at the 'Patio del Samán'. The Samán was a large old tree in the centre of the patio, a so-called 'Rain Tree', which would give workers and pack mules shelter from sun and rain. Its huge crown covered almost the entire patio. From a raised terrace one could see the extensive outer patios, where the coffee was spread out to dry.

The family were aware that in spite of losing their home and all their possessions, they had through a fortunate coincidence not just saved their lives but also arrived in a paradise. But my grandmother did not have much time left to settle in. The climate did not agree with her, but most of all she never got over the loss of her home country. She tried to maintain the rhythm of her daily life in Munich at the hacienda. Each afternoon tea was served on the terrace, and all family members had to join, if possible – she had taken over this tradition from her mother-in-law, Fanny Bernheimer. As the family had gathered at 5pm for tea on Lenbachplatz, so they gathered now on the terrace of the hacienda. There were regular musical soirées, and each evening they dined in style.

But my grandmother died in 1943, of a broken heart, as my mother used to say.

My father, however, adapted quickly. He had a great gift for languages, and found it easy to learn Spanish in a short period of time. Soon he rarely spoke German, only when he could not avoid it, either with his parents or when he had to write letters; otherwise he clearly wanted nothing more to do with Germany.

He met the beautiful daughter of our neighbours, Mercedes Uzcátegui, and, in my grandfather's words 'a girl from one of the best local families'. Her father Don Daniel Uzcátegui was the owner of the neighbouring hacienda 'La Palmita'. The Uzcátegui family had arrived in the seventeenth century from the Basque country. They had lived on their estate in the Andes near the border area between Venezuela and Colombia since the end of the nineteenth century.

Don Daniel, however, insisted that the young man was christened before he could marry his daughter, as the Uzcáteguis were strictly Catholic. My father agreed straight away, and I think it helped him to move beyond his German past. He entered a new world and really left his history behind. Padre Nieto, the Dominican who gave him

My father as a young man

religious instruction and also christened him became a close family friend. Later, he also christened my sisters and me.

After my grandmother's death my grandfather had erected a small chapel on the hacienda in her memory. This was the venue for the christening. It is a peculiar scene: in the middle of a coffee plantation in Venezuela a Jewish emigrant builds a Catholic chapel surrounded by coffee plants and palm trees, including a characteristic Bavarian tower with its onion-shaped dome. As a reliquary a lock of my grandmother's hair had been buried by my grandfather in a casket under the altar. He had two stained glass windows made in Munich, based on designs by Professor Joseph Oberberger. One depicted the Adoration of the Magi and the other the Flight into Egypt. This all happened in 1943, in the middle of the war. I still cannot quite understand him; Having lost everything in Munich with his family, having escaped from Dachau and Germany, after the

My mother as a young woman

hardships of travel as an emigrant in order to arrive at a coffee plantation in the Andes of Venezuela, Otto Bernheimer asked a Professor of the Munich Academy to design stained glass windows for a chapel. The commission was completed and the windows safely reached the plantation – quite a remarkable story.

The building of the chapel and the commission for the windows were actually financed through winning the top lot of the weekly local lottery. Once a week, a little boy used to make the long way up from the village up to the hacienda to sell my grandfather a lottery ticket. One day it really was *'el gordo!'*, as the boy kept shouting from a distance. My grandfather used half of the sum to finance schooling and education for the boy, and the rest for the chapel.

When I visited Rubio a while ago, a gentleman asked to see me urgently. I met with a well-dressed and clearly very educated man, a few years older than me. He introduced himself as the small boy who

Our chapel in Rubio

had sold my grandfather his ticket, and he wanted to thank me for everything my family had done for him. He had come from abject poverty, and they had paid for his schooling and his university studies, and always kept an eye on him. He was now a professor of medicine at San Cristóbal University, and he insisted on handing me his high national order award, which had recently been bestowed on him. This order and everything else he had achieved in life, he said, was due to my family alone. We were all very touched.

Part II

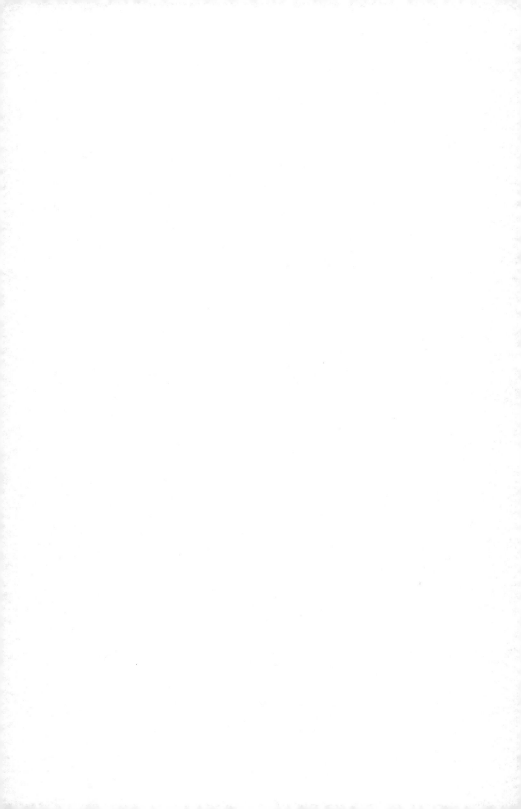

The Post-War Period and Reconstruction

*

'The nightmare is over!'

(Otto Bernheimer)

My parents, Kurt and Mercedes, married in Rubio in the spring of 1944, with the participation of the entire village, and were enveloped in the large Uzcátegui family. My father had quickly won the hearts of his in-laws. He got on very well with his father-in-law, Don Daniel, as well as with his brothers and sisters-in-law, and he worshipped his beautiful young Mercedes. Munich and the terrible experiences of Dachau and the Gestapo cellars were far away. He loved his new homeland, which had accepted him with open arms, and his young family was everything to him. My elder sister Maria Sol was born in 1945, I followed in 1950, and then three years later my younger sister Iris.

But as soon as the war was over, Otto Bernheimer wanted to return to Munich as quickly as possible. The nightmare of the Nazi period was over, he explained to his astonished sons, and now he wanted to go home. He could not wait to resume his work in Munich. Nobody in the family could understand what drove my grandfather to want to return to Munich at all costs. Among the Lämmle, Heinemann and Drey families, who had been his Jewish art dealer colleagues and neighbours on Lenbachplatz, nobody gave a thought to returning, after all that had happened. My grandfather received a letter from his brother Ernst in Cuba: he would have to deny his support, with all due respect. We should all be glad to have escaped. How could he imagine this would work, going back to Germany as if nothing had ever happened? In the meantime, the horrendous acts in the

concentration and extermination camps had become public knowledge, and the newspapers had published the most unimaginable pictures. In the name of the German people, unspeakable events had taken place.

Otto Bernheimer, however, had just one thought: in spite of his family's incomprehension, he wanted to return home. As early as August 1945 he was back in Munich, as he wanted to see what was left of his hometown and investigate whether and how he could rebuild the business. Ninety percent of the city centre of Munich had been destroyed, and the shop and office premises had been hit by bombs. Large parts of the collections were missing. But Otto Bernheimer did not harbour the slightest doubt about rebuilding his firm, even though at that time he was already sixty-eight years old.

The fact that all Nazi property, including Bernheimer's, had initially come under the administration of the occupying powers caused great complications. After the forced sale in 1938, the company had been owned by a firm run by the Gauleiter. Lengthy negotiations took place with the American occupying authorities, which finally led to a restitution of the firm and the immovable properties in 1948. The following business year was the first with my grandfather back in charge. At first he lived at the Hotel Regina, one of the few buildings that functioned as a hotel to some extent in the almost entirely destroyed city centre. His sojourns in Munich, his birth city and hometown, were difficult, since the Nazis had withdrawn German citizenship from the entire family, and he had become a Venezuelan citizen after a number of years as a stateless person. Both the occupying authorities and the emerging German Republic therefore regarded him as a foreigner. He required a visa, which initially he could only receive for six weeks at a time. When it expired, he had to return to Switzerland and wait while living in a hotel until the new visa had been registered in his passport

The destroyed house in Munich

before he could return to Munich once again. Every six weeks, the process had to be repeated. It was only at the beginning of the 1950s that my grandfather was able to get an extended residence permit. The forced trips to Zurich form part of the most extraordinary experiences of our history. The 'nightmare', as my grandfather had called the Nazi period, lasted twelve years, from 1933 to 1945. To get his citizenship back took him another nine years, from 1945 until 1954.

What would my grandfather have said if he had lived through the story of my naturalisation? My mother arrived in Munich with my sisters and me in 1954. All of us had been born in Venezuela, in the small village of Rubio in the Andes. We too arrived with Venezuelan passports, and needed a residence permit, which was granted for limited periods of time and needed to be extended. But at least we did not have to leave the country to renew the visa as my grandfather had to do. It remained complicated, as again and again we had to

'Consul' Otto Bernheimer

travel to Frankfurt in order to renew our passports at the Venezuelan
consulate. We also required a visa for all neighbouring countries.
Austria was particularly bothersome as we could only get six-week
visas. Other countries to which our mother took us from time to time,
such as France, Italy or Spain usually gave us visa for six months
or a year. At least when I became a student in 1969 I received an
unlimited residence permit for Germany. When I applied, I also
received a work permit, but only as a 'shareholder of the firm of

Bernheimer', as it even stated in my passport. When I took owner-ship of the firm in 1977 and had to travel frequently, my Venezuelan passport became somewhat arduous. And when all European air-ports began to introduce different processing for EU citizens and the rest of the world, the queuing became quite unbearable. At the beginning of the 1990s I therefore decided to apply for German citi-zenship. I went to the residents' registration office in Munich, armed with a short summary of my family history just in case, and to my amazement I found that I did not need to apply. I already was a Ger-man citizen! I was informed that according to an article of the Con-stitution of the Federal Republic of Germany the withdrawal of Ger-man citizenship during the Nazi period for political, 'racial' or religious reasons had been void. No German who had had his citi-zenship withdrawn on emigration had in fact ever lost it! Why my grandfather had to fight for it for so many years is one of the many mysteries in our history. I went home with my German passport, called my mother and gave her the helpful news from the regis-tration office. As my father had remained German while in Vene-zuela, she had therefore also become German through marriage. My mother just shook her head in disbelief.

My decision to obtain a German passport was in the end also influenced by Ilich Ramírez Sánchez, aka Carlos the Jackal, the ter-rorist who kept the world under constant threat at the time. Unfor-tunately, he and I had a lot in common. During the 1980s, when Carlos was active, I suddenly had to undergo extensive checks on arrival at Munich airport, and not just once. At one point I was put into a cabin and had to strip down to my underwear, and I wanted to know the reason for such an unusual check. I turned to Manfred Schreiber, a member of my Rotary Club and Chief of the Munich Police at the time. I found out that, incredibly, I shared a profile with Carlos. We were about the same age, he came from Venezuela, and he had also been born very close to Rubio in the state of Táchira.

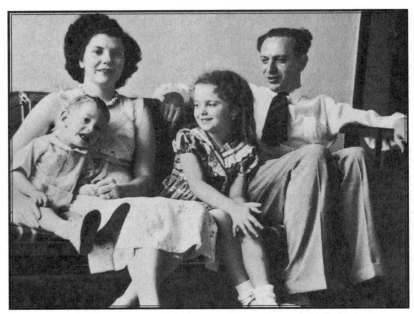

With my parents and my sister Maria Sol in Rubio

And I had a Venezuelan passport, too. Indeed, the similarities were striking. Carlos's father, a respected lawyer, was even a distant relative of my mother's family, since my grandmother, Don Daniel Uzcátegui's wife was a Ramírez, and indeed the family lived in the same village street. I may well have met little Ilich as a boy in the village. In 1994 he was extradited to France, and in autumn 2011 he was brought to trial for the second time for his terrorist past. In France the wheels of justice appear to grind especially slowly.

In July 1954, while my grandfather was in Munich, he received two terrible messages in short succession. Firstly, Don Daniel, who had become his best friend in Venezuela as he used to say, died. Ever since he had arrived at the plantation 'La Granja', his neighbour at 'La Palmita' had been his greatest support and best advisor on how to grow coffee. It is surely not least due to the support from

the Uzcáteguis that the Bernheimers were able to settle into the completely new world of coffee growing. Shortly thereafter my grandfather received the even more devastating news of my father's, his son Kurt's, death.

For my mother, this time in July 1954 must have been the worst of her life. First her beloved father Don Daniel, to whom she had been very close having grown up without her mother, died. Her mother had died in 1925 in childbirth, together with her eleventh child, when little Mercedes was two years old and her younger sister Blanca was only one. The second oldest sister, Carmen, aged fourteen, had taken over the household and brought up the younger siblings. The oldest sister Maria Teresa was already married to Angel Ovidio Carrasquero, who later became my godfather, and they had moved to Caracas. The third sister Emilia and the younger brothers Leo and Erasmo were still at home, until each left to study, one agriculture and the other pharmacy. The second oldest son Luis had to help out on the hacienda, and the oldest, Daniel, was allowed to study law abroad.

Then my father died shortly after Don Daniel, leaving my mother a widow with three small children at thirty-one.

This was a completely unexpected death that took everybody by surprise. In the morning my father had taken my older sister Maria Sol to school as usual, and had then gone up to the hacienda like every other day. In the afternoon he wanted to collect my sister again and take her home, as he always did. But on that day he never came. My mother must have been beside herself and could not comprehend her fate, as her world collapsed.

It may have been the best solution for her that her father-in-law took control and decided that his daughter-in-law and grandchildren were to move to Munich to be with him. The move had been planned in any case; my father had died immediately before the return to Germany. We now flew to Europe without our father. The

Uzcátegui family had decided that Carmen, who had not married, should support my mother. Objections were not an option in this family, and Carmen also left home to accompany her younger sister Mercedes to chilly Germany. The thought of going to Germany must have been frightening for my mother. At the same time it allowed her to escape from the depressing situation in Rubio. She had only ever heard terrible things about Germany. This was the land of the extermination of Jews, the land which had driven the Bernheimers away, the land which her husband never wanted to mention again. It was a cold and devastated country whose language she did not speak, the same language her husband had never wanted to speak again. She had been there once, when my grandfather had persistently demanded that they travel to Munich. This had been in spring 1948 when Otto had wanted to convince his son Kurt to follow him to Munich. There was a lot of work to do, he said, and he was no longer young, he needed support in rebuilding the firm. All the other family members had refused to come to Munich and help. His brother Ernst was now completely deaf and lived in Havana with his wife Berta and son Karli, from where he had admonished my grandfather for his return to Germany. Ernst's son Paul lived in Cambridge, Massachusetts, with his wife Louise, where they had opened a small antiques shop. They had also declined. Karoline, the widow of the eldest brother Max, lived in America, as did her sons Richard and Franz, neither of whom was a candidate for succession at the firm. Finally, Otto was not on good terms with his son Ludwig. That left only Kurt, his favourite. After some hesitation my father was persuaded to come to Germany with his young wife.

Shortly after their arrival my father suffered a breakdown that must have been significant. He was probably unable to withstand the psychological pressure, and his emotional scars had clearly not healed. My mother had to take him to a Swiss mountain sanatorium in Vulpera. It took several weeks before he was able to travel and

return to Venezuela. Nine years later, in early summer 1954, my father finally gave in to my grandfather's relentless pressure and agreed to come to Munich and become his successor. At first he only planned to stay one year and then decide if he wanted to remain in Munich with us, his family. And then everything changed.

My Childhood in Munich

*

'The boy spoke Bavarian
before he spoke German!'

(Otto Bernheimer)

I n early September 1954 my mother, our Aunt Carmen, who we called Cacale, my two sisters and me set out from Rubio. We first crossed the Andes to Caracas, where we stayed for a few days with my Uncle Carrasquero before the long flight. Maria Sol was almost nine, I had just turned four, and Iris was a baby of nine months. I have vague memories of the flight, of sitting in the aisle and playing with my little coloured spinning tops. My mother told me later that the flight took thirty-six hours, in a KLM super-constellation. We went from Caracas to Paramaribo in what was then Dutch Guyana, then on to the Azores, to Lisbon, and then to Amsterdam. We had a stopover there and took, I believe, a Swissair flight to Zurich. There still were no scheduled Lufthansa flights, and I am not sure why we went to Zurich, as Munich airport was already operational again. Maybe it was in order to slowly acclimatise. In any case, in Zurich Papa Otto and 'Aunt' Erna, my grandfather's new companion, met us. We were first taken to a hotel; I think it was the Dolder. I remember long walls with many curtains, and Aunt Erna's smothering cuddles. Erna Imfeld was a Swiss citizen; she had met my grandfather before the war and our exile, and soon turned up in Venezuela when she heard that my grandmother had died. Even though I did not like her pushy attitude towards us children, she was an important support for my grandfather. She would certainly not leave his side. After a few days in

Zurich we continued to Munich, with one car for us and another for the luggage.

In 1954 the centre of Munich was still badly damaged, with many fenced-in ruined sites. But most importantly there was a lack of housing, and so for an entire year we moved into a hotel. The Hotel Regina was the one closest to Bernheimer's and to my grandfather's flat. I remember our rooms there very well; there were two adjoining rooms with a red linoleum floor. In one corner room my mother and I slept in large double beds, and in the other one my Aunt Cacale and my two sisters. We enjoyed the luxury of having our own bathroom and not having to use the bathrooms along the corridor. Each bedside table had a cupboard at the bottom that contained a porcelain chamber pot. Once, when I dropped mine, the chambermaid wrung her hands and exclaimed: *'Kaputt! Kaputt!'* This became my first German word. Soon my grandfather taught me important local expressions in Bavarian dialect such as *'Ramadama'* (we'll clear it).

Otto and Ludwig Bernheimer with the staff in 1954

This was famously used by the Lord Mayor of Munich, Thomas Wimmer, in order to encourage the population to roll up their sleeves to rebuild Munich and clear the rubble from the destroyed city. One of Papa Otto's favourite dialect words was the notorious *Oachkatzlschwoaf* (squirrel tail), which is traditionally used to identify a native speaker of Bavarian dialect. It was very important for my grandfather that we learned to speak Bavarian dialect, and later he kept telling every visitor gleefully how the boy had first spoken Bavarian and only then had moved on to German. He loved it best when I wore the traditional *Trachten* outfit or a short pair of lederhosen, and my mother was happy to oblige.

Months later, when my grandfather was able to buy a flat for us, we were able to move out of the hotel. The flat was by the canal leading to the castle in the Nymphenburg quarter. The location near the park of the castle was beautiful, but the flat was very small. Once again we had only two bedrooms, which we shared in the same way as at the Regina, one bathroom, a tiny kitchen, and a living and dining room. But the furnishings came from Bernheimer's throughout.

My kindergarten was five minutes' walk around the corner. I remember very well how hard it was at the beginning, since I didn't understand a single word. But children learn quickly, and after a few months my German was passable, even though I was often mocked. I still remember how upset I was when the other boys said that I must have climbed down from a palm tree in the jungle where I had grown up with the monkeys. But the kindergarten also became the place of my first friendships. My first friend was Nicki Becker; his mother was a paediatrician. She saved my life when I had a ruptured appendix at age six, which thank God she diagnosed immediately. In the middle of the night I was operated on, and they said had it been a few hours later I would probably not have survived. I still see my old friend Nicki, even though it is only every couple of years. But the

As a four-year-old in traditional outfit

familiarity of the old friendship comes back at once. We then talk about the old times, about our childhood and how we often met in New York in the 1980s, where we tried out the first Sony Walkman together. He is now a successful lawyer and lives in Munich.

After two years in the small flat my grandfather managed to buy a very nice large house for us, which was in Malsenstrasse on the other side of the Nymphenburg canal. Each of the children had their own room there, and there was a lovely large garden. In my room under the eaves there was a huge and very tall four-poster

bed, which I regularly fell out of, but was inordinately proud of. The janitor's family lived in the basement, headed up by the very resolute Frau Reingruber, who I called 'Feingubi'. Her husband was called 'the Russian', since he had only returned from a Russian POW camp in 1955, which had affected him badly. Even his wife only referred to him as the Russian. He used to terrify us children, and he always filled in the tracks on the gravel paths in the garden which I had created for my lovely glass marbles. The Russian was really not a very pleasant character, and we tried to avoid him as much as possible. There was Helene, the nanny, Ottilie, the Reingrubers' quite friendly daughter who occasionally worked as a chambermaid, and the prettily named son Leander, who was a carpenter and hardly ever made an appearance. But he drove a motorbike, which greatly impressed me. In addition, a bulky cousin of the Reingrubers' arrived. I do not remember what his profession was, probably none since he was usually drunk and was often seen in his underwear, like a character out of a film by Rainer Werner Fassbinder.

My questions about my father also form part of my first memories of life in the big house on Malsenstrasse. I wasn't quite four when my father died, and so I only had a hazy recollection of him, as very few events from the time in Rubio had stayed in my memory. But my father's loss preoccupied me and made me keep asking about him. The official version was that 'in the middle of the preparations for the move to Germany, Kurt Bernheimer had had a tragic car accident in 1954'. This was also the version described in my grandfather's memoirs, which he published in July 1957 on the occasion of his eightieth birthday. Even as a child it became increasingly clear to me that this could not be true. I simply did not believe this version of events and kept asking my sister Maria Sol about it.

During the first few years after we moved to Munich my mother even tried to tell me that my father was on a business trip in South

America. She must have been so traumatised after her husband's death that she was completely incapable of talking to us children about it. Although my sister Maria Sol knew about my father's death, she was not allowed to talk to me about it. Even later as adults it was impossible to speak with my mother about it. I must have been five or six years old when I asked my mother why she only ever wore black or black and white. She told me these were her favourite colours.

Only three years after my father's death did she gradually began to wear colours. I remember her first coloured piece well, it was a dark green velvet skirt suit with a large shawl collar and matching small hat, which was attached with a long hat pin ending in a large pearl-drop. One day I found a photograph in a shoe box. It showed a man laid out in a sea of flowers. I thought I recognised my father and I showed the photograph to my mother. She ripped it out of my hand and said that this was nobody I knew. Afterwards the photo was never seen again.

My sister Maria Sol had been nine years old when my father died, and she remembered him best. Half her life she tormented herself with self-reproach, as she had been told that our father had died on the way back from the hacienda to the village. At lunchtime he had wanted to collect her, and she believed it had happened when he was on the way to her. Many years later she told me how much our father had lived with and in his books. Sometimes he could not be found for hours, until he was finally spotted at the hacienda, sitting under a tree and absorbed in reading a book.

In the summer holidays of 1964 we visited Venezuela and the Andes village of Rubio for the first time since we had left. I remember my feelings at the time well. I found it peculiar that memories would suddenly flare up here and there in different places. Long-forgotten images appeared, and I also believed that I had certain scenes with my father flash before my inner eye. During a walk

My mother and grandfather at the Munich antiques fair in 1956

on the hacienda, on the road where I believed the often referenced car accident would have taken place, I tried to question my mother's brothers one after the other: first *tio* Daniel, the eldest, then *tio* Erasmo. They were equally evasive, did not really know, had not been at the scene ... Considerable doubts remained in my mind, and I found it more than curious that nobody wanted to talk to me about my father's death.

Several years later, when I turned eighteen, the family lawyer Dr Leibrecht in Munich gave me a chest he had kept until this moment, containing a few personal items from my father. There was a pocket watch and my father's Venezuelan passport with its brand new visa for the immigration to Germany, which had been planned for July 1954. I still mistrusted the version of the car accident, and on that day I asked the lawyer how my father had really died, since surely this had not been a car accident. I did not get an answer; I was only told that since he was just the family lawyer he was unable to answer my question. When I turned to my mother no conversation

was possible. By now I was certain that my doubts were justified. My father's death remained a mystery, and I had nobody to whom I could talk about it.

We had a lovely time in Malsenstrasse. Life in the large house and enormous garden was a paradise for us children, we felt happy and carefree. Sometimes our grandfather visited and stayed for lunch, as Feingubi was an excellent cook and he was delighted to get away from his own cook, who hailed from Berlin and spoke the dialect of the old Bavarian arch-foe Prussia. 'Frau Meier, what's for lunch today?' – '*Klösse, Herr Konsul, Klösse!*' – 'How many times do I have to tell you that here in Bavaria we call these *Knödel*?' Of course next time she yet again referred to dumplings as *Klösse*. At least our Feingubi spoke polished Bavarian, which pleased my grandfather no end. In order to be able to have his siesta with us, he had installed his own bedroom, with tapestries, Renaissance armchairs and a huge seventeenth-century Portuguese bed with numerous turned columns. I would have loved to always sleep in this heavenly bed, but I was only allowed when I was sick, since my grandfather's bedroom was on the ground floor and our bedrooms were on the first floor. Right next to it was our playroom, where my sisters and I each had a separate cupboard for playthings, painted in the Venezuelan colours yellow, blue and red. I was the middle child and only son, and my cupboard in the middle was blue. There was also a large white cupboard which I did not like; it contained blankets and other things I did not care for. But this piece of furniture was ideal if one wanted to see what would happen when crumpled up paper was put underneath and set on fire with a candle. Not a good idea, since I was unable to put out the fire under the cupboard. And when it became too big for my taste I decided to go into the garden, as if none of this was my concern …

Fortunately the smoke was noticed quickly. Everybody in the house came running with water buckets to extinguish the fire, which

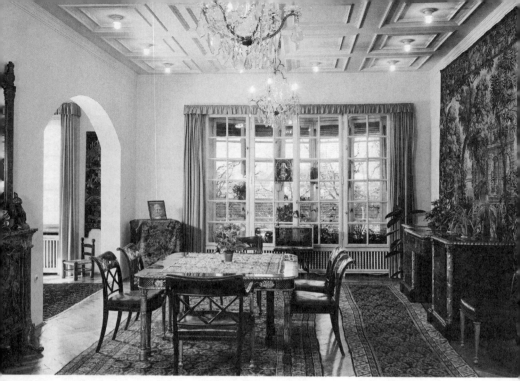

Dining room in Malsenstrasse

by then had engulfed the entire playroom. I recall that the bulky
Reingruber cousin played an important role in this, so he must have
been good for something. In the meantime, elderly Herr Weisse
chased me around the big hall table to give me a good thrashing. He
just happened to be in the house when the playroom went up in
flames. He was usually the gentlest of souls, but he was beside him-
self. It was he who had been my grandfather's secretary at the con-
sulate before the war, and who had alerted the Mexican president to
the family being in Dachau, thus saving the family's life. He was
now employed to tutor my sister Maria Sol in German. He often took
me to the Deutsches Museum, which was his domain since my
grandfather preferred to take me to art museums. I loved the differ-
ent technical departments. Herr Weisse was unable to catch me
going around the great table, but Feingubi did, and gave me the

most resounding slap in the face that I had yet received in my six-year-old life.

I could get to my elementary school on foot in about a quarter hour. After a few weeks I was allowed to walk there on my own. On my way I had to pass a number of ruined houses. In some of them my friends from school lived in sparsely furnished rooms, usually in the basements. Sadly, I was never allowed to bring these friends home, so I visited them in secret. Sometimes Feingubi caught me, since she usually found out when I was up to something I was not allowed to do. Then I got slapped. If the worst came to the worst she told my mother, and then I was grounded in my room.

On dark winter mornings I used to meet the gas man on my way to school. He went from one lantern to the next and extinguished one light after the other with a hook on his long pole. In those days there was a lot of snow in the winter. We children could build snowmen and igloos in the garden. On a December day when there was a great deal of snow, my grandfather arrived to say that he had seen St Nicholas outside. Soon afterwards the bell rang and there was a great figure of St Nicholas in a red coat, with a flowing white beard, pastoral staff and tall mitre in white and gold. He was followed by the celestial scribe in light blue breeches and a white waistcoat, with a curly white wig *en queue* with a blue bow, and a tricorn hat with plumes. Under his arm he carried the great Golden Book, which held all information known about us. He was mightily refined and genteel, this scribe. I mistrusted him from the start, and rightly so. St Nicholas was rather kind and gracious to begin with, giving my sisters small presents and stroking their hair, while telling them how good they had been. But then things took a turn for the worse. The hypocritical scribe had hardly opened his book again when he told St Nicholas in his nasty whining voice, which I remember very well, that nothing good was written about me in the book. He then began to list all my supposed misdemeanours – house fires, unauth-

orised visits to the houses of strangers, once even to a girl! Feingubi was clearly in league with him. Now St Nicholas became very stern and said that this was a case for the Demon, which in Bavaria usually accompanies him. Three knocks with the pastoral staff, and there was a terrifying rattling of chains outside. An extremely ugly giant covered in black fur crashed into the room. He made awful mumbling noises and picked me up without a word. To the horror of my mother and sisters I was thrown into a dark black sack. I still thought he was not serious, but before I knew it he tied the sack and lifted it over his shoulder. I could shout and fight as much as I wanted, but he carried me out into the garden, where he put me down and dragged me through the snow all around the house. I cannot remember what happened next, I must have been too shocked, but it took a long time before the terrible memory faded.

St Nicholas never came back to us as long as I was a child. My mother put a stop to these rough Teutonic customs for which she had no patience.

Between the ages of six and ten my childhood differed from those of my peers, as I was the Consul's grandson. My grandfather, our 'Papa Otto', was respectfully referred to as Consul by the people around him. My mother called him 'Don Otto', as had been the custom in Venezuela. Like all other children at my age, I was taught to read and write in school when I had just turned six. Shortly after my schooling began, my grandfather must have assumed that I could do so already, since one day he said to me: 'Boy, now that you can read and write, you have to start working.' This meant that once or twice a week I was collected after lunch by his chauffeur in a big white Chevrolet and taken to Lenbachplatz. I was allowed to meet him in his flat around the corner from the business premises. The way around the corner was really too short for a drive, as my grandfather could see the firm's Italian courtyard from his dining room window. So he mostly went there on foot, but had his chauffeur meet him.

As a six-year-old

Accompanied by the chauffeur, he went from his flat to the office in the morning, then back for lunch, back again, and home in the evening.

The short way from the flat to the office took us past a bookshop, and every time I was allowed to pick an art book. My mother was embarrassed to find that I was often taken home in the evening not just with one but with several books, as I wanted to choose some for her and my sisters, too. Sometimes there were duplicates, which I was allowed to exchange. I think in the long run it might have been cheaper for my grandfather to buy the bookstore.

When I was not visiting him in the office, he took me to see clients. He always introduced me as his grandson, who would one

day take over the firm. Alternatively we went to visit the museums of Munich. I can actually say that I grew up in the Pinakothek and the National Museum. Usually a tour lasted one or two hours, and the visits always focused on a particular subject. Papa Otto told me, when you go to a museum don't look at 'the museum', but think beforehand what you would like to see. Our trips were planned accordingly. If, for example, he decided to look at the bronze mounts of Baroque furniture one day, we looked at these and at nothing else in a very focused way before we left again. On another day it might have been the patina of Renaissance bronzes, or only pictures of the Madonna in the Pinakothek, or only Spanish paintings by El Greco and the Murillos. I used to be fascinated by El Greco's *Disrobing of Christ*, where the red robe of Jesus is reflected in the silvery armour of a soldier. I also used to worry about the health of Charles V because of his pallor in the portrait by Titian. I loved Albrecht Altdorfer's *Battle of Alexander* with its innumerable soldiers and spears. When my grandfather told me that this painting had once hung in Napoleon's bathroom, it was patently obvious to me that such paintings were one day also going to hang in my bathroom (though sadly it has never come to that).

In our family it was taken for granted that everybody addressed our Papa Otto as 'Herr Konsul', typically stressed on the second syllable. He had technically given up his official role as honorary Mexican consul on his emigration, but it concerned nobody, including himself, that he was really a former consul. It certainly sounded dignified and suited Papa Otto well that everybody treated him with great respect.

I was therefore very honoured a few years ago when I was offered the role of honorary Mexican consul in Munich. It would have made sense since I could have expressed my gratitude to the great country whose president, Lázaro Cárdenas, had saved the Bernheimer's

lives in 1938, to which I ultimately owe my existence. Sadly, I was not in a position to invest either the considerable time or the funds into this office that it requires. Instead, I recommended my friend Emil Schustermann, who had told me that the Bavarian state chancellery had enquired if he might be available as honorary consul for one of the vacancies. To my delight he accepted and became honorary consul for Mexico. As my friend is a perfectionist and puts great commitment into any new endeavour, he was the best Mexican consul imaginable. The Mexican community in Munich adored him. He won their hearts shortly after taking office by inviting everybody to the opening match of the football World Cup, where Mexico played against South Africa. He had rented a film studio with a gigantic screen for the purpose, and there was food and drink in abundance.

When my friend Emil suggested having his inauguration ceremony as Mexican consul in the tapestry hall of our former building on Lenbachplatz, I naturally agreed. Nevertheless, I felt uneasy, since I had hardly ever returned to Lenbachplatz since we sold the building. During the first few years after the sale I even went out of my way to avoid our *palais*. The sale continued to sadden me for many years. After twenty-five years it is now no longer an issue, even though I still do not like to return there. But I could not say no to my friend Emil, and I later saw that he had a particularly valid reason for his request. Unfortunately Emil was sick on the night and could not come to his own inauguration. Instead, his son Daniel read his speech, which was very poignant. Emil had written about November 1938, when the incredible reaction of the Mexican president rescued our family from Dachau and allowed us to emigrate. Emil also said that it was I who had recommended that he take the office of Mexican consul, as I did not feel that I could fill the role. There could be no more worthy place for the inauguration than the Bernheimer tapestry room, in the house of his pre-predecessor as Mexican consul, Otto Bernheimer. I was very moved by my friend's

gesture towards my grandfather, and greatly regretted that he could not be at his event himself.

We have been close friends with Eva and Emil Schustermann for twenty-five years, and we have shared many happy as well as sad moments in our lives. The friendship has only intensified over the years. Emil has told me many times the story of his extraordinary fate. His mother was already pregnant when she was brought to the concentration camp of Plaszów, near Cracow in Poland. It is incredible that the Nazis did not discover the pregnancy and that the child was born in the women's barracks, where it was protected and hidden by the other women prisoners. With the baby's arrival the risk of discovery increased. What would happen if the guards heard the baby crying? They would have all been in danger. The women in the barracks achieved another miracle, also to protect themselves. They used an unguarded moment to throw the baby over the barbed wire fence. Polish farmer's wives took it in their care and hid it. Miraculously, the mother also survived. She was strong enough to be moved to another labour camp at the instigation of Oskar Schindler, where she was liberated at the end of the war. She would probably not have survived in Plaszów. Those who did not die there were sent to Auschwitz; there were no survivors in Plaszów.

After the war the mother managed to find her child with the Polish farmer's wives, which is the third miracle. As far as we are aware, my friend Emil is the only person who survived being born in an extermination camp. It is incredible, but his birthplace in his passport is the concentration camp in Plaszów. He says that someone like him should really not exist.

I must have been six or seven years old when my grandfather first took me on a business trip. I remember these travels until today, and they are the reason why I took my young daughters on father-and-child trips many years later, when they were six or seven. Teresa

came to the Chatsworth sale in London, Isabel to Paris, Blanca to an auction in Monte Carlo, and Feli to Vienna. They have indelible memories of these trips, as I have of my travels with Papa Otto, but I am sure theirs are more pleasant than mine.

My first voyage with my grandfather was to Zurich where we occupied a double room in the Baur Au Lac. My memory of this first night alone with my grandfather is somewhat traumatic, as I was unable to sleep without my small pillow, my *almohadita*. It had a green cover, and unfortunately my grandfather's pyjamas were of the same colour. He saw my pillow and with his failing eyesight identified his pyjamas, and things took a lamentable turn. I was pulling from one side, defending my beloved property, my grandfather pulled from the other as he could not understand why this stubborn child would not release his pyjamas. After that I had to sleep in a separate room when we were travelling, but at the age of six or seven I found being alone in strange hotel rooms utterly terrifying. I also knew that my grandfather would wake me up in the middle of the night. He was an insomniac and usually woke up around 4am. I would then have to get fully dressed to accompany him downstairs into the lobby, which would of course be deserted at the time. This did not prevent him from calling loudly for his breakfast: 'Where is my tea?' He further emphasised his demands for service by forcefully banging his stick against the panelling.

I remember our visit to the great collector Robert von Hirsch's house in Basel. At the time I did not yet understand the importance of the collection. I was more impressed by the dust-covered abundance of items, which caused me the same itchy allergic reaction that I had in my grandfather's Munich flat in Ottostrasse. I was served the same black tea as the grown-ups, and small rolls with smoked ham. I hated both and could hardly get them down. But since I had always been treated as a small adult I had to grin and bear it.

Many years later, in 1978, Sotheby's London sold the Robert von Hirsch collection at auction. I remember it well; I sat in the second row. The Chairman of the Board of Deutsche Bank, the already legendary Hermann Josef Abs, orchestrated the acquisitions for the different German museums. He directed several dealers who all sat within view, awaiting his sign. Among them were Walter and Marianne Feilchenfeldt, sitting directly in front of me. They bought a watercolour by Dürer for the Kunsthalle in Bremen for the then extraordinary sum of six hundred and forty thousand pounds, at the time almost two and a half million German marks. Before the sale, Hermann Josef Abs had seen me take a very close look at a wonderful writing table by Abraham Roentgen. It was a fabulous piece, with numerous secret drawers, which I would have loved to have had of course. But Herr Abs ('A as in Abs, B as in Abs, and S as in Abs') came towards me wagging his finger and practically forbid me to bid on it. He wanted the piece to go to the Frankfurt Museum for Applied Arts, and he got it. Every time I see it there I have to think about this story.

Whenever I was in the presence of my grandfather as a child, I had to wear a jacket and tie as a matter of course. As I could not yet put on my own ties, I had ready-made ties and bow ties on an elasticated band that went under the collar, which I could put on myself. Since all grown-ups always saw me in these, they assumed that I loved them, and every visitor brought me a new one. Over time I accumulated a sizeable collection.

But Aunt Erna, my grandfather's girlfriend, especially never tired of giving me horrendous ties. She found me 'so cute'. She had gradually developed great skill in extracting all manner of things from my grandfather by turning poor Papa Otto's head.

Years later Erna Imfeld came to a terrible end. In the middle of the 1960s she was fished out of the river Main in Frankfurt, where

someone had evidently pushed her from a bridge. It was certainly not a robbery, since she still wore her jewellery, and her handbag with its contents remained on the bridge. There were whisperings that an enemy secret service had been involved, as she was suspected of being a spy. Why else would you be on a bridge at night if not for a conspiratorial meeting? I think we had all seen too many spy films!

Otto Bernheimer on the front page of Der Spiegel

DER SPIEGEL

11. JAHRGANG · NR.52
25. DEZEMBER 1957 · 1 DM
ERSCHEINT MITTWOCHS
VERLAGSORT HAMBURG

AUF DER SUCHE NACH DER VERLORENEN ZEIT
Antiquitätenhändler Bernheimer (siehe „Kunsthandel")

The Lenbachplatz house was a fairly awe-inspiring building with its many floors, dark cellars full of large and small art objects, huge vestry cabinets and Chinese vases, and a textile strongroom over two floors for grandfather's beloved carpet collection. On the floor above there was the enormous so-called embroidery hall with cupboards up to the ceiling, where the liturgical vestment collection was kept. Visitors were always most impressed by the unique mix of great art gallery and private museum.

Entering the building in the 1950s, one could see Herr Konsul himself in his armchair every day, registering every visitor and greeting him, only then to rise slowly, leaning on his stick, and move with short shuffling steps towards the large carved Piedmontese cupboard that held the latest acquisition behind its top door. The visitor was proudly shown the object, only to be informed that the owner would never consider parting with it again. This mighty cupboard with its richly-carved front became the first piece to move from Lenbachplatz to Marquartstein castle.

My afternoons in the business premises usually followed the same pattern. Once I had done my tour of the house holding my grandfather's hand, he decided where I was going to spend the day. If it was the furniture department, I went to see Mr Bullinger, Head of Antique Furniture, and I learned that a commode 'with belly' was Baroque, since when it was flat-fronted it was either Louis XVI or Biedermeier. I learned the difference between different types of *Schrank*, be it a *Wellenschrank* or a *Nasenschrank* (both displayed a wave pattern, but the latter also had nose-shaped corners), and I soon knew that a Maria-Theresia-*Schrank* had to be Austrian, since it was made in the time of Empress Maria Theresa. When I visited the carpet department there was Mr Beck, always in a white coat like a doctor or pharmacist. I had to sit on the floor with him and count knots, while learning the difference between a Turkish and a Persian knot. Soon I was able to answer my grandfather's questions.

When he pointed his stick toward a carpet I told him if it was a Bergama, a Ladik or an Ushak. If we looked at the Persian stock, I could tell him whether it was an Isfahan or a Kirman. The Turkmens were a particular challenge as they all looked the same, but usually you could not go wrong with Buchara. The Chinese ones were easy, especially when the question was if it was Imperial, since in that case the dragons would have five claws and not four, as for mandarins, or even three, for mere mortals. I might also be sent to see Dr Waller, who knew most about *maiolica* and sculptures. Soon I was able to distinguish easily between Deruta, Castel Durante and Urbino plates. To recognise Spanish lusterware vessels was almost too easy.

In principle my grandfather did not really like Dr Waller, who was a little affected, spoke with a Viennese accent, wore grey double-breasted flannel suits with bow ties and moved in a cloud of perfume. Again and again my grandfather got upset with him, threatened him with his stick and shouted that he was fired. And every time Dr Waller then went up to Herr Friedmann, the Commercial Director, to inform him that he had been sacked by the Consul yet again. It was duly suggested that he should lie low for a few days, by which time things would have settled down. And indeed, three days later, at the most, my grandfather used to ask where Dr Waller was; he had not seen him that day, could he possibly be on holiday again?

One of my favourite assignments was to spend time with the elderly Frau Patschky in the department for antique fabrics and embroideries on the third floor. I soon learned to distinguish between Venetian and Florentine velvet, and that a complete set of vestments comprised a chasuble, a dalmatic, a cope, a stole and a maniple. Sometimes there was also a matching cloth to cover the chalice. I was also allowed to rummage in the box for old trimmings, which were used as models. The pleasure of handling textiles was

Otto Bernheimer

marred by my allergic reaction to breathing in the dust, however, which caused terrible itchiness and a white rash. This had happened when we visited Robert von Hirsch and it happened every time I went to old Frau Patschky's textile department.

However, I owe Frau Patschky for Marquartstein most of all. I was supposed to go to boarding school for my secondary education, and my grandfather had insisted on the convent school in Ettal, since he was friends with the abbot. Therefore, in the autumn of 1959 we went to Ettal to register me for the coming school term. We had tea with the abbot, everything was magnificent and Baroque, and as a present I received a chess set with figures that had been carved in Oberammergau. (The towers were especially nice; these were designed as small elephants with towers on their backs!) For my grandfather

my going to Ettal was a settled matter, but my mother insisted on inspecting the boarding school at the convent. When she saw the freezing dormitories where forty boys would sleep in rows of narrow iron beds, she dared to protest. Never would she send her little boy there. I am still amazed that my mother was able to prevail in what was probably her first time ever to bravely oppose my grandfather. In any case, an alternative was sought, when Frau Patschky came to the rescue. Her son was head of the boarding school at Marquartstein in the Chiemgau region. We travelled to Marquartstein with Papa Otto, who had been informed that the school was in the castle. We went up the hill to the drawbridge and found the castle locked. It was explained to us that the school had just moved to new buildings for the next term, so we descended to the main road again and after a few hundred metres took the next turn up the hill. We arrived in front of modern buildings with large windows, where the head of the school, Max Patschky, awaited us. My grandfather refused to leave the automobile. He was not going to set foot in such a 'glass box'! But my mother liked the atmosphere immediately and was won over by the liberal yet strict philosophy of the institution. I think she was also pleased that I could escape from the chilly walls of the castle. The following May I took part in three days of admission tests, and was to start in September 1960. I was looking forward to boarding school, which also meant an escape from the female-dominated household in Malsenstrasse, with my mother, aunt, sisters, housekeeper and chambermaid. I did have a male dog however, a black poodle called Negro, and two tortoises whose gender was undetermined.

I did not really have many friends in Munich anyway. Most boys in my class at elementary school came from the ruined houses, and I was not allowed to play with them. My classmates also regarded me with suspicion because I was regularly collected by a uniformed chauffeur in a white Chevrolet, which actually embarrassed me. I

was also not allowed to play football, and I would not have had time for it since I had to 'work' so much in the afternoons. Finally, my German was still not perfect, and I lacked some important vocabulary. I still remember hearing the new word 'ash hole' on the street. I imagined this to be something like a sewer into which the men who cleared the ash cans emptied the dirt. I was not quite sure though, and when I asked Feingubi what an 'ash hole' was I got no answer but a hard slap in the face.

I was excited about my boarding school life that was due to start in the autumn. But then in July 1960 my grandfather died and much changed. He had a stroke at home and never recovered. Papa Otto was brought to hospital in the Schwabing quarter. The first visit there was unusual since the room looked entirely differently from normal hospital rooms. I knew these from previous visits and from having had my appendix removed. My grandfather however had his hospital room entirely decorated by Bernheimer, with tapestries on the walls, Baroque chests of drawers, sofas and armchairs, as he was used to. The only piece of clinical equipment was the hospital bed. Papa Otto had also kept his obsession with watches. He always carried six of them. On his left wrist there was his father's gold watch, which set the time for all the others, which needed to be adjusted several times a day. There were two pocket watches and about three or four wristwatches carried in various trouser, waistcoat or jacket pockets. Now they were in his pyjama pockets. One night he woke up, called the night nurse and kept asking for his daughter-in-law Mercedes. The nurse had no idea that this was the daughter-in-law's name and tried to calm him down by saying that his Mercedes was safely locked in the garage, which escalated the situation considerably. Finally, my mother, who had been called in desperation in the middle of the night, came to the hospital so that my grandfather could see her. He calmed down, but for days he could not get over his daughter-in-law being locked in a garage.

Shortly before his death the city council of Munich decided to bestow the citizen's medal on my grandfather. The newly elected young Lord Mayor Hans-Jochen Vogel came to the hospital to put the medal on my grandfather's chest in a small formal ceremony. To my grandfather's delight I had learned the Bavarian skill of yodelling while still very young, and he insisted on a performance on each visit. After the ceremony he duly asked me to yodel nicely for the Lord Mayor. The memory still causes me acute embarrassment, and apparently I am not alone in this. When I met Hans-Jochen Vogel a few years ago at a reception, he mentioned the little yodeller.

I have clear memories of my grandfather's burial. Recently we had to go to the Jewish cemetery to bury the son of friends who had died in a tragic accident, and it brought back the funeral service of my grandfather that took place in the same mourning hall. The family of the boy withdrew to the room where the coffin stood to say their

The Bernheimer grave

silent goodbyes. Then they went to meet all the people who had come to the large hall, where the coffin was also moved. My grandfather's funeral had been exactly the same.

At the time, in July 1960, I cried bitterly because I was not allowed to say goodbye to my grandfather. I had been kept out of the room with his coffin, and when I finally saw it the shock was even greater. As is the custom for Jewish funerals, my Papa Otto was laid out in a simple wooden box. I could not believe that my grand, beloved and venerated Papa Otto was to be buried in such a plain box and not in the magnificent coffin I had imagined. Nobody had explained to me that all Jews are buried in this way.

After the funeral of our friends' son, Barbara and I stood at my grandfather's grave for a long time. The great willow above had come down in a storm a few years ago and the cemetery administration had advised me that the remaining trunk should be removed entirely. Today I am glad that I decided against this, as the trunk is now wrapped in a thick layer of ivy and has become an ivy tree, providing shade and protection over the family grave.

When I was just ten years old, my relationship with my grandfather ended, but the connection still continues today. Papa Otto's influence on me was so strong that he has stayed with me all my life. Over the years I often went to the cemetery to commune with him. When I had difficulties he was a kind of patron saint to whom I appealed for help. He always was both my motivation and my burden of inheritance.

My mother put it in a nutshell many years ago. When I told her about a success I had, I cannot recall which, she said that I only did it all to compete with my grandfather, with whom I had had a contest my entire life. My mother's words may have been harsh, but she was not entirely wrong.

School Boy and Student

*

'If music be the food of love, play on,
Give me excess of it; that surfeiting,
The appetite may sicken, and so die.'

(Shakespeare, *Twelfth Night*)

When I look back on the years at boarding school in Marquartstein, they seem to have flown by, probably because it was a very happy time for me. The village of Marquartstein is in one of the most beautiful valleys of the Chiemgau region, just a few kilometres south of Lake Chiemsee at the foot of the Alps. The boarding school was founded in 1928, and for the first decades it was located in the castle. It was only shortly before I joined that the school moved to more modern buildings, which may not have been very beautiful but were certainly practical, though as my grandfather had put it, looked like 'glass boxes'.

My sister Maria Sol was sent to a convent boarding school on an island in Lake Chiemsee nearby. Even though we could not visit each other, we wrote to each other in verse.

Overall I did not find school too difficult, though I was far from being top of the class. I loved walking in the woods. Once a week I went to the village to treat myself to the greatest luxury imaginable to us: the *'de luxe'* bread roll at Kuni's, a small café by the bridge over the river Ache, which divided the village in two. Kuni's name was really Kunigunde, and she loved us schoolboys as much as we loved her. The famous delicacy consisted of a roll with poppy seeds, cut open and buttered on one side, and filled with a slice of smoked ham and a slice of cucumber. The price was fifty pfennigs, the

equivalent of the younger pupils' weekly pocket money. In the following years, Kuni's back room became an important venue where we could smoke and drink beer while Kuni stood guard in the front room in case a teacher might come by.

As could be expected, at boarding school culinary delights were few and far between. It was therefore a welcome change when Mary Holzbock, who later married my teacher Eschenbeck, offered to organise a cookery class. Apart from that she taught the external girls housekeeping and sewing. We had a lot of fun, but I remember very little apart from 'Toast Hawaii'. The legendary dish, consisting of a slice of toast with ham, pineapple and molten cheese on top, was considered the height of sophistication at the time, and represented a culinary peak of the 1960s.

Several years later we sometimes made pasta with tomato sauce. Or we pinched a loaf of bread and a large pot of plum jam from Sister Superior in the kitchen, which served to satisfy the appetite of pubescent boys. One step up was canned ravioli, sometimes eaten cold from the can in a hurry. We did not create much trouble, generally, and there were hardly any incidents, apart from burying an 'enemy' from a parallel class in an anthill (with trousers dropped of course). Once or twice someone in my class allowed a girl to climb into our dormitory, but unfortunately he was found out and expelled. There were nocturnal expeditions outside, which usually passed without any complications. Once there had been snow in the night, and the footprints in front of the window gave the game away.

'If music be the food of love, play on, give me excess of it; that surfeiting, the appetite may sicken, and so die.' This quote stands for the theatre at Marquartstein to me. From my very first year I was a member of the school's theatre group, starting with small fairy tales known to every German child, where I was 'discovered' as an extra waving a camera, and progressing to leading roles. However, I

did not always get the roles I wanted. In Shakespeare's *Twelfth Night*, for example, I would have loved to play the Duke, who had to whisper this very line while sitting at the edge of a well and sighing over his beloved Olivia. Instead I was usually selected for the comical roles, which admittedly suited me and with which I had great success. In *Twelfth Night* this was forever tipsy Sir Toby, which got me special applause at the end. One of my most famous roles was the *Le Malade Imaginaire* in the play by Molière. This turned out to be counterproductive later, as I had got into the habit of spending one or two days in Sister Eva's sick room during times leading up to an essay deadline in German or history. The interval allowed me to finish the work in time without the pesky interruptions of having to attend lessons. Sadly, once I had excelled as the *Malade Imaginaire*, doubt began to fall on my regular ailments and indispositions.

With the performance of Plautus's *Miles Gloriosus* I even made it into the arts pages of the local newspaper. The review of my interpretation of the title role said that: 'On stage the main character K. Bernheimer went on the rampage like a crazed Bramarbas roaming the forests of Arcadia', whatever they meant by that.

My favourite teacher, Hermann Eschenbeck, was a marvellous director, and each year we studied a new play. The passion I developed for the theatre even kept me from going to Eton as an exchange student. When I was sixteen, I declined the offer of spending a term at the famous English public school, arguing that I had already started rehearsals for *Twelfth Night* and would be indispensable. I regretted this a lot later. I may even have met Johnny van Haeften, who later became my friend and colleague, as he was in Eton at that time.

In any case, by the time I was in my final year the acting in Marquartstein would lead to lifelong happiness for me. In the meantime I had risen from actor to head of the theatre group, and directed Carlo Goldoni's *Servant of Two Masters*. A fellow student, Ludwig

Schäffer, played the elderly gentleman Don Pandolfo. When my mother came to the performance on parents' day she received a shock, because on stage there was my grandfather incarnate. Unwittingly, I had given directions to the actor to imitate my grandfather's shuffling walk, his gestures and facial expressions. But the crucial moment came after the performance, at the stairs leading to the stage exit. There stood a very beautiful girl, and I knew on the spot that she would be the love of my life. She was Don Pandolfo's sister. This was the nineteenth of May 1969, one month later I asked her to marry me, and she obviously said no. Despite the initial setback I did not give up my pursuit, following the motto 'where there is a will, there is a way'. We became engaged on the thirtieth of August 1972 in Salzburg, after a performance of *Twelfth Night*, and we married on the second of August 1975. She still is the love of my life.

There were lots of tears when I had to leave Marquartstein, where I had spent nine happy years. I was sobbing in the arms of my teacher 'Eschi', Eschenbeck, and his wife Mary. Over time they had become like a family for me, and of course Eschi was a father figure. For seven years he had not just been our form teacher, as well as German, philosophy and history teacher, but also my tutor; and last but not least the leader of the school theatre group where I enjoyed my early acting accomplishments.

The happy life I led in the village and the school was certainly a decisive factor many years later when I made up my mind to take up residence in Marquartstein castle. During one of Eschi's visits, as we were looking down on the village from the balcony, he told me that I had once pointed up from the school to the castle and said that one day I would live there. To which one can only say: *Se non è vero, è ben trovato*. I still have a close connection to Eschi, which does not need many words. I think he knows how much I owe him.

The Imaginary Invalid

My mother took care of my musical education, and I was often allowed (or told) to go to the Munich opera with her when I came home from boarding school for a weekend once a month. During the first years however, I was afraid of being locked in at the theatre, as I had been told the following story. My grandfather liked going to the opera. After the war all performances took place at the Prince Regent's Theatre, which had survived almost undamaged, unlike the State Opera house, the ruins of which continued to dominate Max-Joseph-Platz for quite some time. It finally reopened in 1963. My grandfather always insisted on sitting in the front row, he said it was because of his legs, but I suspect he simply liked sitting right behind the conductor. However, he used to fall asleep straight after the overture and one had to wake him up if he snored too loudly. He

always said he did not like Wagner as the noise kept him from sleeping.

On the particular evening that I was told about, he and my mother had gone to the Prince Regent's Theatre to hear *Salome*. He liked Richard Strauss, and also knew him personally. They were installed in the front row seats, the opera began, my grandfather fell asleep and the production took its course. When the final applause sounded, my grandfather woke up. Everybody rose to leave. My mother said, 'Don Otto, the opera is finished, *vámonos!*' He shouted: 'Nonsense, this is the interval, we remain seated!' (He always stayed put during the interval.) '*Salome* does not have an interval', said my mother, and he replied: 'Nonsense, every opera has an interval, we stay.' So they stayed. The doors were shut, the lights went out. After a while even my grandfather began to believe that this was the end, and they wanted to leave. But by then the doors were locked, and my grandfather had to bang his stick against the exit for quite some time before they were released.

When I was six or eight years old, I was also taken to see *Salome*. This put me off both Richard Strauss and *Salome* for quite some time, and it was only thirty years later that I saw it again in the Munich State Opera, which brought back memories of my first visit and the story about my grandfather.

My mother relented somewhat afterwards and moved her strict and regular musical education for a few years to the reopened theatre on Gärtnerplatz, which had a lighter programme. I listened to a complete repertoire of every single operetta, from *Gräfin Mariza* to *Der Zigeunerbaron* and *Die Fledermaus*, as well as the *Das Weisse Rössl*. This also caused me some lasting damage in that I still know practically every operetta aria by heart.

We have a special relationship with Richard Strauss at Marquartstein. His parents-in-law lived directly below the castle on Burgstrasse, and he himself married the singer Pauline de Ahna in the

castle chapel in 1894. Richard Strauss composed a number of works in Marquartstein, such as *Electra* and *Feuersnot*, an opera that is never performed (presumably for good reasons). He spent his summers here until 1908, though once he had earned a lot of money with *Salome*, he built his own house in Garmisch.

After Papa Otto's death, and while I was at Marquartstein, my Uncle Ludwig had returned from Venezuela to Munich to take over the management of the firm. My grandfather had had a family dispute with his son Ludwig that was never explained, and had disinherited him in favour of my sisters and me. After my grandfather's death Ludwig had insisted on the legal share of the inheritance that was his due under German law, where direct relatives cannot be disinherited entirely. As the necessary liquid assets were not available, both Otto Bernheimer's private collection and the lovely house in Malsenstrasse, which he had bought for us in 1956, had to be sold. We loved the house with the large garden, but we needed the funds. Alternatively we would have had to give my uncle a greater share of the firm, which my mother opposed completely. So we sold the house and moved into a rented flat.

The relationship with my uncle remained under strain for many years. He had even forbidden my mother and me to come to the firm. This prompted my mother to take every opportunity to visit the business premises in my company, either on my home weekends, or during the holidays. We were after all the largest shareholders. I had only seen my uncle there once, when he banged his door shut as soon as he saw my mother and me arrive. I saw him once again, and for the last time, during the one hundred year anniversary of the firm in 1964. A great celebration had been arranged in the festive hall of the Hotel Regina, and all employees as well as many honorary guests had been invited. The family members, some of whom had travelled from the United States, were seated on the stage, only my

mother and I had to sit with our lawyer at a small table below the stage. It was a visible demonstration to all guests that we were, as it were, second rate. I looked up to the stage and could not believe why I was to be punished in this way in front of everybody. I stood up and said to my mother that I wanted to greet my uncle. She called after me that I had better not go up, but I already stood in front of him at the head of the long table. I greeted him and held out my hand. Uncle Ludwig looked at me briefly before he turned his back on me. I could never forget this humiliation. A lot must have happened before a man treats his fourteen-year old nephew like that.

When Ludwig died in 1967, the family asked Paul Bernheimer, still based in Cambridge, Massachusetts with his shop near Harvard Square, to chair the partners meeting as the most senior member of the family. Since there was no other Bernheimer available, he named an old school friend to be director of the firm. Professor Bruno Taussig was a theologian and art historian, and at the partners meeting he was presented as having great knowledge of art and the ability to lead a company, even though he had no experience at all, having been a university professor before. One partner however, kept asking sceptical questions at every meeting, and that was my mother. I was at the partners meeting when the professor was introduced, as from age seventeen, when my uncle died, I had to accompany my mother to the meetings. My mother became very unpopular with Paul and his sister Lise, who venerated Bruno Taussig. 'I don't like his eyes', my mother said, and her intuitive assessment was to prove correct.

Professor Taussig behaved in a peculiar manner. First he installed a red light outside the director's office. When it was lit, nobody was allowed to even knock. Nobody knew what it was that he did in his office during these times. Wild rumours circulated, which were fuelled further when he once asked our carpet specialist Bogner to his house and opened the door stark naked. German

Bogner bolted and rushed back to the office to spread the news. When I was about seventeen, the professor also invited me to tea at his home. The first thing he did was put on a Harry Belafonte record, and declared that he did not just love the singer's voice but also how he moved, like a black panther! I soon left this interesting date, fortunately unscathed.

One day even clients noticed the professor's behaviour, when he ran through the halls while shouting that he hated antiques. Nevertheless, at the next partners meeting he presented a proposal that would have given him shares of the firm and the majority of the voting rights. Even for Paul Bernheimer this was too much. Aunt Elizabeth, or was it Aunt Karoline, shouted that Taussig was a communist and was scheming to disown the family. The professor vanished from sight as quickly as he had appeared on the Bernheimer scene. My mother was sure that Taussig had deliberately provoked his exit through unreasonable demands, because he could not cope with the task. In any case he earned a nice payoff, thanks to Uncle Paul's generosity. I think my mother was right, as so often.

My mother's instinct was also to prove correct with regard to another member of staff. In 1960, while my grandfather was still alive, a young man named Kurt Behrens had been employed with the business. Soon he proved to be exceptionally capable, and every time I came home to Munich from boarding school and visited the firm, my mother told me to give him an especially friendly greeting, since one day he would be head of the company. My mother was to be right. Kurt Behrens became managing director on the same day Bruno Taussig was dismissed.

In the autumn of 1969 I began my studies in Munich. Instead of art history I decided to study business economics. After my very strict upbringing with a view to becoming my grandfather's heir, I also went through a rebellious phase. During the liberal post-1968 years

I was no longer sure what I really wanted. I looked rather like Jimi Hendrix and was not averse to some youthful transgressions. I provoked a medium-sized scandal just after the national elections of 1969, when I proclaimed during a partners lunch that, had I been allowed to vote (I still had Venezuelan citizenship), I would have voted for Willy Brandt. I had just graduated from school and was still under the influence of my 'left-wing' teacher Eschenbeck. My Aunt Elizabeth exclaimed in horror: 'So that is the future of the house of Bernheimer!' Dr Curt Silberman, the lawyer for Paul Bernheimer, tried to calm the waters by saying that those who did not have socialist sympathies aged twenty had no heart, and those who still had them aged thirty had no brains. But when I proceeded to discuss Che Guevara, who had just been killed in Bolivia, the situation got out of hand.

So I studied business economics with an emphasis on auditing and taxation. I could definitely imagine working in that field. Art history as it was taught at university was quite interesting but also rather lacking in practical relevance. At the same time I cherry-picked those art historical lectures and seminars that I liked best. I will always remember the lectures Professor Wolfgang Braunfels gave, especially those on Michelangelo. 'Children!' was how he usually addressed his audience. 'Children! Imagine you are lying in a bathtub, and your body is covered with water. Then you pull the plug and watch how the limbs slowly emerge from the water. This is how you must imagine Michelangelo's sculptures coming out of the stone, with the marble bodies slowly gaining shape.' He was especially vivid in his description of how Michelangelo had created the unfinished Slaves, which had originally been intended for the tomb of Pope Julius II. While I sometimes wandered into my 'choice' of art history, I stayed true to my 'duty' of studying economics. My diploma thesis was on 'The concept of capital preservation in trade

and tax balances'. In May 1975 I passed my exam as one of the top students in Bavaria. One of my professors subsequently offered me an assistant post at his institute with view to doing a doctorate in economics. I was not entirely opposed to this, but I knew time was pressing. Paul Bernheimer was not getting any younger, and as he still lived at distance in Cambridge, he could not manage the firm very well. He only came to Munich once a year for the partners meeting with his friend and adviser Curt Silberman.

Curt Silberman became one of my most important mentors. Although he really was Paul's adviser, he always supported and encouraged me. Like Henry Kissinger he came from the city of Fürth, and both had also arrived in the United States as young men. Curt became American through and through, while never losing his Franconian accent with an otherwise flawless pronunciation. After the war Curt Silberman played an important role in the negotiations on restitution and reparation with the newly founded Federal Republic of Germany. He was also a great supporter among American Jews in favour of financing the foundation of the state of Israel. At the same time, he was wonderfully capable of laughing at himself. It was very amusing when he told me the reason he had given to decline the offer of becoming Nahum Goldman's successor as president of the Jewish World Congress: 'What can a Silberman do as successor of a Goldman?'

In my first years of attending the partners meetings, even while I was still a student, Curt Silberman took me seriously and kept encouraging me to continue my study of economics. It would be very useful one day in managing a company, be it this one or another, he said so often that I began to wonder whether he might not want me to join Bernheimer's. Of course it was quite the opposite, he just wanted me to be sure. He had witnessed my childhood under my grandfather, and had seen how I had been pushed at far too young an age into the role of successor. When Papa Otto died, my mother took

over and put her entire energy into making her son the future head of the firm. Whenever I came home from boarding school she made me go to the firm and do the complete round of the offices, so that all employees saw me, while I greeted everybody and exchanged a few pleasant words with each.

Silberman now wanted to make sure that it was my wish to become the head of the firm, and that I had not been forced into it. On behalf of Paul he was in Munich twice a year to see if everything was in order. He told me that I should feel free to continue with a doctoral dissertation after my business exam, as the company would survive without me. But if I were interested in art after all, he could imagine that working for some time at Christie's or Sotheby's in London might be useful. If that was what I wanted, Paul could write to the Chairman of Sotheby's or Christie's and request that I might be taken on. I did want that, but I could not make up my mind if I wanted to work at Christie's or Sotheby's. I came across an article that described them as follows: Sotheby's were auctioneers who pretended to be gentlemen, and Christie's were gentlemen who pretended to be auctioneers. Of course I liked the latter more. Paul Bernheimer accordingly wrote to Guy Hannen, Christie's Managing Director, on my behalf, in autumn 1975.

Excursion into the Family Tree

*

'Blood is a juice with curious properties.'

(Aunt Karoline, after Goethe's *Faust*)

T he annual partners meetings in Munich were also regular family gatherings. Aunt Karoline, the widow of Max, the eldest of the three brothers, lived in Munich again since the early 1960s.

My grandfather used to say that Karoline only married his elder brother Max because she could not get him. The wedding had taken place one year after my grandfather had married my grandmother Carlotta. Great-uncle Max died early in 1933, and his widow always stayed near Otto. I cannot say whether they ever became closer, but I do not think it impossible. According to Karoline's stories, she had a happy and carefree disposition, and my grandfather certainly had a reputation as a ladies' man. She did come to Venezuela a few weeks after my grandmother died and stayed at the Bernheimer hacienda for a few weeks. Some of the pastels she drew in La Granja were hanging in Marquartstein. There is a letter from my grandfather to Aunt Karoline from the 1940s or 1950s, where he asks her to restrict future correspondence to business matters. It seems that she still pursued him at the time.

Karoline spent her final years in a residential home on Lake Ammersee, where she died in the early 1970s. She was one of the last Grande Dames of the last Century. She did not receive visitors before noon, since she spent the entire morning doing her make-up and having her 'lady's maid' do her hair. She actually referred to Frau Nürnberger, known as 'Nü', in these terms, if only out of ear-

shot. Nü for her part referred to herself as 'Madame's companion'. When Aunt Karoline made her entrance at the partners meetings, she donned her pearls, looped five times around her neck and resting on her ample bosom, and wore a wide-brimmed hat as seen in Tischbein's famous picture of *Goethe in the Roman Campagna*. In fact she loved quoting Goethe: 'Blood is a juice with curious properties', she used to say, referring to the close ties of the Bernheimer family rather than to Mephistopheles, who wanted to seal the deal with Faust with a drop of blood.

Richard Bernheimer was the elder son of Max and Karoline. He had already left Germany in the early 1930s for a professorship in the United States. Until 1933 he remained a junior partner at Bernheimer's, looked after the firm's East Asian department, and wrote a much-admired catalogue for the exhibition *Khmer and Siam Sculptures* from our private collection. He made his mark in art history with the publication *Wild Men in the Middle Ages*, which today remains the standard reference book on the depiction of wild creatures in paintings, sculptures and tapestries. He died in 1958 in Lisbon in still unexplained circumstances. He was found hanged in his hotel room. A suicide was assumed, but his wife Gladys always contradicted the official version. He had contacted her just a few hours before his death to make an appointment in Geneva for the following day. When Gladys came to Munich in the nineteen-eighties, she told me he had been murdered, probably by a foreign secret service. We never found out whether Richard really worked for a secret service or whether this was a figment of his widow's imagination. It is not entirely far-fetched, since Lisbon was a main battleground in the Cold War between the intelligence services in the nineteen-fifties. However, his son Charlie – Professor Charles Bernheimer, who taught comparative literature in Buffalo and later in Berkeley – was never willing to substantiate the story of the secret service murder.

In spring 1939 Richard's younger brother Franz came to the United States, together with his mother, after his release from Dachau. He had to wait months for his visa, all the time being under house arrest. After only a few weeks in New York he was run over by a car when crossing the road, and remained paralysed in both legs. He spent the next years in a wheelchair, but due to his iron will and the devoted care of his wife Alice, known as Bice, he learned to walk again. Bice was a protestant pastor's daughter from the East Coast, and she never left his side again as long as he lived. She lost most of her eyesight in old age, but both retained their sense of humour in spite of the hardships. They often joked 'here come the lame and the blind'. Franz used to paint and draw, but they made a living from his small income as a professor of art history and a cheque from Bernheimer's, where he retained a small share until I paid him out in 1982. He had to give up painting in oils after his accident, as it was physically too demanding, but he made charcoal drawings wherever he went until shortly before his death. He, and even more so his wife, fought hard to get him recognition as an artist. But his work was never widely popular, most viewers found it too austere and too introverted. I have to admit that I also struggled to give his work the recognition it most likely would have deserved or that his wife would have wished for. Part of his earlier oeuvre was stored in the castle at Marquartstein, where it was moved after we found it in the carpet strongroom on Lenbachplatz.

Franz and Bice returned to Europe at the end of the nineteen-fifties. They no longer enjoyed living in the United States, but they also did not want to return to Munich or anywhere else in Germany. Franz was not in good health, and they looked for a place with an agreeable climate. They picked the North Italian town of Bergamo, where they still lived in April 1961 when all of us were transfixed by the reports of the Adolf Eichmann trial in Jerusalem. For them it was a key experience, they realised the importance of Israel and decided to give up their Italian home and move there.

We were all shocked by the Eichmann trial. I remember well how we sat in front of the television and saw this ice-cold man in his glass cage; for the first time I heard in detail about the atrocities of the Nazis. In my family hardly anybody spoke about it. I might have asked my grandfather, but he died when I was ten years old, and my mother never wanted to discuss this period. In any case, she could only have repeated what my father would have told her, as she grew up in Venezuela. I only remember one time when my mother spoke about my father's experiences in Dachau, how badly he had been mistreated and beaten, and that his back never healed.

As a child I was captivated by the story of how a few Mossad men had managed to find Eichmann in Argentina, captured him and put him on trial in Jerusalem. Today I find it hard to look at the newspaper clippings about the Eichmann trial over fifty years ago. I cannot bear looking at pictures of this terrible, cold-blooded and detached mastermind behind a desk. He organised the entire logistics of transporting the Jews to the extermination camps, but he presented himself as just a small cog in the wheel. He never personally killed a Jew, he said, he had just followed orders. Hannah Arendt wrote about the 'banality of evil', and was criticised for that. The writer Bettina Stangneth recently published a book *Eichmann Before Jerusalem*, where she describes how he himself had created a diabolical plan and how much he travelled around to personally inspect the effectiveness of the extermination camps. Eichmann was certainly not just following orders. Was Hannah Arendt taken in by Eichmann? Did she not want to see the monster in this cold-blooded mass murderer?

Once they were in Israel, Franz and Bice found a little house in Tivon, a small artists' colony northeast of Haifa. They could not count on the sympathy of his mother, my great-aunt Karoline, and as far as I know she never visited her son there. They met from time to time when Franz came to Munich, which was rarely the case. I only

met Franz after Karoline had died. He sometimes came to the old Bernheimer partners meetings, since he had inherited Karoline's shares.

Once we went to visit Franz and Bice in Israel, in the little house surrounded by shady trees. Floor to ceiling poles had been installed in every room, so that Franz could move around without using his canes, at least while he was at home.

They never lost their sense of humour, not even when Saddam Hussein had rockets fired on Israel. Northeast of Haifa the rockets went straight over their heads. When there was an alarm, people had to go into a shelter with their gas masks. But Franz and Bice stayed in their house. They put on their gas masks and lay on their bed, holding hands. Franz says they nearly fell off with laughter, as lying on their backs they had looked like the insect in Kafka's *Metamorphosis*.

Great-uncle Ernst and his wife Berta, who had emigrated to Havana, had three children: Paul, Lise and Karli. When Ernst Bernheimer died in Cuba, great-aunt Berta and Karli returned to Munich. They lived very quietly in their flat in the Schwabing quarter. A three room flat on Kaulbachstrasse was much more modest than the Oberföhring castle which Ernst had bought in 1913. My mother made a point of visiting them regularly, but as a child I was frightened of handicapped Karli, even though he was extremely friendly. Lise, Paul and Karli's sister, had married a banker, Richard Rheinstrom. The bank went under in the world economic crisis and he went bankrupt. The family took the responsibility for a large part of his debts, as they concerned mostly clients of Bernheimer's. Among those who would have lost their money there were also members of the royal house of Wittelsbach. Ernst, and especially my grandfather Otto, believed that they could not allow this to happen, and paid off the debt with their private income. Lise never forgave my

grandfather for this humiliation. For his part my grandfather felt that she had better blame her husband, especially as he made off with his secretary and abandoned his wife and small daughter.

When Lise arrived in New York in 1942, she took her little daughter and began to look for work. She was taken on by the Arnhold family, who had been bankers in Dresden. They had also owned the banking firm of S. Bleichröder, formerly bankers to the Kaiser and the Bismarcks. Henry Arnhold and his wife employed Lise as a nanny, and Henry said she must be the only nanny who arrived for work with a painting by Georges Braque tucked under her arm. It was the only possession she could take out of Germany.

Over the years it was always a special pleasure to meet Henry Arnhold at the art fairs in Maastricht and London. He often repeated the story of his nanny with the Braque under her arm, which amused him greatly. The Arnholds had begun to collect Meissen porcelain while in Dresden, and this collecting passion never left them. Henry must have one of the most important collections in the world by now. Some of it has been on loan to the Frick Collection for some time, and the museum glassed in their portico to create an appropriate showcase for the Arnhold porcelain collection. But it was always a special treat to be able to see the collection in his penthouse apartment on Park Avenue.

In spite of the history of the Rheinstrom bank, Lise was always proud of the Rheinstrom family connections to the Feuchtwanger family and to Albert Einstein. We keep meeting Edgar Feuchtwanger, son of the publisher Ludwig and nephew of the writer Lion Feuchtwanger. Edgar was born in Munich in 1924, and he is twelve years younger than my father. He lives and works in Winchester as a historian specializing in German and British history. I especially enjoyed his book *Albert and Victoria: The Rise and Fall of the House of Saxe-Coburg-Gotha*, on the lineage of the Windsors. He gave us a copy with a dedication: 'For Konrad, Barbara and Felicia with best

familial wishes, Edgar, 29 June 2010.' On that day we had spent a particularly pleasant day in his daughter Antonia's house in London. I feel enriched by each encounter with Edgar. It is a great joy to be able to speak about German history and also about our family history with such a well-read and knowledgeable man. He recently published his own memoirs under the title *Hitler, My Neighbour*. His family lived very close to Hitler's private home, and as a child he could observe from their window the excited activities that took place when the 'Führer' was in Munich.

Lise had a daughter, Ingrid, who is an artist and lives near Washington, D. C. She never seemed to take her daughter's art very seriously, since when asked she would say: 'She paints a little.' Ingrid, however, was a very ambitious artist, and together with several fellow-artists she created an artist centre in Alexandria on the Potomac River. It is located in a former torpedo factory, where torpedoes were actually built until the end of the Second World War. The huge loft-like spaces are perfectly suited for artist studios. We went to visit Ingrid a few times, and I got on especially well with her.

After emigration Paul Bernheimer and his wife Louise settled in Cambridge, Massachusetts and opened a small shop on Brattle Street. He sold antique jewellery, tribal art, antiquities and much more. I went to see him twice, once together with the former head of our carpet department on Lenbachplatz, German Bogner. In January 1978 we were on a trip through America to buy antique carpets. We were caught in a heavy blizzard in Cambridge, and it was quite a dramatic journey to reach our hotel in Boston on the opposite side of the river. We were stranded at the Copley Plaza for three days and nights, with the snow drifts reaching up to the first floor. The telephone network had collapsed and our families in Germany, who had seen the terrifying television reports about people missing

and freezing to death, were greatly worried because they could not reach us.

Paul Bernheimer was a wonderful, mild-mannered, very endearing man with a very strong wife. Louise was the sister of Pierre Rosenberg's mother, and until a few years ago Pierre Rosenberg used to be the very powerful director of the Louvre. He is also a member of the *Académie française* and married to the sister of Éric de Rothschild, the owner of Château Lafite.

Paul and Louise have two sons, Martin and George. Sometimes I meet Martin Bernheimer in New York, and we go to his favourite Italian restaurant. For many years he was the renowned and feared music critic of the *Los Angeles Times* and later the *Financial Times* in New York, and he is a Pulitzer Prize winner. When I met the great conductor Lorin Maazel many years ago, he said to me: 'Bernheimer? You are *not* related to *that* Bernheimer?' It seems that Martin wrote a few less than complimentary critiques about Lorin Maazel.

George's son is Max Bernheimer, Christie's very successful International Head of Antiquities, who manages their global antiquities department from New York.

When I think of Adolf Loewi, my grandfather's nephew, I think of Venice. From 1911 he had his home and his business in the Abbazia di San Gregorio, right next to the church of Santa Maria della Salute. Adolf Loewi's mother was Emma Bernheimer, sister to the three brothers Max, Ernst and Otto. Since my great-grandfather Lehman only took his sons into the firm, his daughter received a generous settlement. Her son Adolf was a highly talented art dealer, and had he been able to join Bernheimer's he would surely have been a great asset. But as a young man he went to Venice and became one of the most successful art dealers in Italy. He stayed in the Abbazia di San Gregorio for a few years before he moved to a palazzo in San Trovaso

right behind the Accademia. In 1938 he left Europe to settle in Los Angeles.

In Venice he soon became one of the main points of contact for visitors who were interested in art. And what an inspiring place Venice must have been in those days, long before the advent of mass tourism! When his daughter Kay Robertson came to Marquartstein she showed us some photographs of the Abbazia. One of them showed the elderly J. P. Morgan, as he climbed out of a gondola and was received by Adolf Loewi.

Adolf's daughter Kay soon became an efficient and successful partner in the business. From New York and later from Los Angeles, the firm of Loewi-Robertson supplied American museums with great works of art. The most important sale was probably that of the 'Studiolo', an entire room from the Palazzo Ducale in Urbino, which had been created for Federico da Montefeltro. It had the most incredible *trompe-l'oeil* intarsia, and is one of the most fascinating rooms at the Metropolitan Museum. A few years ago it was completely restored and reconstructed.

Kay is over ninety now, and she still lives in her house in Los Angeles. She rang me at the end of the 1980s and wanted to meet with me in London. Together with her husband Bill, she had made an exciting discovery many years ago of a small wooden statuette by Giambologna. It was one of his earliest works, and his only work carved in wood. It is a nude figure of Julius Caesar in imperial posture on a wooden plinth, and on the base of the plinth there is a dedication to Bernardo Vecchietti, the first sponsor of the young Giambologna. He had probably kept the statue at his villa, 'Il Riposo'. Kay had lent her Giambologna to the Victoria and Albert Museum, where it spent many peaceful years in a showcase together with other works by the same master. Anthony Redcliff and Charles Avery, who were the curators of the sculpture department at the V&A at the time, were very sad when Kay and I took the

Giambologna out of the glass case. Kay disapproved of internal politics and several staff changes at the museum, and had quite spontaneously decided to withdraw her loan, even though none of this concerned the Giambologna. At the time she offered me a half share, which I gladly accepted. Since then we have owned it jointly. Having kept the statuette at Marquartstein for many years, I lent it to the Bavarian National Museum some years ago.

Not far from the Abbazia di San Gregorio lies the Peggy Guggenheim museum. I still say 'I am going to visit Peggy Guggenheim', since I met her there one day. It must have been in 1967 or '68, while I was still at school. My mother and I were in Venice, and for whatever reason I went to see the Guggenheim collection on my own. When I entered the garden there was Signora Peggy, sitting on a marble bench. When she saw me she called me over. She wanted to know where I came from and why I was in Venice. 'Who are you, my boy?' I sat down on the bench next to her and began to tell her my family history. She listened attentively. I see her sitting on that bench every time I visit the *palazzo*. When she died in 1979 she was buried next to her dogs in the garden. Every time I visit, I also go out on the beautiful terrace overlooking the Canal Grande to pay my respects to Marino Marini's rider. The sculpture's large erect penis used to be detachable, since the Venetian patriarch could not be expected to face such an obscenity when he led the annual Corpus Christi procession with the holy of holies on the Canal Grande. It is said that Peggy insisted on personally removing the penis before each procession, and on screwing it back on directly afterwards. Today the vital part is firmly soldered on to prevent it from disappearing.

Our Wedding and My Time
at Christie's

*

'Put it back on the shelf,
it's your first day!'

(Anthony du Boulay, my boss at Christie's)

After Barbara and I had met in Marquartstein in 1969 and our relationship became ever closer, she spent the summer semester of 1972 in Madrid in order to learn Spanish. She had originally wanted to go to Rome and learn Italian, but I told her that if she might be serious about me, she would be well advised to take up Spanish, which everybody in my family spoke; so instead of Rome she went to Madrid.

During my semester break I went to visit her in a nice little flat near the Bernabéu Stadium. It was on the other side of the Paseo de la Castellana, in Calle de Pedro Teixeira. Every day Barbara went to Spanish class while I spent a wonderful time in outdoor cafés and went on extensive visits to the Prado. There were lectures and talks there on Velázquez, Goya and Murillo, and I made the most of learning as much as possible about Spanish painting in front of these great originals. On the weekend we often went out of town, to Segovia, the nearby palace of La Granja, the Escorial, and Aranjuez with its lovely park and the Casa del Labrador for example. It was a perfect setting for young lovers. In Toledo we could study the work of El Greco in detail, and in the vestry of the cathedral I was able to see the large version of the *Disrobing of Christ,* which I knew so well from childhood through the version in Munich. We spent Easter week in Seville, where we stayed in a family's nursery room. But in

any case we were outside all night to see the nocturnal processions where hooded figures brandishing torches wielded the heavy figures of the Madonna and Christ carrying the Cross through the streets. And when we were in Granada, I declared the Lion's Court the most beautiful place in the world.

We spent such a happy time in Madrid that we both knew we would stay together. When she returned to Munich, Barbara secretly moved into my student flat in Schwabing. We told our families that she would come back from Madrid later. Together we went to the Olympic Games and had a carefree time together, until the day of the terrible terrorist attack when the entire city of Munich went into mourning.

We wanted to become engaged, but we did not know when and where. I had carried a ring in my trouser pocket for some time, in case a good opportunity came up. At the end of August 1972, on the eve of my birthday, the right moment arrived. Barbara had bought tickets for Shakespeare's *Twelfth Night* at the Salzburg Festival. It was a wonderful performance, with some of the best actors of the time. Hans Dieter Zeidler, who for some reason I hardly recall, played my 'signature' role of Sir Toby. After the performance we had managed to get a small table at the Goldener Hirsch, and the moment came. Between roasted pheasant and the inevitable Salzburger Nockerln, I slipped the small red box with the ring under her napkin.

Three years later, in August 1975, the time had come to get married. I had wanted to wait for my exam, as I felt better equipped to support a family once I had my university degree, the prospect of going to England to work at Christie's, and the long-term perspective of taking over Bernheimer's one day. The wedding took place on the second of August 1975 in the small Trinity Church in Munich, followed by an extensive and unforgettable party in the Bernheimer tapestry hall with many friends and family and to the accompaniment of South American music.

After the wedding we left for our honeymoon to Venezuela. I wanted to show my wife my birth country, and I really really wanted to get to know it myself. On arrival at Maiquetía Airport we got a first impression of the size of my mother's family. We were greeted by no less that fifty-eight people, and a caravan of cars subsequently moved with us from the airport over the motorway to Caracas. The land was in the grip of an incredible oil bonanza. We were open-mouthed when we saw the skyscrapers and the city highways with eight lanes winding through the narrow Caracas Valley. The surrounding hills were covered top to bottom with the *ranchitos* of the barrios. Seeing these slums took some getting used to.

Further east, up into the hills, we came to Prados del Este, the more prosperous parts of the city, where Uncle Wolfgang and Aunt Blanca expected us for a welcoming party. About two hundred people pounced on us, until one of my mother's elderly brothers, *tio* Luis, explained to Barbara that it was all really quite simple: the younger ones were all cousins and the older ones like him were uncles and aunts. Over time we go to know them all, and Barbara, who has always been much better than I am at remembering relationships, still knows exactly how many children each cousin has with whom and what their names are.

After a few days in Caracas we took my cousin Aura Sofia's car, a wonderful white Ford Mustang, on a trip through the country. First we went east to Puerto La Cruz and to the island of Margarita, which still had deserted beaches lined with palm trees at the time, then further into the wild rain forest to Canaima and to the Angel Falls, over the Andes to Rubio and finally to Maracaibo, the pile dwellings of the Guajira Indians, the colonial town of Coro, and then back to Caracas.

With Barbara's support, I was determined to learn the truth about my father's death on this voyage. I wanted final clarity about the story of the car accident, which I had doubted my entire life. I had

long suspected that my father's death could really only have been suicide. There was no other explanation for this dark family secret, about which nobody obviously ever wanted to talk. I knew that the only person who might be open and honest would be my mother's youngest sister, Aunt Blanca. As we went to a beach near Puerto La Cruz the opportunity arrived. I began the conversation very gingerly, as I feared that she too might feign ignorance. I told her that even as a child I had never believed what the grown-ups told me about my father, or rather had not told me. I wanted to know how my father died, and I asked her to tell me what really happened. She then confirmed what I had always suspected: that my father had shot himself at the hacienda. But she also said that his motives had never really been discussed and that nobody had been able to understand it. We both came home terribly sunburnt, as we had spent hours lying on the beach and had paid no attention to the sun during our intense conversation.

After the talk my Aunt Blanca made me promise never to speak with my mother about my father's death, and most of all never to tell her that we had spoken about it. After the tragic events and before her rushed departure to Germany, my mother had made the whole family swear never to mention her husband's death again, and certainly not in front of the children. Whenever I tried later to speak with my mother about my father, she categorically refused.

Over the following years I worked out my own version about my father's suicide and his motives. I do not think that my father would ever have returned to Germany out of his own free will. He had probably suffered most of all family members, psychologically, but also physically. He always complained about back pain, which clearly went back to his imprisonment in Dachau or from the Wittelsbach Palais. My mother once said it was because they had injured him so badly. I know that my father always resisted my grandfather's ever more persistent urge to return to Munich with his family and help

him rebuild the firm and become his successor. My father had finally put his terrible past behind him, found happiness in Venezuela, and had a beautiful young wife and three small children. He had become Venezuelan, and was a co-founder of the Rubio Rotary Club. He did not want to return to Germany, but in 1954 my grandfather got his way. Kurt agreed to move to Munich for one year before making his final decision. Passports were organised, flights were booked. And then, just before travelling, he took his own life, clearly a surprise to all. It looked to me as if he could not bear to return to Germany after all he had suffered there. In addition, I had heard of a row between the brothers Kurt and Ludwig. Otto had blamed his son Ludwig for the death of his favourite son Kurt. This rift finally led to my grandfather disinheriting Ludwig.

When Barbara and I went to my birthplace of Rubio after this conversation with *tia* Blanca, I saw everything with different eyes: the hacienda of the Uzcáteguis, 'La Palmita', the village, the house where I had been born. The Bernheimer hacienda of 'La Granja' had been sold in the mid-1960s when Ludwig returned to Germany, and we could not visit. We could only see the chapel with the onion tower where we had been christened as children. Maybe it was a good thing that I could not visit the place where my father had died. This became possible only many years later, and I have to say it was not a good feeling.

We lived modestly, but very happily, during our first years in Schwabing. The location on a rear courtyard on Schleissheimer Strasse was not perfect, and the view from the living room was onto a brick wall three metres away. But with the assistance of Bernheimer's I had furnished the flat very comfortably. My *pièce de resistance* was a large Biedermeier sofa which I had found in the basement on Lenbachplatz. It was painted black and covered in a fabric with zigzag pattern, reminiscent of the *hongroise* fabrics of

the seventeenth century. I still have the sofa; it was in my office in Marquartstein and occasionally was the site of my siesta.

During this time, the decision had been made to join Christie's in London, and I took private lessons in order to improve my school English. These took place in Munich with a teacher who had been recommended to me, and who spoke a terribly affected 'Queen's English'. She sounded more royal than the Queen, but even worse were the numerous cats in her flat. I had not been a great friend of cats before, but this was the final straw and I became a cat-hater. It was sadly impossible to convince the teacher to hold her lessons elsewhere, so I had to put up with the malodorous feline home for a few weeks. In November 1975 I flew to my final interview with Guy Hannen, managing director of Christie's in London. Mr Hannen had apparently already made up his mind, and it seemed to be just a formality. At least I managed not to appear overly stupid. Christie's was not taking a huge risk anyway, since Bernheimer's paid me with a generous allowance of fifty pounds per week (the pound being at five German marks and seventy pfennigs at the time). By chance I found a lovely little flat in Chelsea near the Royal Hospital, in Ormonde Gate. It was fully furnished, and in very good taste. The flat belonged to a charming Greek couple who were going to Africa together for a year. Mr Boucas was a photographer and worked for UNESCO. They seemed to take to me as well, and entrusted me with their flat.

Barbara followed a few weeks later. She took one semester off her pharmacy studies and we spent a very happy first year of our new marriage in London. We spent the legendary dry summer of 1976 travelling through the United Kingdom up to Scotland, going from one bed-and-breakfast to the other and really did not have a single drop of rain during the entire time, which was remarkable.

How many times have I flown between Munich and London since 1976, I wondered, as once again I was waiting in Heathrow for my delayed departure to Munich. Since my first days at Christie's, London has never gone away. In 1985 I opened my first gallery on St George's Street, ten years later I moved to Mount Street, and then I ended up in St James's. Since 2002, I have been in Bond Street with Colnaghi.

In January 1976 I started at Christie's. As every new employee I began at the front counter. If I remember correctly, I was to start on a Monday. On the Thursday before I had arrived from Munich in order to move into my Chelsea flat. On Friday morning I entered the sacrosanct halls and went to the front counter to introduce myself and ask what time I should start on Monday and who I should report to. It was all quite hectic, as some young men my age (I was in my mid-twenties) were busy with clients or on the telephone. A middle-aged lady took care of me; this was Kathy Pritchard, head of the front counter. 'Let's go upstairs to see the managing director.' We went upstairs and turned around the landing. On the left, towards King Street, there was the office of the all-powerful and feared managing director Guy Hannen. He was on the telephone, waved us in and said: 'Ah, this is young Konrad Bernheimer? Well, Kathy, he will be joining you at the front counter for the next couple of months. Take him downstairs and show him everything.' I did not get to say anything.

So we went downstairs again, and even on the stairs my new boss explained to me in rapid fire style what we had to do at the counter. 'So, people come through the door and bring a picture, or a silver pot, or a drawing, or a Chinese vase to the counter and want to know what to do with it. You boys take it in, bring it up to the specialist, let them explain what it is and what it is worth, come down again, tell the client everything important, and if the specialist said we should keep it for an auction, you must convince the client to consign, then

– 145 –

you get a new stock number on the telephone, fill out the form and bring the object to the respective warehouse. If it is not for us, you send the client on his way, and if it is really horrible, best that you send him straight to Sotheby's.'

With that she left me. I had a brief opportunity to say hello to the other boys, then a telephone rang. I just saw my colleagues dart away and left me there on my own in front of the apparatus.

'Hello?' Something entirely unintelligible came out of the receiver. My school English was not too bad, and the cat lady in Munich had surely done her best, but I could not understand a word of this plummy, very stiff upper lip torrent of language. 'Excuse me, I don't understand?' An even louder torrent was the answer; the only words I could make out were 'idiot', apparently with the addition of 'bloody'. Before I could make heads or tails of this, the impatient and furious gentleman had put down, or rather slammed down the receiver with a big bang. I then saw the other boys come back to the counter, grinning and smirking. What had happened? I had learned the hard way, as so often, that the telephone ringtone changed to three rings from two when the Chairman called. Of course he had no idea that there was a novice at the other end who did not have a clue.

Over time I learned to do my job and I very much liked being on the front counter. It was really a unique chance to learn something about every area of the art market and to understand how the auction world functioned. There were very interesting objects and people who came through the door, but also bizarre and peculiar ones – both people and objects. When a Chinese vase made over one hundred thousand pounds at auction, we were overrun on the follow-ing day by elderly ladies with blue and white vases from their man-telpieces tucked under their arms who simply refused to accept that their vase was not Ming, since it really did come from the estate of great-grand-uncle Giles, who, during the Boxer Rebellion ... 'Yes, he was out there!' I think the vase that made the big price was the

one which Anthony du Boulay, head of the Chinese department, had found in a Scottish castle where it was used to catch drips below a basin in the guest cloakroom – early Ming, or Yuan dynasty.

On one of the first days I had to take a silver candlestick down to the warehouse. Until then I had always passed through the security gates in both directions together with a colleague. But there was also a porter who opened the door from inside. This time I was alone when I wanted to go back up, and there was neither a colleague nor a porter in sight. I saw a red button on the inside and thought, if I press this, surely the door will open. I pressed the button, a siren sounded, and in front and behind me the gates went down with a tremendous rattle. I was locked in. I had pressed the alert button for a personal attack! Above my head I heard a commotion in the entrance hall, as the entrance doors to King Street were shut. Finally, I was discovered, the cause of all the trouble, locked in between security gates. I was taken upstairs, the whole house had come to the entrance hall, employees and clients, and in front of me there was John Floyd, the Chairman, a tall elegant gentleman, very British indeed. He leaned towards me with his beaked nose and said just one thing: 'Did you do this, young man?' But it was not me who got the blame, but my colleagues, who had not explained to me how the security system worked. That was my first experience in British leadership.

A few weeks later, when I had applied in vain to work in the Old Masters department, I started in the Chinese department under Anthony du Boulay. I have this in common with my friend Johnny van Haeften, by the way, who also did not work in the Old Masters department, but first in the press office and then in the stamp department. As a consequence he later became an avid stamp collector.

Anthony was not an easy boss, as he had a temper and was known for his tantrums. All of us had great respect for him, and he could

admittedly be very funny. But I was most impressed by his enormous knowledge. One could learn a great deal from him. I learned an important lesson on my very first day with him. Many Portuguese shipments had arrived at Christie's, as wealthy collectors feared that the new socialist government would expropriate their collections in the wake of the Carnation Revolution. Through the influx of porcelain from Portugal, the Chinese department had one of its best years. I was dispatched to unpack a box with cups and saucers which had been commissioned by the East India Company in China for export to Portugal. I was to put the cups and saucers on the shelves for cataloguing. This was when the disaster happened: the most expensive piece of the collection, a cup with the portrait of Dom João, King John of Portugal, slipped from my hands and broke into several pieces. I heard Mr du Boulay's voice from next door: 'Konrad, what happened?' I stepped out in front of him, trembling, with the pieces in hand. He looked at the pieces and said: 'It's not the one with the portrait of the king, is it?' I saw his carotid artery swell like Vesuvius shortly before eruption, but to my great surprise he swallowed his anger, turned back to his work and said: 'Alright, Konrad, put it back onto the shelf, it's your first day.' And that was it!

He never mentioned the incident again. It was reported to the insurance, the bowl was restored and put up for auction with a reduced estimate. Many years later, at Bernheimer's on Lenbachplatz, my assistant at the time dropped a K'ang-Hsi porcelain bowl. Remembering the generosity of my former boss at Christie's, I had it restored and gave it to her as a present, telling her to take it home as a reminder to never drop anything again. Today my former assistant is the Princess Salm-Salm, and she still has the bowl.

I greatly enjoyed working at Christie's, and I learned a lot. One of the tasks I was given in the Chinese department was to do an exact condition report of every single piece, which then became part of the

cataloguing. In a way this was my punishment for the broken bowl. Over time I developed a good relationship with Anthony du Boulay, and I was also allowed to visit other departments. I was especially taken with the wine department headed by Michael Broadbent. Opposite our Chinese cages, the barred basement rooms of the Chinese department, there was the Special Showroom. All departments used it to present especially important pieces before the official viewing started in the exhibition rooms. Michael Broadbent also used this room for special wine tastings. We boys from the departments opposite kept an eye on these tastings, which were usually scheduled for a Wednesday or a Thursday at 11am. At first I wondered why the guests were dressed so formally for these events, they all wore cutaways or morning coat, or at a minimum striped trousers. That was until someone told me that these were the butlers and sommeliers from the surrounding clubs of St James's, who were the biggest clients of the wine department at the time. I was also surprised to find that bottles of 1864 Latour or 1870 Lafite were so highly praised, since when we sneaked over once for the dregs after the end of the official tasting I did not like the black granular stuff at all – it tasted horrible. Well, I thought, maybe I would develop a taste for fine wines over time, until someone told me that I had simply swallowed the wine's sediment! Surely I did not believe that the gentlemen had left even one drop of the great, venerable old Château Latour for me? And once again I had learned something.

My curiosity in the Christie's basement led to a passion for wine that has stayed with me all my life. In my family wine practically did not exist; since my father had died early and my mother never touched a drop we never had wine at home. When we went out with my grandfather he ordered a quarter of red from the South Tyrol and that was it. So I started from scratch.

After my experiences in the Christie's basement, my first teacher in matters of wine was the sommelier of the Ritz restaurant in Lon-

don. For several years, and before I had my own flat, the Ritz was my preferred hotel when travelling to London. I went through the entire wine list at the restaurant, which was excellent at the time, and my adviser was a very nice sommelier named Claude. Many years later I met him again as the maître d' at Mark's Club. Claude helped me to learn about the best clarets. He also taught me the art of blind tastings; he brought me a bottle and only showed me the label once I had tried to guess what was in my glass.

I learned to buy wines systematically. My system was simple but consistent. I began to buy younger wines from Christie's, which came to the market for the first time. From each great château I bought ten cases. These were put into storage and I waited, usually three or four years, before the vintage had sufficiently risen in price so that I could sell at Christie's to recover the investment, keeping the remainder for myself. Sometimes this was two or three cases, sometimes four. In this way I achieved a handsome wine cellar which cost me next to nothing. Many bottles resting in the well-regulated cellar of our castle in Marquartstein dated from this period; for example the 1979 magnum Lynch-Bages that we once enjoyed. The bottle came from one of those early Christie's sales, went to Lenbachplatz and when the wine cellar moved after the sale of these business premises, it moved with it to the castle. Ever since then it lay undisturbed in its place, until one morning I liberated it from its prison and brought it to life that evening. It may have been a very short life, but an enjoyable one.

During my time at Christie's I was called in by other departments when it came to dealing with Spanish-speaking clients. As the Impressionist department had a lot of South American clients, they often needed my help. Once I had to look after a very wealthy Mexican client for several days, since he did not speak a word of English and needed me to accompany him to the auctions. I sat next to

him while he was bidding on a Pissarro and translated the bidding increments. In the end he bought the picture for seventy thousand pounds, a very large sum at the time. When we said goodbye, he offered me a fifty pound note as a thank you, and idiot that I was I did not accept the tip. All my life I could have kicked myself that I refused out of pride or for whatever spontaneous reason, since this was a week's rent for my flat after all. If somebody offered me such a generous tip today, I would take it on the spot. Sadly, nobody offers me tips anymore.

In the summer of 1976 Anthony du Boulay called me in and told me that Christie's would open its first American office in New York the following year. If I was interested in joining the inaugural team, I should apply. This was both a great honour and a great temptation. I spoke with Paul Bernheimer and Curt Silberman about the possibility, but the family realised quickly that I was in danger of staying at Christie's and called me back to Munich.

Managing the Firm and
My First Years on Lenbachplatz

*

'This is like Bloomingdale's for antiques!'

(New York ladies after a tour of the Lenbachplatz showrooms)

I was back in Munich in December 1976, and I was to start at the firm on the first of January 1977 as managing shareholder and unlimited partner. There was in fact some urgency, since the manager Kurt Behrens had been joined by a commercial director, and the two were at war. They accused each other of incompetence and blocked each other in any decisions. The commercial director left, Behrens stayed and I put forward a plan how the responsibilities were to be divided between Behrens and me. I had already sat down with Kurt Behrens while I was still at Christie's. We had met in Dublin, where Christie's organised a large aristocratic house sale and we both wanted to participate. To be sold were the contents of Malahide Castle. In the evening we sat at the bar of the Shelburne Hotel, where I presented Mr Behrens with my plan for splitting our management responsibilities. He looked at it briefly, shoved the papers back towards me and said, if I wanted to return to Munich to take over the firm he would be very happy to be my second-in-command. A Bernheimer should be head of the firm. This was both a noble and clever gesture by him, and it was the beginning of a long and successful cooperation.

In December 1976, even before I officially took over the company, I prepared for the task ahead of me by moving into my grandfather's old office, where Uncle Ludwig, Professor Taussig and Kurt Behrens

had sat before me. I made a habit of not sitting in my office waiting for what might happen, but to move around the house constantly. At Christie's I had also learned to always carry a small notebook in my jacket pocket. On my second or third day on Lenbachplatz I stood in the entrance hall when a clearly very confident gentleman came in. Since I was the first to meet him I asked him what I could do for him. He wanted to have a look around, was his answer. So I took him on a tour of the rooms. He wanted to see tapestries, and we went up to the tapestry hall. He wanted to look at antique furniture, and we went through the rooms on the second and third floor one by one. After the tour, which had lasted about two hours, we were back in the entrance hall and before he left I asked him what he was interested in. He said: 'You just wrote it all down, make me an offer and then we'll see.' And off he went, not even having asked about prices. I went to share my excitement with the head of the antiques department. He just pooh-poohed me and said such loudmouths came in every week. Was it my youthful naïveté, or was it inspiration? In any case I sat down and prepared a catalogue. I had everything photographed, updated the prices, which for the most part had clearly not been reviewed in years, and called the client to ask for an appointment. Soon afterwards I flew to Frankfurt and met him in his newly-purchased, completely empty house. I made suggestions where the tapestries should hang and where the furniture could go. When I was on my way back to Munich, I had the biggest cheque in my briefcase that the firm had received since the war. My client had bought every piece I had offered.

Usually, at Bernheimer's it went like this: when a client walked through the door the doorman received him. If the client was interested in antiques, the doorman, I think he was called Breitengraser, stuck his head through the door of the furniture department, which more resembled a gentlemen's lounge and shouted: 'Somebody for fuuurniture!' Of the three or four gentlemen in that room, the one

whose turn it was would emerge. And this comfortable system had been thrown overboard by me even during the first few days! It can only be described as beginner's luck. I may not have made myself very popular with the gentlemen, but I got their respect. That could do no harm, since I was a Bernheimer and supposed to be their boss, but I was also the youngest person by far in the company.

The day of my takeover of the management of the house of Bernheimer arrived. At the tender age of twenty-six I became the new boss of the venerable firm on Lenbachplatz. My official tenure began on Monday, the third of January 1977, having spent a month-long 'warm-up phase' in the manager's office. Many long-term employees had known me as a child and used to call me 'Konni', which later became 'Herr Konni' when I was at university. Now I became 'Herr Bernheimer'.

As befits a traditional Munich firm, I started the first day of the new era with a breakfast of traditional white sausages in the tapestry room. The business only opened at noon that day, so that all seventy-eight (!) employees could take part in the celebration. White sausages, pretzels and beer were served, and I made a brief New Year's speech. This was to become a tradition on each first working day of the year. Thank God I always resisted the temptation to tap the beer barrel open myself. I was far too worried about the tapestries piled up on the floor and hanging on the surrounding walls in close proximity.

I was lucky again after the first big sale to the client in Frankfurt. This time it involved the most important series of tapestries we had in our stock. These were four large and magnificent Flemish tapestries depicting scenes from the life of Noah. An Austrian castle was to be refurbished, and after a tour of our rooms I offered the client to come and visit him in his castle before putting together a proposal. As soon as I arrived I realised that the great entrance hall practi-

cally cried out for tapestries, and that the Noah series was a perfect fit. It had been bought just after the First World War and had remained on the books ever since, and the value was listed correspondingly low. I named a selling price in the high six figures, which was entirely appropriate. Nothing comparable has ever appeared on the market since. I suggested to the client that we hang the tapestries to test the effect, and we agreed on the deal on the same day they were delivered.

One day in summer 1978 an American visitor came to us who looked like the archetypal American tourist: T-shirt, baseball cap, and a camera round his neck. He wanted to know if I could show him Chinese Ming carpets. I thought I should explain to him that the Ming dynasty ended in 1644, and therefore we would be looking at the early seventeenth century or earlier. He nodded casually. He knew that, could he now please see something? In our selling stock there was not a single Ming carpet, but there was one in our private collection. I said I could show that to him but it would not be for sale. We went upstairs into the tapestry hall. The concealed door to the strongroom was opened and we showed him the only Ming carpet we had. The client looked at it. 'Ah, that was one of those with the special border, probably late sixteenth century'; he had three of those. Then there were the others on a yellow ground, hence Imperial. I was baffled; this client clearly was an expert. If this one was not for sale, he said, what else could I show him? We set out and went to the different floors of the building. After the sculpture room we arrived on the second floor in a room where shortly before I had joined two collections of Italian maiolica. 'Ah, Italian maiolica! I like that.' He began to ask about prices. After a while, when I must have named about forty prices, I became impatient. Which ones was he interested in, I asked. He gently put a hand on my shoulder and said: 'Oh young man, you don't know me. I never buy individual

pieces; I only ever buy whole collections. Why don't you offer me everything.' 'Everything?' That seemed to be the wrong question. 'Well, take this one out, and this, and this …' Indeed these were the three weakest pieces. Finally, he gave me his card, and it said 'Dr Arthur Sackler'. 'Oh', I said in amazement, 'Dr Sackler! You mean *the* Dr Sackler? The Metropolitan, the Sackler Wing, the Temple of Dendur, all of that?'

It was he, Dr Arthur Sackler, founder and donor of several Sackler museums and donor of the Sackler Wing in the Metropolitan Museum in New York. It was a great stroke of luck that I met him in my first years as a young man on Lenbachplatz. It was also the beginning of a wonderful, and sadly all too short friendship. He first bought my entire collection of maiolica, with the exception of the three pieces he had removed, and afterwards I could buy every single important piece of maiolica for him that I could find in Europe. The market was almost wiped clean – afterwards.

He suddenly died in 1987 during a trip to China before we could build the next collection for him, which would have been German Renaissance wood sculpture. Soon afterwards I was able to sell the most important piece I had found for him in Amsterdam, a marvellous Virgin and Child with St Anne, at short notice to the Musée de Cluny in Paris.

In these first years I had to deal with the traditional rituals which had become ingrained in the firm. When I inherited the management of the firm, I also inherited the secretaries clad in grey skirt suits who had worked for my grandfather. In the morning, having delivered the post, they took turns to appear in order to take dictation, armed with stenographer's pads. The procedure was extremely cumbersome, apart from the difficulty that I could never remember at the end of a dictated sentence how I had started. Letters were typed on typewriters in the typing pool. Before they

could be signed, they went back into the typing pool for corrections. I was faced with incomprehension when I did not want to accept Tipp-Ex corrections and insisted on having the letter retyped. One of the ladies had the greatest difficulties with the spelling of Sotheby's, let alone the ability to pronounce it in a halfway phonetically acceptable way. Her "So – teee – bee" could drive me to distraction. All the ladies were very suspicious towards innovations. They refused to even consider electric IBM typewriters (with spherical head!), and preferred the irregular keystrokes of their mechanical machines. It was supposedly easier to insert the carbon copy paper in those. I therefore decided to write my own correspondence henceforth, and in spring 1977 I registered at IBM for a computer training course. I spent one week in an extremely boring training centre near Stuttgart. This was my entry into the world of computers. I quickly learned how to use them, and soon the first computer arrived on Lenbachplatz. The IMB 36 was an enormous piece of furniture. It required its own room, which had to be air conditioned due to the monster's heat radiation, and it also created a lot of noise. A total of six monitors were connected, since there was as yet no networking capacity. The screens were black and the writing flickered green. The printer also resembled a large piece of furniture. But I loved being able to write my own letters and invoices, and to be able to write the manuscripts for the object descriptions and catalogues at my own desk. A programmer helped me to build the first client databases. There were also systems developed to handle the inventory, but these had to be changed repeatedly over time, since no such software existed.

My colleague Roman Herzig sent me a photograph some time ago where I look like a typical nerd in front of one of the first Apple PCs. It must have been taken in Maastricht during the early 1980s.

The first Macintosh arrived, and then the famous 'Lisa' with the mouse arrived. The first mouse! It is inconceivable today what an

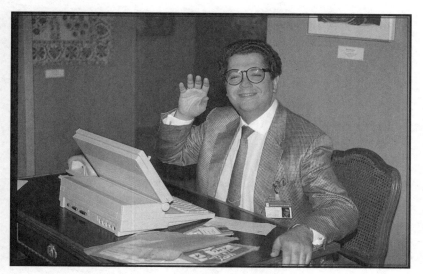

As a 'nerd' at the computer

excitement this caused. Today there are iPads and iPhones, my new best friends. When the iPad was launched, I read the marketing slogan: 'It will simplify a lot of tasks you never had to do before.' So true! But the latest thing in our family, which we all enjoy, is Whatsapp. We keep each other up to date, receive the latest photos of our grandchildren, and send our comments back straight away.

In 1977, when I joined Bernheimer's, the system was essentially the same as during my grandfather's time. There was almost everything one needed to furnish a house. There were the modern furnishings departments, who had seen an upswing during the 1970s under Kurt Behrens. The old heart of the company, the textiles department, continued to be popular with traditional families from Munich and Germany. Upholstered furniture was made to measure. There were fitted carpets, wallpaper, and 'period furniture', reproductions in the style of earlier periods. Then there were the antiques departments, which from the beginning I considered to be the most important. These had

furniture from the seventeenth to the nineteenth centuries, Asian art, antique carpets, tapestries (mistakenly referred to as Gobelins, since only those tapestries made in the Paris *Manufacture des Gobelins* should bear this name), antique textiles, liturgical vestments, and so forth. There was, however, no silver and no jewellery, and most noticeably no pictures.

The furniture department was dominated by German Baroque. I slowly began to internationalise the offering, adding French and Italian eighteenth-century furniture, as well as selected English pieces. But I had to be careful with those, since clients loved buying copies of English furniture. We had a supplier of English furniture copies, who made excellent pieces listed in a catalogue. Arthur Brett & Sons had such a high turnover with us that they supplied their deliveries with an enamel plaque screwed to the underside: 'Made in England by Brett & Sons – exclusively for Bernheimer München.' A small dealer once offered us a particular early eighteenth-century English writing desk with 'very old provenance'. I asked him to bring the precious object in, and when it was unloaded I took one glance and I explained to the horrified man that this was a copy. He did not want to believe me, until I showed him the Bernheimer enamel plaque underneath. The middleman, who had apparently bought the piece from us, had not bothered to check underneath and neither had his client. I was inured against such blunders since childhood. In the 1950s, Mr Bullinger, head of the Furniture department, had shown the Consul's little grandson how one had to scramble under a piece of furniture to check if it really was 'of the period'.

I thought it unfortunate that our firm sold antique as well as copied furniture. There was a very popular book in the 1960s, *Au pays des antiquaires*, by a certain André Mailfert. As indicated in the subtitle, these were the confessions of a forger. Monsieur

Mailfert described in it all kinds of methods, some very outlandish, of forging antiques. He also stated that Bernheimer's in Munich had been one of his best clients. However, he lost the subsequent lawsuit, and Bernheimer's could no longer be mentioned in any of the following editions. Bernheimer's had indeed been a good client of Mailfert's, but with regard to top quality period style pieces which were declared as such. In the first instance, Maison Mailfert was one of the best producers of *bureau plats* in the style of Louis XVI.

A prominent client came to visit us during these early years, Hermann Josef Abs. The great banker had moved from being the Chairman of the Board at Deutsche Bank to Honorary Chairman, and he wanted to furnish his new office. Herr Abs was looking for an imposing desk. I took him to the second floor and showed him two wonderful Louis XVI *bureau plats*, both circa 1780, one for about sixty thousand marks and the other for eighty thousand. He thought about it for a moment and said, very nice, but he had seen a fine desk in passing, slightly larger, on the ground floor, he would like to see that one. When he heard that this cost as much as six thousand five hundred marks, he chose the copy on the spot. I tried to change his mind: 'But Herr Abs, surely you do not want to have a copy in your office?' He said: 'Do you really think anybody would dare to assume that the desk in Hermann Josef Abs's office could be a copy?'

The mixture of old and new was to be the firm's downfall in one instance. In the early 1970s and fortunately long before my time, an employee in the furniture department had sold a refectory table made out of antique wood in the style of the Italian Renaissance. It had been produced by a firm called Negrini, and he sold it as genuinely of the period. Whether this was a mistake or a deliberate attempt to damage the firm could never be established. It created a scandal, and Bernheimer's was dragged through the press at length. I was still at university and helped the firm to find the right lawyer. But the story about the fake tables stuck, and over the years I was

often asked about it. People remember such stories. The incident confirmed my view that it was wrong to offer originals and copies under the same roof, even if they were labelled correctly. At the same time, the period style business was especially successful during the 1970s, and Bernheimer's defined itself not only as an antiques shop but also as a furnishing house.

One day a group of delightful American ladies arrived for a guided tour through the famous shop, about which they had heard so much in New York. I gave them the complete tour, all four floors, from antique furniture to Chinese porcelain, antique carpets and tapestries. After about two hours, when we arrived back in the entrance hall, they wanted to pay me the best compliment they could think of, coming from New York: 'This was so wonderful, Mr Bernheimer, this is like Bloomingdale's for antiques!'

My grandfather and his brothers would most likely have been pleased, but I was taken aback. The remark got under my skin, and I knew this was exactly what I did not want. So I decided to begin with the painful but necessary restructuring of the firm.

When I started to look through some papers some time ago, I found a number of news cuttings and some reports which I sent to shareholders at that time. From the beginning of my years on Lenbachplatz I had made it my business to report not just every six months, but monthly about the profit of the firm. Month by month I compared the figures of the respective departments with the equivalent period in the previous year. In that way I gained a very good overview of the development in the various departments, which benefited not just the shareholders, who were not used to such detailed reporting, but most of all myself. I also understood the strengths and weaknesses of the business structure, which had hardly changed since my great-grandfather's days. The concept of 'everything under one roof' had meant that there was everything you needed to furnish a house, be

it antique or modern. The disadvantages became more and more obvious: collectors and museum curators essentially did not take Bernheimer's seriously, as the firm did not offer important works of art but rather nice antiques which could be used to decorate an interior in a period style. The exception was the carpet department, which thanks to the expert German Bogner appealed to the circle of carpet collectors. With regard to the furnishing departments it became increasingly difficult to compete with other interior decorating firms in Munich. Our furnishing concept dated from a time when Bernheimer's had a virtual monopoly, and this was clearly a thing of the past. In those early years I had a hard time presenting my thoughts and proposals for change during the partners meetings, bearing in mind my small inherited holding of 9.25 percent. In the eyes of most family members I was also simply too young. They had elevated me to the position but they did not really take me seriously. As a fully-fledged business degree holder I presented my calculations to the first shareholder meeting which I attended as manager. I explained that even if we appeared to be profitable, we were not if we calculated the notional rent for the premises we used in our own building, which comprised a sizeable twelve thousand square metres. We would never be profitable if we included this in the calculation, but would make a permanent loss without ever having the chance of achieving profitability. Protest rose, especially from great-aunt Karoline, who always had her place at the opposite end of the table (each family member had their usual seat together with his or her lawyer). She was in five rows of pearls and her wide-brimmed Goethe hat. Even while I spoke, she was impatiently drumming her fingernails on the table, until she finally cut in and said: 'What nonsense is this about rent, we own the house!' I had to accept that I could not progress like this. It must have been on one of these days that I decided I needed to pay off the other shareholders in order to have a real future.

As a next step I called in the business consulting firm Roland Berger, which was already well-established. With their help I wanted to explain to the shareholders which departments were profitable and which were not. It cost a tidy sum for something of which I already knew the outcome, but now the family believed it too. The result was sobering. It said that we used far too much ground space in the building ourselves, and that we should develop a plan for renting out those rooms which we did not need. That was the first sacred cow which had to be sacrificed. Then followed the analysis which individual areas and departments, taken as separate cost centres, made a profit and which made a loss. And lo and behold, the most sacred cow of all, my great-grandfather's legacy, the textile department was the loss leader, closely followed by the department for bespoke upholstered furniture. It was quickly decided to give up the department for fitted carpets and wallpaper, since everybody had understood that these could not be profitable. It hurt less, since they were not tied to the traditions of the firm. More painful were the closing of the carpentry workshop and the restoration department. The firm's pride and joy, they had been part of the business from the outset, but they were uneconomical. We stopped the delivery service with our own vans and hired external shippers. In the end, I received confirmation that the two profitable departments which I had pushed, antique furniture and antique carpets, made gains, which were then eaten up by the losses of all the other departments, some of which were significant.

In 1982 five successful years had passed, during which turnover had risen considerably in spite of the old structures and the tricky constellation of shareholders. I now felt strong enough to go to the bank and ask for credit to pay out the other partners. Curt Silberman supported me in this, and I discussed the best approach with my lawyer and fatherly friend Lois Erdl. I began to calculate and arrived at the

sum of twenty-five million marks. This was the credit needed to buy most of the shares. The first step was a current valuation of the company, both at net asset and earnings value. In consultation with our fiduciary advisory firm at the time, the reputable SüdTreu, I undertook this myself. After all, I knew the company, its assets and its potential for earnings better than any external adviser. In theory there should have been a valuation by an independent third party, especially in preparation for a payout of shareholders, but this would have cost another tidy sum, and the result might not have been so accurate. I did my best to write the report in as neutral terms as possible. Basically, we followed the traditional procedure in Jewish families for family division: one creates piles, the others get to choose. That way you can be sure that neither takes advantage of the others. I was proud when the Chairman of the Board from SüdTreu, Dr Steichele, confirmed during the partners meeting that my heavy file with the valuation report had received his firm's seal and official approval. He was both a benevolent and strict elderly gentleman, and he also told the audience that if Konrad Bernheimer had no future at Bernheimer's, he would be happy to offer him a position at his own firm. This gave me enormous support. The partners meeting decided to follow my suggestions for a payout, if I was able to secure the financing. Now the ball was back in my court. Lois Erdl advised me to go to Peter Pfeiffer, the director of the Bayerische Vereinsbank. With trembling knees I arrived for my appointment. Dr Peter Pfeiffer was a renowned banker who still had the outlook of a businessman (the species is almost extinct by now). He cross-examined me. In autumn 1982 I was thirty-two, and he addressed me with the familiar *du* – unless this was kind of a regional Bavarian *du*. For my part, I respectfully stuck to the more formal *Sie*. I did not even get the opportunity to present my careful foldouts listing the complex extrapolations of my earnings projection. Mercilessly, he asked me to explain my plans in my own words. It took maybe ten minutes, but

it felt like two hours. Having asked twice if the real estate was actually included, and did I then really own fifty-five percent of shares, and how much did I actually need, twenty-five million? Was that all? Dr Pfeiffer leant back and was silent. My heart was in my mouth; I thought this is it, I will never get this loan. After a moment he rose and said: 'Well, if that's all you should have the money in your account in the next few days.' Mr something or other would call me about the formalities. That was all. Looking back today, it seems incredible.

With the help of the bank, we thus managed to achieve the payout of the majority of shares. My sisters Maria Sol and Iris, and my cousin Ingrid Leeds, the daughter of Lise Rheinstrom, stayed on board as shareholders, and Uncle Paul also retained a small holding. Together with my sisters I now had a three-quarters majority, so in the future I would be able to do what I wanted. My sisters greatly supported me in these years. Maria Sol worked in the textiles department, and Iris worked at reception and organised exhibitions, where she used the opportunity to look after special clients. I have fond memories of our regular lunches, where we discussed all outstanding questions and exhibition projects.

During the last year on Lenbachplatz after taking over the firm, the idea gradually developed to take go one radical step further. In the meantime I did my best to fill the still much too large building with activities, from themed exhibitions to seminars on art and wine. In autumn 1985 I had opened the Bernheimer branch in London, and this had convinced me that a successful art dealership of quality could exist very well in a much more limited space. I hatched the plan to turn the huge house on Lenbachplatz into a hotel, as a joint venture with a hotel company. I planned to contribute the building to a multiparty company. The hotel operator would do the necessary investments and we, the family, would retain a share of the firm,

while letting to the operators. I would then have my own gallery space in the hotel, which I imagined to be called something like 'Bernheimer Plaza'. I first discussed this with Falk Volkhard, who owned the neighbouring Hotel Bayerischer Hof. He quite liked the idea, but he quickly came to the conclusion that the space was too small for a hotel, considering the extensive investment that was required. Many interior rooms were listed, which would have to be kept in mind during a rebuild, and the sixty to eighty rooms which could be created would not generate a sufficient return on investment. This was not what I wanted to hear, and I continued to negotiate with Georg Rafael, founder of the Regent Group, who had gone into business independently with the Rafael Group, and also with the elderly Lord Forte in London. The first person to advise me to sell the building and pay out the rest of the family was the entrepreneur Josef Schörghuber, who always had a good head for figures. He said everything else would come to nothing, which of course I also did not want to hear. But one day a man came into my office who told me that I might know a lot about art, but nothing about real estate. He wanted to buy Lenbachplatz because he wanted to collect the most beautiful buildings in Germany. This was a certain Dr Jürgen Schneider. I have to admit that I found him dubious from the beginning. During our first meeting I explained that I was not willing to sell the building, and if I ever decided to sell, my asking price would be so high that he could never afford it. I really just wanted to get rid of him. He left my office with a crimson face, only to return a few weeks later with an offer that was considerably higher than our own estimate. I went to my friend and lawyer Lois Erdl and he said a phrase that I have never forgotten: '*Avoir* means having. Sell, sell!'

I left the negotiations, which I found painful, to Lois Erdl. In spite of all the financial possibilities which the sale opened up to me, it grieved me very much. It meant no less than the end of an era. I had also quickly realised that things were not quite right at the

Schneider firm. I knew how much he had paid, and I also knew how much he wanted to invest. I spent several evenings with my friends who were knowledgeable about real estate doing calculations. Using the most basic forms of calculation, adding and dividing, it was obvious that the investment could not be profitable. It simply could not be the case. Still, this was no longer my problem, but nevertheless, I had a bad conscience and for several years I was unable to pass Lenbachplatz. I always chose alternative routes when driving through the centre of Munich. A few years later the great real estate and financial empire of said Dr Schneider indeed collapsed like a house of cards. The banks that had financed him, perhaps a little too easily, to the tune of hundreds of millions lost a lot of money in this spectacular bankruptcy.

Thanks to the financing banks, the funds had arrived promptly and in full in our account. I could now pay out all my remaining shareholders: my sisters, my cousin Ingrid, and my mother. I was grateful that they had stood by me to the end. My sister Maria Sol fulfilled a long-held dream and completed her education as interpreter and translator for Spanish and English. Later she took care of the Bavarian state chancellery's guests. And Iris used her training as a paintings restorer to take many opportunities of working in this wonderful field over time.

Part III

Two Galleries, One Castle

*

'Ars non habet inimicum nisi ignorantem.'

(Benvenuto Cellini)

Having sold the building on Lenbachplatz, dissolved the old family firm, and paid out all remaining shareholders, I was now the sole owner of both my new company and the remainder of the Bernheimer Collections. As I had to leave our *palais* after the sale, I now had to find a new location. I began to look for a building in Munich big enough to become a home as well as business premises. However, there was no suitable building in the centre of Munich which I would be able to afford, in spite of the blessings of Dr Schneider. I therefore decided to rent a small, but well-positioned gallery space on Promenadeplatz, opposite the Hotel Bayerischer Hof.

But the question remained, what to do with the family collections? Several years before, I had visited the then owner of Marquartstein castle in the Chiemgau region where I had gone to school. The baroness was quite a character. This was the first time since my school days that I entered the castle. The school had been housed there since the nineteen-twenties, and when it moved out the castle had become the venue for a 'castle inn' run by the previous owner, an eccentric writer. He wanted to play at living like a knight and had the rooms filled with armour, halberds and stuffed bears. The restaurant was off limits for us boarding school boys, which did not prevent me from having my first (illicit) beer and cigarettes in there. It was a peculiar feeling to return to the place of my youthful misdeeds. In 1985 the baroness had called me

in for professional reasons. I was to come and look at her things, since she wanted to downsize. When I came back to Munich I told Barbara that I had been to the castle, and that I had not bought any of the old lady's horrible contents, but that we could buy the castle! Barbara said I was insane. However, two years later, in 1987, when we had sold Lenbachplatz, the subject came up again. On the one hand I now had the necessary means, and on the other hand I was actually looking for a big house. So we took on the castle, which was available for much less than anything in the centre of Munich.

Our first task was a complete but careful restoration of the old castle. Although we loved historic buildings, we still wanted windows which sealed properly, fully functioning central heating in all rooms, and a watertight roof above our heads. In short, we wanted eleventh century but with twentieth-century comfort. We also had to take into account the regulations for listed buildings. For two years we had a major construction site, but as soon as we moved in it looked as if we had always lived there.

Marquartstein was not just our family home, where we also loved to invite friends, but we also invited clients. (Many a collector melted, too, when I showed him a very special picture in the peace and quiet of the library.) During the summer and autumn we always had a number of events at the castle, which Barbara organised, and I have to admit that my involvement only went as far as the joint selection of the menu and wines. Barbara or our daughters decorated the long table beautifully, often with leaves from the courtyard, grapes or redcurrant, and I could lean back and enjoy the party together with our guests.

On sunny days Barbara and I sometimes took a long walk through our forest, which was also part of the estate. I have known it since I was ten after all. Some paths have been renewed, but I still find the locations of the tree houses which we built when we were boys. They

Marquartstein Castle

held large supplies of pinecones, which were of strategic importance as ammunition during the 'wars' with enemy 'gangs'.

After nearly thirty years we also took the castle into the twenty-first century, with Wi-Fi in all rooms.

After the sale of Lenbachplatz I began as sole owner of my new Munich firm in 1988 in a small but graceful gallery on Promenadeplatz, the antithesis to the huge old premises, directly opposite the Hotel Bayerischer Hof. On the ground floor there was a small exhibition space with two showcases for Chinese porcelain, and on the first floor a bigger viewing room and an office. Tucked behind that was my small cupboard, it cannot be described otherwise, containing an inbuilt desk. But it was my own firm! I had basically achieved what my grandfather had not done after the war out of consideration for the family, to create a new beginning as sole owner and without shareholders.

One object in my opening exhibition was a wonderful writing desk by David Roentgen. As one of my new firm's first sales, it went to the Museum for Applied Arts in Berlin. It was an encouraging beginning. In addition to selected French furniture and a small but very fine selection of Chinese porcelain, there was an increasing number of paintings. Even in the first year I realised that I had overshot the mark in my new modesty. I did not have enough space to store pictures, and most importantly, I had absolutely no space where I could withdraw for a quiet conversation with a client, which is really essential in our business. But I had signed a ten year lease, and I stuck it out.

In 1989, the first year of the new firm, we celebrated the one hundred and twenty-fifth anniversary of my great-grandfather's founding of Bernheimer's. This allowed me to look back on a great tradition as well as celebrate my new beginning. I had the slightly ambitious idea to ask each art dealer colleague with whom I had done business and become friends with over the years, to lend me a single object with special provenance. The result was extraordinary: the anniversary exhibition was stocked with exciting objects, each lent by one of seventy-eight colleagues from all over the world, and from all ends of the art spectrum. The listing read like a Who's Who of the international art trade. Even during the first few days we were very successful, as on day one I was able to pass a large Saint Magdalen by Niccoló di Pietro Gerini to a collector from the Rhineland. It had been lent by Galleria Bellini in Florence, and I was particularly pleased since even before the war my grandfather had done business with Mario and Luigi Bellini. Colnaghi's director Richard Knight sent us a Rubens sketch for the Torre de la Parada in Madrid. The Oetker Group then still owned the firm. Johnny van Haeften had sent a charming picture of two young ladies feeding a parrot by Philip van Dyck, which also sold quickly. The now defunct

Heim Gallery in London sent a magnificent portrait by Angelica Kauffmann, which went to the Germanisches Nationalmuseum in Nuremberg. The maecenas Peter Ludwig helped to make this happen. One day he appeared in the exhibition and said: 'So that is the picture Nuremberg wants me to buy?', and he just bought it.

Jan Krugier was represented with a Degas, and French & Co in New York with a fabulous triptych by Michael Wolgemuth, which was very close to Dürer. My grandfather had also dealt a lot with French & Co in the 1920s, before the firm was owned by Martin Zimet. They had at that time been Bernheimer's main competitors for tapestries. Röbbig had sent several Meissen plates from the Swan Service, and the Kraemer family in Paris was represented by a monumental bronze cartel clock by Caffiéri, which needed a special wall bracket fixed. Buyers quickly snapped up the Louis XVI rosewood and a pair of bellows with floral marquetry which had come from Rosenberg & Stiebel in New York, as well as Didier Aaron's porphyry vases. A mounted jade bowl by Fabergé had come from Wartski. Jan Dirven in Antwerp sent a resplendent seventeenth-century cabinet-on-stand in black lacquer, which remained in Munich, as did a Louis XV *table de salon* that Jacques Perrin had sent from his shop in Quai Voltaire. I myself bought a beautiful set of six richly carved South German chairs from circa 1760, which had been sent by Jonathan Harris from Kensington Church Street, but they did not stay with me for long. German buyers acquired the fabulous Tang figure of a court lady from Giuseppe Eskenazi, and also the Tang horse from his cousin Johnny Eskenazi in Milan. I had contributed some outstanding Kangxi pieces, such as large *famille verte* plates and huge black-glazed and blue-and-white triple-gourd vases, all of which sold.

The dazzling success of the exhibition was proof that I was on the right track.

My success was based first and foremost on good cooperation with other dealers. Working together on an international level was of vital importance for the trade then as it is now. In times of extremely shrinking supply, friendly teamwork among colleagues can lead to the joint tracing of works which are fresh to the market. Combining knowledge about different regions or countries produces quicker results. In addition, the price developments in the market require a much higher capital expenditure, which can be taken into account through joint financing of individual objects. And finally, a friendly network of dealers with personal connections to private and public collections can help each other to place important objects. This has not changed much since the 1980s.

It makes me smile when I see in my introduction to the exhibition catalogue that I found very clear words about the interaction between the trade and the auction houses. Even at that time the market policy of the auction houses became more and more aggressive, putting us dealers increasingly on the defensive. I wrote that we could only face up to this by working together, by putting quality ahead of quantity, by carefully researched descriptions instead of rushed cataloguing, and through full liability and guaranteed authenticity of the object. We needed to provide expertise and responsibility through personalised advice.

All this is still true, although not only has the political world changed since, but also the world of the art trade.

In the autumn of 1991 another catalogue was published with the elegant title *Ars non habet inimicum* ... I had borrowed the title from the British Antique Dealers' Association, of which I had become a member with our London branch. The association's motto comes from the Florentine Renaissance artist Benvenuto Cellini, creator of marvellous sculptures and bronzes: *Ars non habet inimicum nisi ignorantem*, art has no enemy but ignorance. It was my first bilingual catalogue for my galleries in Munich and London, brimming

with furniture, sculptures, bronzes, tapestries, carpets, and Chinese porcelain. But there were also some of the first paintings, including a large allegory by Angelica Kauffmann.

However, the story of an art dealer is not just a series of successes. We fail just as often, and although we do not enjoy talking about it, I must nonetheless tell one story of calamity.

My first business transaction with Boedy Lilian, my colleague from Amsterdam, was a rather odd one: at the Maastricht fair I had a very nice large painting by the popular seventeenth century Dutch animal painter Melchior de Hondecoeter. An elderly Dutch couple fell in love with it as it hung in a central position in the middle of my stand. The gentleman handed me a cheque on the spot and asked me to deliver the picture to their home before the weekend, if possible on the following morning, as they were about to go travelling. They suggested that I liaise with Boedy Lilian, as they were clients of his. This we did, and Boedy was most helpful in organising the transport for the next day. But first I had to rehang my entire stand, since I could hardly have an empty centre wall for the rest of the fair. We had to pay duty on the picture, since the clients lived in Belgium, near Antwerp (this was long before the Schengen agreement). The paperwork was extremely complicated: the picture had arrived at the fair with German papers, had to pass through customs to the Netherlands, as the transaction had taken place in Maastricht, was then re-exported through the Netherlands and imported into Belgium. When we finally arrived after an hour's drive at the address we had been given, I realised that this was not a house, as I had expected, but an apartment building. Before the shippers unpacked the picture, I went to have a look at the rooms, as I feared the worst. And I was right: the picture would not even have fit through the staircase up to the second floor flat. When I arrived at the front door, the charming client came to meet me. I asked him which wall he had had in mind for the picture, and in his naïveté he pointed above the

sofa. The upright format would not even have fit horizontally; the ceiling height was far too low. There was only one thing left to do, return the cheque to the baffled client. He could not believe that he had got it so wrong. Fortunately, and thanks to Roman Herzig, we were able to sell the Hondecoeter shortly afterwards to an Austrian collector.

In 1998, after ten years on Promenadeplatz, I had the opportunity to move into much larger rooms on Brienner Strasse. It was a suite of lovely bright rooms with high ceilings, and enough space for offices and picture storage. It also had a view towards Wittelsbacher-platz, which delighted me immediately. Soon my colleague Katrin Bellinger, her right-hand man in Munich, Martin Grässle and her Old Master drawings also moved into the building. The wonderful cooperation which we were to establish later at Colnaghi in London was thus established in Munich.

When we opened on Brienner Strasse, I still planned for a small department with Chinese porcelain. I could not yet quite let go of the area which had been my passion during my time at Christie's. However, in 1990 Barbara and I travelled to Asia, including Hong Kong and Taipei, and this trip changed many things, and indicated the end of my dealing in Chinese ceramics and porcelain.

The decisive moment in this context came in Taipei. The enormous National Palace Museum in Taipei is built into the rock-face to house the Chinese state treasure. The collections are so huge however, that only the tiniest part can be shown at a time. We had come with a letter of recommendation from my friend Johnny Eskenazi, and as a result the director and his staff had gathered in the great audience hall to receive us. He was a dignified elderly gentleman who looked a bit like Mao. The museum's badges of honour were pinned on us, and to our utter amazement Barbara and I found ourselves the centre of a diplomatic ceremony, where

speeches were made on the subject of understanding among nations and the German-Taiwanese friendship. I found myself in the role of a high-ranking diplomat, responding in phrases otherwise only heard at televised state receptions. I still have no idea what Johnny Eskenazi wrote and as what he had announced us, but in any case it was most effective. Best of all in this VIP treatment was an offer the venerable director made after my response speech. He introduced all the curators who were present with their specialities, and I was allowed to choose one as our museum guide for the following day. This really was a marvellous present, and I chose the very personable young curator for 'Ching Dynasty later Porcelain'. The reason was that I was mainly trading in seventeenth and eighteenth-century porcelain, but in addition I thought I might contribute some of my European knowledge about Chinese export porcelain and its reception from the seventeenth to the nineteenth century. The curator also spoke excellent English.

We spent a lovely day together, had many interesting discussions, and both sides were able to benefit greatly. At the end, the curator wanted to give us something special to do along our way. She recommended that we visit a particular 'contemporary potter', and handed me two visiting cards. On one she had written the exact directions for our driver in an endless row of Chinese characters. On the back of her other visiting card she wrote who we were, and this one I was to hand over on arrival.

We thanked her for the wonderful and very instructive day, and we were wondering afterwards why she had been so insistent that we visit the contemporary potter. Barbara felt that we should go. On the following day we therefore went with our driver into the hinterland. We thought we would never arrive, let alone make it back. Finally the driver stopped in front of an old house in a mountain village. He was doubtful, but got out to make enquiries. He came back waving at us, and we entered the small house, where we were greeted by a

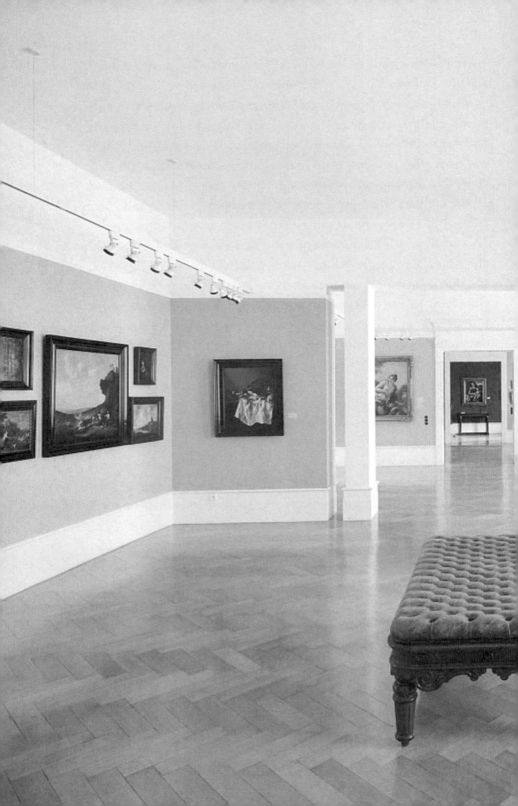

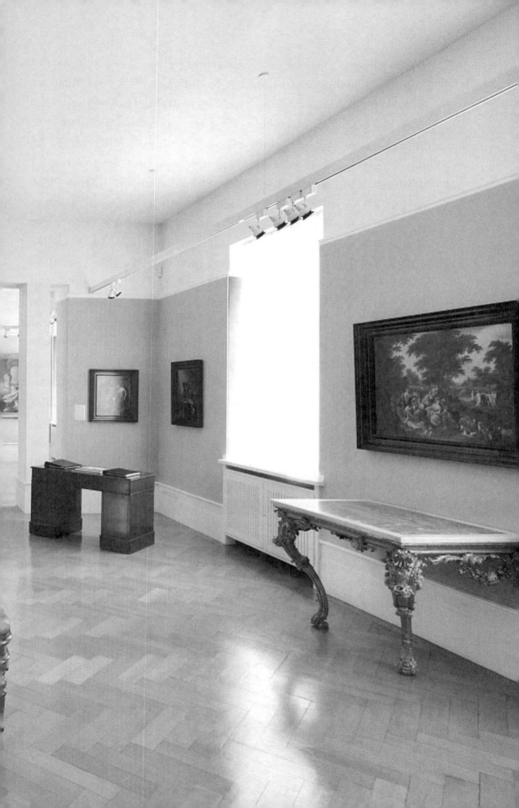

young woman who spoke relatively good English. When she saw the back of the visiting card from our friend at the National Museum, she bowed again and said she had been instructed to show us everything; she repeated, *everything*. First she led us into a room where the most beautiful porcelain pieces were kept: Ming blue-and-white, Doucai, Woucai, Ching *famille verte* and *famille rose*. I especially liked a very nice Doucai chicken cup. An almost identical piece from the Ming period had just made a fortune at a London auction. I held it in my hand; it was exquisite, with the typical enamel colours combined with underglaze in cobalt blue. Underneath it had the typical imperial mark from the Chenghua period, in underglaze blue and within the double circle. The earliest bowls of this kind with its popular chicken motif date from the period of the Ming emperor in the second half of the fifteenth century. A second, almost identical bowl was displayed directly next to it, and I was allowed to handle it, too. It bore the *nien-hao*, the seal of the reign of the Yongzheng emperor, an eighteenth-century Ching emperor. Exactly this type of Doucai porcelain was made during the later Ching dynasty in honour of the earlier Ming emperors, and it was indeed almost impossible to distinguish between them. And then there was a third bowl, which I was allowed to take in my hand. However, I could not identify the mark. When I looked questioningly at the young woman, she smiled: 'This is our shop mark.' It suddenly struck me why the curator had insisted that we come here: this was a forger's workshop, and a brilliant forger's workshop at that. I naïvely asked the young woman if she could create my own *nien-hao*? I will never forget her marvellous response, with a gentle smile: 'We do evellything our customers want us to do.' I was no longer surprised when a professor of calligraphy from Taipei University suddenly materialised, who explained that I would need four characters for my mark, and suggested Bern-hei-mer-Collection. He wrote this on a piece of paper, and I now have my own *nien-hao*.

(Later in Munich I had it put on the stickers we put on our porcelain, and I still come across these at auction, when porcelain from our former collection is consigned.)

The pleasant young lady, who by then had revealed herself to be the owner's daughter, had noticed my surprise about the possibility of ordering chicken cups with the marks of earlier emperors. So she suggested that I could commission bowls made with my own mark.

After this impressive introduction we did a tour of the gardens at the back. Different workshops were housed in one pavilion after the other. One for early celadon ware, blue-and-white from the Ming and Ching periods, another for coloured *famille verte* and *famille rose* porcelain, a third one for early Woucai porcelain. Specialists were at work everywhere. An old gentleman who was introduced as 'the boss' accompanied us from pavilion to pavilion to inspect the progress of labour. At the very back there were the kilns. Everything looked as if nothing had changed for centuries, but this was of course exactly what the porcelain was meant to look like.

In the following years I often saw porcelain pieces at auction in the West which looked as if they could have come from one of these excellent workshops. For my part, after this visit to the 'contemporary potter' I suddenly stopped buying porcelain without a provenance from Western collections dating back a long time.

London: Becoming a Picture Dealer

*

'A handsome tallboy, on ball-and-claw feet,
of slightly curved shape, with a bombé *front, half German oak*
and half South American mahogany …'

(Johnny van Haeften, on the occasion of my tenth anniversary in London)

My time at Christie's had not just made me familiar with London as the most significant art dealing centre, but had also made me enthusiastic about the city more generally, which created the desire for more involvement. In 1984, when I began to flirt with the idea of opening a gallery in London, I approached Christie's representative in Munich, Charlotte zu Hohenlohe. I asked her if she knew someone who might be suitable as manager for a London gallery? She immediately suggested that I speak to Heike O'Hanlon, who worked in Christie's press office, as she knew everybody in London, and so I met her over tea at the Ritz. When I asked her who she would suggest for the task, she spontaneously said: 'Me!' So Heike became my first and most loyal of London directors until she retired ten years later.

We were fortunate in finding a house in the best Mayfair location, opposite Sotheby's in St George's Street. It was a beautiful house with an imposing façade over four floors with a gable at the top. But it was a lot smaller on the inside than it looked, since it had a triangular floor plan. The elegant staircase took up a third of the space, which effectively left only one room per floor.

The approach was traditional Bernheimer style – a small but elegant offshoot of Lenbachplatz. On the ground floor there was a department for Chinese porcelain, on the first floor there was eight-

eenth-century French and Venetian furniture, on the second floor sculptures, antique carpets and textiles. And at the top I had small but comfortable living quarters. My two most important employees from Munich came to decorate the rooms, the carpet specialist German Bogner and the manager and main decorator on Lenbachplatz, Kurt Behrens. In the old Bernheimer tradition we used a lot of heavy fabric from Rubelli in Venice.

Many friends from Munich came to the opening in November 1985, including the Bavarian state minister for Federal and European affairs at the time, Peter Schmidhuber. Together with Susi von Wechmar, the wife of the German ambassador in London, he opened the house in his best Bavarian English: 'In ze name of ze Bayerische Ministerpräsident Franz Josef Strauss I declare zis house open!'

I will never forget the generous warm welcome we received from many London colleagues, who embraced us as new members of the fraternity. Even during the first fifteen minutes after opening several new London colleagues arrived. One of them rushed through all the floors and came back a short time later to make me an offer for a few objects. 'I wanted to make sure I was your first customer, because I thought it would be the best welcome for a new colleague!' This was Alan Rubin, owner of the Pelham Galleries in London. He is still a good friend today. During the first years in London we were also involved from the outset in the London art fairs, including the Grosvenor House Fair from 1986. We met many clients there, even some Germans who I had never seen before in Munich. I found it most impressive who you might come across. One day I said to a German journalist, at the Grosvenor House Fair you had the chance of meeting people like Gianni Agnelli or Heini Thyssen. They were both among the most active art buyers at the time. In 1986 I saw both Agnelli and Thyssen approach my stand from opposite sides at the same time, and I thought, 'what a nightmare, how shall I handle the both of them'. They met exactly in

front of my stand, embraced, and then continued together. Neither of them returned to my stand.

In London I quickly learned that you have to work closely with your colleagues to be successful, especially as I had the ambition of establishing myself as a dealer in the field of Old Masters. Working closely together can lead to close friendship, as for example in my relationship with Johnny van Haeften. I had met Johnny at Christie's and we had stayed in touch over the years. When I began to buy Old Masters in London, it seemed natural to work with him, too. In 1977, the same year as I had taken over Bernheimer's in Munich, Johnny had opened his first gallery with his wife Sarah. We liked each other from day one and began to do business together.

The first picture Johnny van Haeften and I bought together was a small 'Hell Brueghel' picture on copper, by Jan Brueghel the Elder, a delightful scene of Orpheus and Eurydice in the Underworld, surrounded by a throng of tiny devils. It was our first joint venture, and the perfect joint enterprise. At the opening of the Grosvenor House Fair, where we exhibited the painting, Margaret Thatcher visited. She went straight to the picture in Johnny's stand. Johnny pointed at a small devil in his bright red cloak and said: 'Prime Minister, does he not look like a member of your opposition?' She did not miss a beat and said: 'Oh no, much too funny, he does not look embittered enough!'

The following day a collector whom I knew well came to my stand and asked if I had seen the Brueghel picture at Johnny van Haeften's, which Margaret Thatcher had recommended to him the evening before. She had dined with him after visiting the fair and they had spoken about the small picture. I explained that the picture was jointly owned by us both, and he immediately decided to buy it, since the Prime Minister had personally recommended it.

What do you give to a head of government when she really should have got a commission? You cannot very well offer money to an incumbent head of government. We found a solution and sent her a bottle of her favourite whisky, with best wishes and great thanks. Her husband Denis would also benefit. We promptly received a handwritten thank you note from Downing Street in return. This was the first of many very good deals Johnny and I did together.

During my first years in London I still dealt in furniture, porcelain etc., and my involvement in paintings was mostly through joint activities with colleagues. I therefore exhibited in Maastricht on the side of the Antiquairs, which is the Decorative Arts area, showing French furniture, Chinese porcelain, and sometimes a few good Old Masters too. Among the first paintings were a wonderful still life by Luis Meléndez and view paintings by Canaletto and Marieschi.

I sold the Canaletto to an important collector from San Francisco. It was one of a set of four Venetian views by the artist and had an excellent provenance. King Ludwig I had bought it in Italy when he was still Bavarian crown prince. When the Pinakothek opened, it was part of the Bavarian State collections, until the disastrous museum director Ernst Buchner sold it during the Nazi period, as were so many works. The picture came to England, and in 1991 it was sold from an estate at Christie's. Together with two partners we were able to buy it. I showed it in Maastricht once, then it went to the American West Coast.

In the early nineteen-nineties I realised that my investment in Old Master paintings was by then much higher than that in decorative arts, even though my galleries in Munich and London still offered furniture and some Chinese porcelain.

Then came the Bellotto. This picture was the turning point from being an antiques dealer to becoming an Old Master dealer. It

marked the final farewell to the traditional Bernheimer disciplines and ushered in a new focus on the pinnacle of the art trade, Old Master pictures.

In 1991 Sotheby's auctioned Bernardo Bellotto's *Fortress of Königstein* from 1756. This was the last picture he painted in Dresden before he had to flee the city with the entire Saxonian court as a consequence of the Prussian invasion. The painting entered the British art trade, was in the collection of the Prime Minister Lord Palmerston, and finally was consigned to auction by the heirs of Lady Beauchamp.

Before the Sotheby's sale, the Zurich dealer Bruno Meissner and I had agreed to buy it jointly. From the outset I was absolutely convinced by the picture, in spite of some objections being voiced: the sky was said to be not in good condition. Before an auction there are often people finding fault with the best pictures, though perhaps they are usually the ones who cannot afford to buy them and would never bid on them.

On the day after the sale the director of the Bavarian State collections at the time, Hansi Hohenzollern, called me to say: 'Mr Bernheimer, please reserve the picture for the Alte Pinakothek!' At least that was a clear statement. We agreed that the picture would be sent to the Doerner Institute, which was affiliated with the Munich state collections, to have the layers of old varnish removed. We had known all along what the critics had not wanted to see – the apparent condition problem was not in the layer of paint but only in the layers of varnish. Several superimposed layers of varnish had become milky. We also agreed that, should the Pinakothek buy the picture, the in-house restoration workshop would restore it at their expense, and if the purchase did not go ahead we would pay.

The chief restorer at the time, Bruno Heimberg, did a fantastic job. The result was unbelievable, the picture glowed. But then it hung for almost a year in the director's office, while he hoped to con-

vince the diverse foundations of the republic to fund the purchase of this wonderful painting. Sadly he did not succeed. As the interest payments kept going up, after one and a half years I had to recall the picture from Munich. What now?

For the first time I had registered for the International Art & Antiques Show at the Armory in New York, and I had the bold idea to present the painting there. It was more a virtue of necessity, since nobody had yet sold an Old Master of this calibre at an art fair – we were after all talking over twelve million dollars. We had quite a sizeable space which we arranged entirely around the Bellotto: all in black, just the one big painting on the back wall, labels left and right, a row of chairs in front and that was it.

It was the talk of the town. Everybody, but everybody came to look at the painting. At the entrance the question usually was: 'Where is *the* picture?' (I did not make myself very popular at that time with my colleague Richard Green, as he had his stand right by the entrance. He was constantly asked about our Bellotto, even though he had a Bellotto of his own on view, but it was smaller, and it was not the *Fortress of Königstein*.)

During that single week I met pretty much every important American museum director and curator. Charles Ryskamp, who was the director of the Frick Collection, came every day at 5pm, sat down on one of the chairs in front of the Bellotto and stayed for half an hour. On the final day he said, if he could buy it for the Frick, he would rehang the big picture gallery. For me that was the greatest compliment.

But then Rusty Powell came, who had just become the successor to the legendary director Carter Brown at the National Gallery in Washington. He stated: 'So, this is the picture everyone tells me National Gallery has to buy?' Pete Bowron, their curator for Italian painting at the time, had especially urged him to buy the picture for Washington.

Rusty asked me to bring the picture to Washington. He wanted to hang it in the exhibition rooms to see how it fitted into the collection and into the context. And he added: 'You have to give me two months.' After one and a half years in Munich this sounded almost a little too confident. But he managed to make the Bellotto his first great purchase for the National Gallery. As I had not just taken the lead in buying this important picture but also in selling it, with great enthusiasm, I decided that the time had come to focus more on the Old Masters business, and not just as a shareholder with my colleagues.

Over the next few years the business developed according to my plan. In Maastricht I also offered less and less furniture and porcelain and more and more paintings. One day it was suggested that I should move over to the picture dealers' Pictura side from the Antiquairs. This was not at all a matter of course. For me, moving to the other side of the aisle meant that I had really changed direction in my career. From then on I was to be a picture dealer.

When Richard Knight, who had worked at Colnaghi for many years, joined Christie's a few years later and had to leave as Chairman of Pictura, I became his successor, and I am still there.

Another important picture which went to the National Gallery of Art in Washington a few years later was the Master of the Death of St Nicholas of Münster, a fabulous large-scale Crucifixion from around 1470 and one of the latest gold ground paintings. It had been restituted, and it has to be said that neither the French state nor the Louvre covered itself in glory in the process. The painting had once been owned by the dealer André Seligmann in Paris. The Nazis confiscated it for the Führermuseum in Linz. After the war the Allies returned the painting to the French state, and it should have been restituted to the Seligmann family, but instead it went to the Louvre.

It was only in 1999 that the picture was returned to the by then very elderly daughters of André Seligmann, who consigned it for

sale to Christie's. Otto Naumann and I went into partnership to buy it. After the sale we heard that unbeknownst to us we had bid against the National Gallery in Washington. When the picture hung at our Maastricht stand in the following year, the president of the trustees of the National Gallery at the time, Bob Smith, visited us with his curator Andrew Robison. We agreed on a deal in Maastricht and sealed it with a handshake. Andrew had managed to convince the Trustees that this was a picture that the National Gallery had to have, regardless of the higher price.

Another turning point for my new firm and me was that we bid farewell to our past with regard to carpets. I decided to sell the Bernheimer carpet collection.

Many carpets still dated from the time of my great-grandfather Lehmann Bernheimer. They had been bought before the First World War and between the wars, during the first trips to Istanbul, or Constantinople, as my great-grandfather and grandfather still called it. But there were also carpets and fragments that my grandfather had purchased in the nineteen-fifties. In the nineteen-eighties, whenever our carpet specialist German Bogner came back with a particular rarity from his travels, I used to add the occasional piece to the collection. My family used to regard this collection as a specimen collection, a kind of reference to document the high standing of the firm in dealing with oriental carpets. Over time, the collection gained the reputation of being one of the foremost carpet collections in the world, having grown from its beginnings under my great-grandfather until well into the 1980s.

In the great tapestry hall, which since my childhood had been used mainly for carpets, there was the hidden door to the famous carpet strongroom. A big cast-iron key was turned in a lock and with a slight creaking noise the heavy door swung open slowly towards the inside. The walls were steel-lined, so it actually was a real strong-

room. If the entire house had burned down, the treasures inside would have survived. My grandfather was extremely proud of this achievement, as he had designed the tapestry hall and strongroom himself when the house was built. Inside the strongroom, a narrow and steep wooden staircase led to the different rack levels, where the carpets were stored and rolled in their order. There was a storage ledger which noted the exact location of each carpet. It also noted when a carpet left the room and when it returned. My grandfather only ever allowed the viewing of a few carpets at a time, he usually decided: 'Today we are going to look at the large Star Ushak!' A porter would bring out the carpet and unroll it. It was tied with a particular type of knot, which I soon also learned to tie. The carpet would be inspected, felt, admired, and in the end rolled up again and returned to the rack. At the end, the key would be turned with great ceremony and the strongroom closed.

It is amazing that the collection survived the Nazi period and the war. Before 1938 my grandfather had divided the entire collection among several convents in Upper Bavaria for safekeeping: Frauenchiemsee, Kloster Ettal and Ottobeuren. I still find it incomprehensible – they had seen the danger after all, and they had decided to safeguard the collections, but not themselves.

In 1985 I saw the first exhibition of the most important pieces from the carpet collection during an international conference on carpets in Munich. I had invited all participants to Lenbachplatz, including the main dealers and collectors from all over the world. Over several floors we had hung our treasures, which many specialists only knew from literature. Some pieces were shown for the first time ever and had never been published. This really brought the importance of the collection home to me.

When we moved from Lenbachplatz to Marquartstein castle, the textile collections were stored in a suite of rooms with custom-made shelves. Apart from the carpets there was the extensive collection of

European and Asian antique textiles, the collection of liturgical vestments and the tapestry collection. But the rooms were not temperature and humidity controlled, and I lived in constant fear of a moth invasion. At the beginning of the 1990s I decided to sell the collections. By then I had moved away entirely from textiles and carpets in my business, there was really no reason to maintain them, especially as I did not live with them. On the contrary, I even avoided having to enter these rooms, as inevitably they brought on the allergy which had afflicted me since my childhood. Every time my grandfather had taken me to the textile collection during a visit to Lenbachplatz, I started to itch. It was clearly the dust, the particular smell, which emanates from antique silks and carpets which caused my reaction. But not just that, even thinking about the ancient textiles was enough to cause the itching.

When I decided to sell the Bernheimer textile and carpet collections I was not sure whether to give them to Christie's or to Sotheby's. In the end I decided in favour of Christie's, even though the negotiations with the managing director and CEO at the time, Chris Davidge, were rather tiresome. (This was the very same Chris Davidge who later was to fall over the price fixing scandal with Sotheby's Dede Brooks.) It took an unpleasant and unusually long time before I had pushed through the points in the contract which were important to me. My decision in favour of Christie's was influenced not just by the fact that their carpet department seemed more professional than Sotheby's, but also by the star auctioneer Andrea Fiuczynski. I had first met her in the early nineteen-nineties when she still worked in the New York furniture department. Her charm and dedication soon made her the most popular and best auctioneer at Christie's. All departments requested her when difficult sales had to be handled, and on top of everything she had the advantage of being very good-looking.

One of my conditions was therefore that Andrea Fiuczynski should be the auctioneer for all sales: the tapestry auction in New York, the carpet and textile collection in King Street, London and the liturgical vestments in South Kensington, London.

The first sale took place in New York, where the tapestries were sold at Christie's on Park Avenue on the eleventh of January 1996. The carpets followed on the fourteenth of February in London. We had originally considered selling the carpets in New York, too, but the American trade embargo with Iran stood in the way. It was hard to understand that a trade restriction that operated in the current relationship between the United States and Iran would have an influence on Persian carpets, which for the most part had been in our possession since the nineteenth century. But even a personal appeal from Christie's chairman to the office of the Vice President made no difference.

So the auction took place in London, and in the end it probably did not matter. The previews were exciting, first in Munich and then immediately before the sale in London. For the first time I saw the entire carpet collection, all two hundred pieces in all their glory. In Munich Christie's had organised the viewing at the Munich Residence, in the Max-Joseph-Saal and adjoining rooms. It looked stunning. I remember that I was so thrilled by the presentation that I went opposite to Eduard Meier's and bought myself a pair of new shoes.

We followed the London auction from a room that was technically part of security. At that time this was the only place where you could see the sale live on screen, as I did not want to be in the room myself. It started slowly, one or two lots were unsold at the very beginning, and I became really nervous. But Andrea Fiuczynski handled it with ease. She fought for every single lot, and in the end the sale was very successful. As expected, our *Polonaise* carpet with a series of silver and gold thread panels (cause of extreme itching for me) achieved the top price. It had been made in Isfahan at the time

of Shah Abbas, during the first half of the seventeenth century, and sold for two hundred and forty thousand pounds. My grandfather had bought it in 1921. The next most expensive lot was our large Mamluk carpet from the fifteenth century. There were many high prices; only the carpet that we called the 'sea carpet' *(Seeteppich)* was a disappointment. The huge Indian carpet from Agra measured fifteen by five and a half metres and had been made for the Delhi Durbar and for Queen Victoria. In Bombay, where the carpet was due to be shipped to London, the precious object had dropped into the waters of Bombay harbour, and as a result the colours had run. It was impossible to present Queen Victoria with a rug in this condition, and so it came into our family collection. My great-grandfather had bought it from the London trade. Most of the time the 'sea carpet' was laid out in the tapestry hall, since this was the only room big enough for its size. During the time of the Prince Regent it was lent to the Munich Residence once a year, to adorn the annual Knights of St George festival of the house of Wittelsbach.

Now this historic object was sold for just less than thirty thousand pounds. Had I had the option to put it somewhere, I would have kept it, but where for heaven's sake do you put a carpet that is fifteen metres long? Later I heard that it is now in an English country house, which seems a fitting home for the 'sea carpet'.

As I have said, Andrea managed her task admirably. I am sure that some of the gentlemen who usually took the London sales would not have put so much effort into every single carpet. One auctioneer of the august firm in particular, who shall remain unnamed, held it against me that he had been passed over. He would certainly not have achieved the same result. Too often had I noticed that he either lost interest when things became difficult, or that he took offense when the sale did not go as planned and hammered down one lot after the other in a huff. This was precisely what I had wanted to avoid.

I was especially worried about the sale of liturgical vestments at

South Kensington on the eleventh of June 1996. There were almost two hundred vestments or fragments of them, chasubles, dalmaticas, copes, stoles and maniples. As a good Jewish collector my grandfather had had a *faible* for everything Catholic. There were magnificent and unique objects, some dating from the fourteenth and fifteenth century, and seemingly unsaleable. My concerns were unfounded. The auction went very well, not least due to the efforts of Gimmo Etro, the great collector and founder of the fashion firm of the same name. He bought some of the most important pieces for his extensive textile collection.

Our textile collection was sold in King Street on the second of October 1996. There were over five hundred lots; the entire building in King Street was filled with them. It was a marathon, but this sale also achieved a satisfactory result. It had been very difficult to auction this volume of very diverse pieces. Most textiles were of great interest, but they were after all fragments of velvets and silks from the sixteenth or seventeenth century, embroideries for altar cloths, Coptic fragments, needlework panels etc. I was glad and relieved when it was all over.

In 1995 I could celebrate my ten-year anniversary in London. Together with my London director Heike O'Hanlon I stood in our exhibition at the Grosvenor House Fair, and we were discussing which might be the right venue for a great party, where we could invite clients, friends and colleagues. At that moment Charlie Hindlip came along, then Chairman of Christie's. Spontaneously, I asked his lordship if he might consider letting me have a celebration in his Great Rooms. His first question was what guests I was thinking of inviting. I said: 'Art dealer colleagues, but of course also collectors and clients from Germany.' 'German collectors?' he said. Lord Hindlip seemed to like the sound of that, and said I should be in touch with his office about the details.

So we invited everybody to our party at Christie's. I had asked Johnny to make the speech, and behind my back he had conspired with Barbara to get some photographs from our family album. Little Konni aged two in his playpen, doing craft activities in kindergarten, as a teenager, stick-thin and with Jimi Hendrix hair (and embarrassingly looking rather dazed), leaning against one of the Alhambra's stone lions. These photos had been enlarged to a height of five feet, and during Johnny's speech his colleague Dave Dallas carried them through the room like a ring card girl. Johnny had the great idea to present his speech like an auction. He went into the rostrum, knocked down an ivory gavel and began his speech, pointing towards me: 'And here we have, as lot number one, a handsome tallboy, on ball-and-claw feet, of slightly curved shape, with a *bombé* front, half German oak and half South American mahogany ...' It was very funny and the guests were in stitches. At the end of the evening a German client came to me to thank me, especially for the pictures from my hippie years. They had given him hope that his wayward son might still turn into a success. At Johnny's fiftieth birthday I later returned the favour, when I gave the speech.

In autumn of 2000 I received a call from Rudolf Oetker. Out of the blue he suddenly said: 'Mr Bernheimer, you should buy Colnaghi.' Of course I knew the old gentleman well. The collector Rudolf Oetker was a well-known person in the art trade; he had already bought several paintings for his collection from me. But the call was still a surprise. It may have been triggered by Christophe Lazar from Paris, a former banker who had become an art dealer and for some time had managed Colnaghi in Paris for Oetker. Even when the Paris branch closed he had stayed in close contact to the Oetkers. He had probably mentioned to them that I was looking for a gallery space near Bond Street. In 1982 Rudolf Oetker had bought Colnaghi from Jacob Rothschild, and he obviously had second thoughts about

his investment in the art business, especially since his son-in-law Tito Douglas had declined to take over the venerable firm in Bond Street.

I hesitated for some time, but by 2001 I was in negotiations. I had done business with Colnaghi in the past, in particular with their former director Richard Knight, and I had the greatest respect for this pillar of the British art trade. Colnaghi was founded in 1760, and it was and still is the firm with the best reputation and greatest tradition in dealing with Old Masters on an international level. Oetker and I were in the middle of negotiations when the events of 11 September happened. Everybody was in shock, and friends and family recommended that I withdraw. In my incorrigible optimism I was however convinced that, as terrible as the attack on the Western world had been, it was not the end. The art trade would recover after a while, as would the world economy.

Every year on 11 September the entire world commemorates the victims of the terrorist attacks. Looking back, one can say that this day really changed the world like no other event in our generation probably has. For some historic events everybody remembers where they were when they heard the news, and this is one of them.

On 11 September 2001 I sat in a taxi in Versailles, where the TEFAF executive committee for Maastricht had held a preparatory meeting in a hotel. After lunch I had called a taxi to take me to my friend Christophe Lazar's, with whom I was to stay overnight. I listened to the car radio and it took me a while to understand what had happened. An aeroplane had collided with one of the World Trade Center towers. My first thought was the same as that of many other people: maybe the pilot of a private plane had not paid attention. I remembered the hours I had spent in front of a flight simulator in the 1980s, which I had bought in the early days of personal computers and had installed at home. Sitting in front of the computer for hours at night, I had flown over Manhattan a lot. I departed from La

Guardia, circled over Manhattan, and landed again in JFK or another airport. Flying in between the twin towers of the World Trade Center was a special challenge. How often had I crashed into one of them! How macabre, I thought, that it really happened. But shortly after 3pm there came the news that a second plane, a scheduled flight, had flown into the other tower and had caused a devastating explosion. Then it became clear that something truly terrible had happened. As soon as I arrived at Christophe's place, we rushed to the television and spent the rest of the day and half the night following the horrendous news. It was an awful day and God knows it did change the world.

After the successful conclusion of the negotiations with the finance director of the Oetker Group, Dr. Ernst Schröder, I took over the house of Colnaghi on the fourteenth of January 2002. My first visitor, on the very same day, was Dr. Reinhold Baumstark, director general of the Bavarian State collections – maybe this was a good omen.

When writing about Colnaghi I must also write about Katrin Bellinger, my partner and colleague for Old Master drawings, whom I have known for many years. She often says, reproachfully, that she applied for a job with me on Lenbachplatz after her university studies, and that I turned her down – and unfortunately I have no recollection of it at all! In any case, she went to Neumeister instead.

Katrin built up her business selling Old Master drawings in Munich and has become one of the most successful dealers worldwide. When I took over Colnaghi in 2002 I was looking for a partner in the field of Old Master drawings, since throughout its history Colnaghi has always had an excellent reputation for Old Master drawings. I do not have the necessary expertise myself. Once again it was Barbara who had the great idea of asking Katrin. When I had lunch with her in London and suggested a partnership, she agreed straight away. She also encouraged me to ensure that we also bought

the famous Colnaghi library. Originally the Colnaghi library had not been part of the negotiations, since Rudolf Oetker's son-in-law Tito Douglas had already bought it separately and wanted to ship it to Germany, where he planned to build a new library on his country estate. We persuaded Tito to change his mind and the library remained in Bond Street. Katrin and I are joint owners under the banner of a newly founded firm The Colnaghi Library. We have also from time to time bought pictures together under the same entity. These enterprises have always proved lucky for both of us. Katrin also kept her own company, called Katrin Bellinger at Colnaghi. And I am still the owner of P&D Colnaghi, with the initials of the original founders Paul and Dominic Colnaghi.

When I am in London I often go to the library to look something up. When Katrin and I bought the library in 2002, it was not in good condition. There were twenty-two thousand volumes, but there was no real catalogue, just a very incomplete card index, that was all. And there were large gaps. Many new publications and exhibition catalogues, which have become important reference works for specific artist or periods, were missing, and periodicals had not been kept up to date. Many works which should have been bought when they came out were now out of print.

Two years later, and having worked several students to near exhaustion, everything was catalogued. Today the library can be used very well indeed, everything is clearly laid out and one can find what one is looking for. The book dealer Thomas Heneage ensures that every new publication finds its way to Bond Street. It is a considerable expenditure, but a well-kept library is also one of Colnaghi's great treasures.

Sourcing, Buying, Cataloguing
and Selling

*

*'Mr Bernheimer, how exactly can you tell
that the painting is not by the
hand of the master?'*

(Art fair visitor)

Tracking down new paintings is becoming more and more
challenging, but it is still the most exciting task for an art
dealer. It is often laborious work to trace pictures that we
believe we absolutely have to have. Sometimes we need to go into
battle with the rest of the world to conquer them, and sometimes,
when we are lucky, they fall into our lap. But we also have to be able
to sell the pictures we seize. (Sometimes we forget that!) Our objec-
tive is not to collect but to sell. Buying, sourcing, cataloguing and
putting the new find into an art historical context can still be more
inspiring that the sale. This is often the case when we do not have to
win the picture at auction, where not just the paintings but also the
buyers are visible to all, but when we gain access to private collec-
tions where we can look for potential and sensible acquisitions. In
that case we either try to buy the pictures directly or take them on
commission, in order to pass them on for the best possible result on
behalf of the consignor.

Every opportunity is taken, and if there is good reason to believe
that a painting or a collection could be interesting, we board the
next flight.

Lucas Cranach is kind of a 'household god' for me. I have studied
the work of the master and his workshop in great detail, and I have

been able to buy and sell a number of paintings by both the father and the son in recent years. Word gets around, thank God, and over the years we have also been offered several wonderful pictures from private collections. The last one was a marvellous portrait by Lucas Cranach the Younger of Philipp Melanchthon, the great humanist and philosopher of the Reformation. In his later years Cranach the Younger stepped out of his father's shadow and created paintings with an immense aura. His style can then appear closer to Holbein than to his father. On the same day that I sold the Melanchthon portrait in Maastricht, I signed the purchase for the next breathtaking picture, a nude Venus by Lucas Cranach the Elder from 1531 – a masterpiece!

I much enjoyed reading a recent article on Lucas Cranach in *The Art Newspaper*, with the headline 'Why the Art World is Crazy About Cranach'. It ran on: 'Forget Caravaggio. The new "hot" Old Master is Lucas Cranach the Elder.' The article reported on the increasing frequency of Cranach exhibitions over the last years, and on rising prices. It also mentioned, rightly so, that Cranach's beautiful nude women with their 'sensual feline' almond-shaped eyes had inspired many modern artists, from Picasso to Otto Dix to John Currin. The article illustrated the large painting *David and Bathsheba*, which we were able to sell at the Maastricht fair to one of the top Italian collectors. I have also found in recent years that Cranach has a great appeal for collectors of modern and contemporary art. I thought, maybe this time I will sell the Venus to a contemporary art collector. Instead, the treasure was bought on the spur of the moment by the Prince of Liechtenstein.

Every week pictures are offered to us in London or Munich, and sometimes there is something interesting, but not always. An American visitor, who had sought to make contact with me for a while, had flown to Munich from New York especially to see us. I

really hoped that he had not travelled so far merely on my behalf, to show me a folder full of photos of his paintings. There were all the big names, Rubens, Raphael, Titian, Tintoretto, but none of the pictures was even close to the work of these masters. It is a very thankless task to destroy such dreams. My visitor was particularly stubborn on the subject of his 'Rubens'. He showed me images from a small book he had brought, where he compared individual figures or heads from famous paintings by the master, all of which hung in great museums, and he pointed out similarities with one or the other detail in his picture. It was not easy to explain to him that it was not just the quality – the brushstrokes and sometimes the palette – that was different, but that it is the very characteristic of a copy to include certain set pieces from the master's work and rearrange them in the different context of a new composition. In other words, this was a *pasticcio*. He took his file and left disappointed and without believing me, at least that was my impression.

To authenticate a painting, expert reports are frequently commissioned. Recently, I have been asked often about their significance, both in the context of Old Masters and after the debacle of the Wolfgang Beltracchi forgery scandal and the failure of the experts in classical modernism.

Not long ago a group of very enthusiastic collectors from the younger generation, the Young Collectors Circle, visited the Munich art fair Highlights at the Haus der Kunst. They showed great interest and expert knowledge. When I put a large landscape on display, a joint work by Jan Brueghel the Elder and Joos de Momper, there were a lot of interested questions. How was it possible to distinguish between hands in a collaboration? How precise was such an analysis, and what was the significance of an expert report? What if one bought, for example, a painting as Jan Brueghel the Elder and a few years later another expert came along and declared it to be not by the Elder but by the Younger? I pointed out the basic difficulty in

providing expertise. Even at the time of Walter Berndt, who produced a large turnout of Dutch seventeenth century expertise reports in Munich in the nineteen-sixties, it was usual for an expert to charge a fee for their work. This is legitimate, since they have to live on something. In some cases this can lead to an expertise industry, in order to generate as many fees as possible. The quality of the expertise is not necessarily always compromised, but it can be. It is problematic when there is a conflict of interest: when an expert acts as an agent in the sale of a painting for which he provided an expert opinion, and if he then gets paid a percentage of the profit. (This seems to have happened several times in the Beltracchi case.)

It was very important to me to clarify for the visitors that there is only one person who guarantees the authenticity or the attribution, regardless of expertise, and that is the dealer who offers and sells the picture. This means that I have to draw my own conclusions. I must not simply rely on the expert's report, but I must be in a position to judge the painting. If I cannot do that, I must leave it alone. It is that simple: as an art dealer you must never trade in something you cannot assess. Of course there are many cases where we need the views of the experts, for example when it comes to the great names like Rubens, Rembrandt, or Velázquez. Even if I am personally convinced that a work is by Velázquez, I will have a hard time without the blessing of two or three art historians who have developed their international reputation in the field of this master. Every collector, every potential buyer will ask what their opinion was. Requesting these crucial opinions is part of our due diligence so to speak, the duty of care that we have to investigate the matter.

Further problems we have to deal with on a daily basis are export regulations, which are different for each European country. In a globalised world, where we routinely deal with clients all over the world, it becomes more and more difficult to know about the

respective European legislations. It is also very important to be highly accurate, since customs authorities are not at all forgiving about errors. It does not help to plead ignorance. By virtue of necessity we art dealers have all had to become experts in this field too.

Spain, for example, is a country where many large collections of paintings have accumulated over centuries. Accordingly, there is a wealth of fascinating private collections. I have had very good contacts in Spain for years, with my Spanish mother tongue certainly helping. We have found a number of pictures in Spain over the years, but here, too, it becomes more and more difficult to acquire something interesting from a private collection. And once something has been found, often an export license is not granted. Italy is a similar case. This restrictive approach to the fine arts is not European in spirit, but rather a relic of national state policies. The owner is also facing something akin to an indirect expropriation. But we have to live with this fact.

Spain and Italy are not alone, however. In Germany there is the 'National List'. Anything listed here must not leave the country. For example, Holbein's *Madonna of Darmstadt*, one of the most important paintings in a German private collection, was for several generations owned by the family of the Landgrave of Hesse. For years the family had tried to sell the work, but the painting was on the National List and could not be exported abroad. It is surely one of the most important Renaissance paintings north of the Alps, and some art historians argue that it could even be on a par with Raphael's *Sistine Madonna* in Dresden. On the international market this painting would easily achieve over one hundred million euros, but within Germany it is much less. For years no buyer could be found who would have paid a halfway acceptable price. The Städel in Frankfurt and the Munich Pinakothek together could have offered forty million, but the Hesse family understandably felt this

was too little for a painting which would have made over one hundred million euros without the export restriction of the National List.

But one day it was announced that the Madonna had been sold. Tito Douglas, the very effective private dealer, had convinced the great collector Reinhold Würth, and the endless speculation was over. It is said that Würth paid around sixty million euros, which would in any case be a good deal for either side.

Some time ago a major Pieter Brueghel the Elder appeared in Spain. The state pre-empted it and is said to have paid seven million euros, which is perhaps a tenth of the price which an American buyer might have paid. Is this not a form of indirect expropriation? Or should the owner of an important artwork be expected to sacrifice his legitimate claims on the altar of national interest? One thing is certain: had the European countries been this restrictive in earlier centuries, the world's museums would be empty today. There would be no *Sistine Madonna* in Dresden and no incredible Rubens collection in the Munich Pinakothek.

Overall, Great Britain has the most equitable approach. Regardless of an artwork's importance, an export license must ultimately be granted even if it was initially denied, once a certain time limit has passed. This permits finding a national buyer, either private or institutional, who is willing to buy for the same amount that the buyer abroad would have paid. This system should keep everybody happy. Many artworks in Britain are also offered directly to the museums in lieu of taxes, for example to meet inheritance tax demands. This practice has spread to some other countries over the last years. Bavaria applied it for the first time on the death of Johannes von Thurn und Taxis, when a large amount of inheritance tax was due. The tax calculation took it into consideration when parts of the collection were sold, some to the museum in Regensburg, some to the Bavarian National Museum in Munich.

Just as the rules of art import and export are full of surprises, so too is the life of an art dealer. One day I had a very interesting visitor in London, though I almost missed him as I was going out to lunch. Good old friends from Spain, collectors and great connoisseurs, wanted to ask me if I was interested in a Rubens. A Rubens! The picture came with all necessary export paperwork, which in Spain is a rarity. Judging from the photographs, it was a very nice Crucifixion, early in the oeuvre, possibly painted as early as 1612 to 1614. The early date was supported by the fact that there were two copies which the young Van Dyck probably made after this picture. The date would correspond to the time when Van Dyck was still working in Rubens's workshop. The workshop would have been small in these early years, and Rubens was likely to have painted it himself, but this would need further research. In any case, it was all very exciting, and both my sales director Tim Warner Johnson and my head of research at Colnaghi, Jeremy Howard, were ecstatic when they saw the photos. Now we would have to do our research, as is customary in such a case. We would ask for the opinions of the Rubens experts in order to present the picture accordingly – a very agreeable task.

Then the painting was delivered, and what an exciting event! I went upstairs into the library several times a day to look at the picture that stood on the padded easel. In the afternoon our restorer Patrick Corbett came. When he stood in front of the painting he exclaimed: 'Oh, my God!' Patrick is one of our most talented and experienced restorers, and I felt he was perfectly suited for the restoration of the Rubens. He had also restored a Rubens portrait of a young man that we had sold to an important New York collector in Maastricht during the previous year.

Several superimposed layers of varnish and dirt were evident in the Crucifixion. Patrick suggested removing only the top layer carefully and then to decide how we wished to proceed. I had immedi-

ately sent the family of owners a draft commission contract. I was hoping to get it back as soon as possible so that we could begin with the work. There was little time left until the opening of the Maastricht fair, TEFAF, where we wanted to show it. We also needed to find a new frame. These are the highlights in the life of an art dealer.

Shortly afterwards the contract for the Rubens was ready to sign. The collectors came to my office once again and we quickly agreed on the details. We also got the blessing for the restoration process.

When I was back in Munich, Patrick called me late one evening from London. He had begun to remove the varnish and the later overpaintings in the background of the Rubens Crucifixion and he was most hopeful. He had uncovered *pentimenti*, corrections in the composition of the limbs, which could only have been made by Rubens himself. Only the master himself would have corrected his work during execution, no workshop assistant would have done that, who would have copied or repeated the master's original. Patrick was quite elated.

A few days later Tim reported from London on the progress of the restoration work. He was thrilled and said: 'I should add that Patrick said: This is the best painting he has worked on for a long time.' I could hardly wait to see the picture again in London. When I arrived early in the morning, Tim, Jeremy and I went to Patrick Corbett first thing. I was really impressed: the nineteenth-century overpainting, which had been done in the taste of the period to make the background darker and more 'spooky', if you will, could be removed without any problems. The original background was much lighter and overall sketchier, from today's perspective more 'modern'. At the same time Patrick was also able to make the *pentimenti* visible, which made the whole thing even more thrilling. Patrick said once again that he had hardly ever had such a sensational and important painting in his studio.

We were able to collect the picture from him shortly before

TEFAF in Maastricht. We had it photographed for the press release. All Rubens experts, from Christopher Brown to Peter Sutton, had confirmed the attribution, and we took our new trophy to Maastricht full of anticipation. From the moment we hung it in the stand, crowds of colleagues arrived to cluster around the Crucifixion, and word got around fast: we had one of the most exciting pictures at the fair on view, an early Rubens! Museum colleagues asked me about the picture again and again. There was general admiration for the painting.

The day of the preview came. Frits Duparc, former director of the Mauritshuis, the Netherlands' Royal Collections, had already hinted to me the night before that he might recommend purchasing the Rubens to the great collectors Eyk and Rose-Marie van Otterloo, whose collection adviser he was. The couple arrived even during the first hour after the opening, and after another hour they had decided to buy the painting. As the van Otterloos are among the most famous collectors in the United States – the world of art collecting is small – and they themselves felt that it might not be possible to keep it secret, they allowed me to name them as the buyers to the press. It is very rare that a buyer is fully named, unless it is a museum, but then we dealers usually have to wait for the museum to announce the acquisition first. Naming the buyers of the Rubens was therefore a rarity, and the press mentioned it all the more often.

Colnaghi

*

'If we want things to stay as they are,
things will have to change.'

(From *The Leopard*, by Giuseppe Tomasi di Lampedusa)

We had spent ten happy years with Colnaghi in Bond Street, when suddenly a change was announced: the buildings were to be sold. Our lease was due for renewal the following year, but after the first talks it seemed likely that the new owners, an Italian fashion firm, wanted to use the building themselves. After all, Bond Street has changed: the formerly dominant art trade has almost entirely vanished, and instead the street has become one of the most expensive addresses for fashion and jewellery. It was a great shame; the rooms on Bond Street were lovely, with the library and the great red picture gallery, both on the ground floor. Maybe we really did not need street level rooms on Bond Street anymore, since the art trade had also changed. But we were worried that it would not be easy to find a new location.

After the sale of the building came six difficult months, since the property management company indicated that the owners wished us to move out at the end of our lease. Katrin and I spoke with numerous estate agents, only to confirm what we had already anticipated: it would be very difficult to find suitable rooms that we would be able to afford. Therefore, it was a huge relief when we heard after a few nerve-wracking months that there was a possibility to stay in the building and rent the three floors above ours. We quickly agreed unanimously that the upper rooms were not just a suitable alternative, but that they worked even better than the ground floor. The

great gallery with skylights, which really could only be filled with what our head of research Jeremy Howard described with the very British phrase of 'a country house hanging', was great for exhibitions, but it was not an ideal sale space. Jeremy Howard referred to the Baroque style the British aristocracy adopt in hanging paintings in their ancestral castles. More intimate rooms were much better suited to a personal conversation.

We all agreed that the move to the upper floors was not just about a new lease but also about giving Colnaghi a face-lift. The venerable gallery would have to be taken into the next phase of its 251-year history, towards the twenty-first century. Not just the rooms would change, but the style also, and everything had to come together.

The move was a logistical masterpiece, which our Colnaghi team achieved in short time and with flying colours. The rooms upstairs look extremely elegant, moderately conservative and at the same time quite modern. We consciously abandoned the old 'Colnaghi red'. Even a week after the move the downstairs rooms looked totally *démodé* in comparison. Things can change so fast. I remembered the famous sentence from Lampedusa's *Gattopardo*: 'If we want things to stay as they are, things will have to change.'

I added this sentence to the press release we issued to announce the move to the upper floors. I felt it could do no harm to have a bit of literature in a press release.

By now we have settled in very well. The lower rooms are really not missed, and most visitors like to come upstairs just as much as they liked coming into the downstairs rooms. There is one difference though: when there are two or three visitors, the rooms already feel lively, whereas people tended to get a little lost in the lower rooms. Basically, the rooms now look like the way many clients decorate their houses. It really helps them to imagine the way a painting would look in their home.

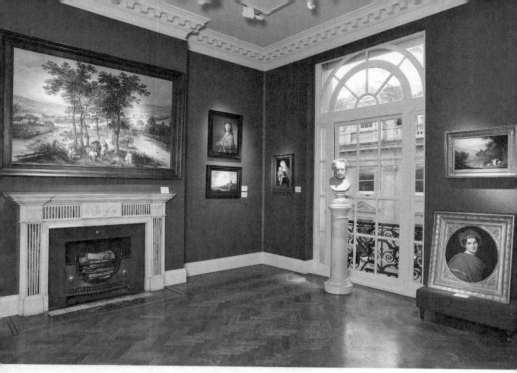

The new rooms of Colnaghi

What is even more important is the fact that is inevitable that a conversation gets started with every visitor, especially as I sit right in the middle of the room, surrounded by the pictures on view, and I enjoy it. Before I had a screen in my office on the first floor where I could see who was in the gallery, but when I went downstairs the visitor had sometimes already left. I much more enjoy direct contact and working with visitors, and I feel more involved. When I want to have a confidential conversation with a visitor I can always go upstairs to the library.

Moving the historic marble bust of Dominic Colnaghi from the ground to the first floor was a historic moment. Before it stood in a rather dark corner of my old office, and now it is in the exhibition room opposite my desk. When entering the room, Mr Colnaghi is directly opposite in the centre of the window towards Bond Street.

– 215 –

On the third floor there is Karin's exhibition space for drawings. On the fourth and top floor we have our picture storage, and in two large adjoining rooms, which have a lot of daylight from large windows and skylights, we could install a large part of our library. There is also our boardroom with a big conference table that we can also use as a dining table, since there is a fully equipped kitchen. Next door, in the smaller library room with the famous padded 'Colnaghi easel', and two armchairs in front for the presentation of important individual paintings. The walls are covered from floor to ceiling with our books and convey an atmosphere of scholarship. It is always good to be surrounded by books, apart from the fact that the library being useful and indispensable on a daily basis. As we do most of our research in-house, we use the library every day, and Jeremy Howard, head of research, has his desk in the library.

A few days after the opening, Blanca came from Munich to look at the new Colnaghi rooms. She had a meeting with a photography dealer and they withdrew to our boardroom. When her colleague visited me on the second floor he was very surprised when he heard that these were new rooms. 'This looks as if you have been here forever', he said, and that was the best compliment I could have had.

There are always incredibly good and important exhibitions in London, and we try not to miss any relevant ones, such as those in the Queen's Gallery. When a selection of Dutch paintings from the Queen's collection opened there, I found once again that we were born too late – roughly two hundred years in this case. George IV, for example, bought a huge number of Dutch paintings from 1812 to 1816. They are of exquisite taste and the highest quality, the best of everything. There are the most beautiful paintings by Aelbert Cuyp, Philips Wouwerman, Jan Steen, Rembrandt, you name it and it's there.

It is important to go to previews, because you can meet many people from the London art and museum world. I have known the Surveyor of the Queen's Pictures, Desmond Shawe-Taylor very well since his days as director of the Dulwich Picture Gallery, and also Lady Jane Roberts, Royal Librarian and Curator of the Print Room in Windsor Castle. She looks after the unique collection of drawings belonging to the Queen, which comprises sixty works by Leonardo da Vinci alone. In 2011 Katrin and I were invited to a dinner at Windsor Castle hosted by Prince Charles, the Prince of Wales. It took place on the occasion of a charity event in aid of the Prince's Drawing School, to which Katrin is very committed. It was fabulous to dine with a small group of people in the presence of Prince Charles. But the greatest delight came after dinner in the library: Lady Jane had prepared some of the most exciting drawings for us, including works by Raphael, Leonardo, Michelangelo and Holbein. What I found most touching was that she had taken out some of the invoices from Colnaghi to George IV, together with the relevant prints from the early nineteenth century, which Colnaghi had sold to the court. It was really exciting. As we had celebrated the 250th anniversary of Colnaghi the previous summer, she had prepared this especially for us – as a small contribution to our anniversary, she said.

Sometimes I enjoy a special privilege in the London museums: a preview of new museum exhibitions outside the normal opening hours. Visiting the Watteau exhibition in the Royal Academy was especially nice, as I had this marvellous exhibition to myself for a whole hour in the early morning. I would have loved to pinch a few works. There was the preparatory drawing for the art dealer Gersaint's *Shop Sign*, which is kept in Potsdam. What would an art dealer give for this picture, where an art dealer's shop is depicted – the paintings hanging on the walls right up to the ceiling, some are packed in crates, others are shown to clients by the dealer. At least a

*With Katrin Bellinger on the terrace of Spencer
House on the 250th Colnaghi anniversary*

while ago I managed to buy the print after the famous picture, and it now decorates my London flat.

One drawing in the Watteau exhibition caught my eye in particular, three studies for women's heads wearing hats from the Gulbenkian collection. The name Gulbenkian always brings back a story of a ship voyage often told by my mother. In the 1950s my grandfather and my mother went on a cruise through the Mediterranean on a very elegant cruise ship for the time, the *Ariadne*. Also on board was Nubar Gulbenkian, the son of Calouste Gulbenkian, the famous 'Mr Five Percent'. He got his nickname from brokering large

business deals where he always made a few percent. He founded the magnificent art collection in the Gulbenkian museum in Lisbon. Both he and later his son had been good clients of Bernheimer's. During the cruise he met my grandfather and mother, and they clearly had a great time together. My mother said that the Gulbenkians took extraordinary trouble with their wardrobe and changed several times a day. But the height of luxury was that Gulbenkian had brought fresh orchids on board in every port, as with every suit he did not just wear a matching tie and breast pocket handkerchief, but also a matching fresh orchid in his buttonhole.

My grandfather clearly made good use of the time spent together on the ship, as Gulbenkian came to Munich several times after the trip in order to purchase antique textiles and carpets for his collection.

A visit to the Frieze Art Fair is definitely the highlight of the autumn in the London art world. The contemporary art fair takes place every October in a marquee in Regent's Park. To go to the preview with both real and imaginary VIPs is always interesting and amusing in equal parts. On one of these openings a few years ago I saw a visitor who clearly felt that he was of the utmost importance. When we were introduced and he came across very pretentious, I said to him: 'Well, it's nice to be important but it's more important to be nice!' He took the point, but with humour, and said: 'I will quote you on that.' (And I have no idea where the quote is even from!)

I certainly do not have the ability to relate to everything produced in today's contemporary art scene, but at least I do feel that it is generally possible to distinguish between quality and weakness. I cannot help but think that much of today's production is made for the market. Even if this is the avant-garde, there is a mainstream of those works where one thinks or knows that they will sell fast, and sell well. But the intention is sometimes all too obvious.

The best new art fair conceived over the last years is Frieze Masters, which was inaugurated in October 2012. I have to admit that it took Fabrizio Moretti, my colleague from Florence, to convince me to take part, otherwise we would probably have not. He is on the Frieze Masters committee, and it would have been a mistake not to attend. In a second marquee, also in Regent's Park and reachable either on foot or easily by shuttle, there are Old Masters and sculptures on view, as well as works of art from antiquity to classical modernism. Old Masters juxtaposed with modernism. We especially liked this theme of the fair, since Blanca and I had successfully practised contrasting Old Masters with contemporary photography in our Munich gallery for several years. We met a completely new audience at this fair, obviously including many visitors whose main interest is contemporary art. At the other fairs we are always somewhat preaching to the converted, but here you really have the opportunity to meet a different audience. To begin with, we also sold quite well. Only one painting went to an old friend, all others were new clients. Blanca showed her marvellous photographs by Annie Leibovitz, Robert Mapplethorpe, and Irving Penn and was almost sold out at the end.

Meeting visitors who clearly had their first ever encounter with Old Masters could be amusing. Many found the dramatic price difference between overpriced contemporary works and relatively cheaper Old Masters surprising. A young couple for example came to look at our Lucas Cranach *The Ill-Matched Lovers* and admired the small picture depicting an old man with a young woman. They said this looked very much like John Currin! I dared to protest and said it was rather the other way round. When they looked at the label they said: 'Oh, my God! This is sixteenth century? So, this is the real thing?' And when they heard the price: 'And it's even cheaper than our John Currin?' But in the end they did not buy the Cranach after all.

When we set up the stand I was about to hang a wonderful por-

trait of a bearded old man by Jan Lievens, when a colleague from the opposite side of the aisle came over and wanted to find out more about it. He said admiringly: 'You can't get much closer to Rembrandt, can you?' This is exactly right, since before 1631, when Lievens and Rembrandt both worked in Leiden, their styles were so similar that even contemporaries often confused them. He could not believe it when I told him the price. 'You know, for the same price you could buy the four neon light works by Dan Flavin from my stand!'

Maastricht and TEFAF

*

'In the middle of nowhere.'

(Geographical description of Maastricht)

The mother of all art fairs is and remains Maastricht. Every year, and for quite some time, TEFAF has been by far the most important fair in the world, the measure of all things. When we say an object has TEFAF quality we mean it is of the highest order.

It has not always been like that. The beginning was not easy and today's success is ultimately the result of long and continuous development. It has also taken some time for the art world to get used to the name TEFAF, actually an ugly acronym for The European Fine Art Foundation.

I am asked again and again how it was possible for this fair to become established as the world's foremost art fair. It is based in a small town, 'basically in the middle of nowhere', with insufficient infrastructure, insufficient hotel rooms, annual fights for restaurant tables, and traffic at a standstill. There is not enough parking, and no international or even regionally connected airport, plus, the exhibition hall is actually unsightly, and so forth.

Every time I answer that it is precisely because it is in the middle of nowhere that Maastricht is so successful. Getting there is complicated; it requires effort and a dedicated will. You need to fly either to Brussels, Dusseldorf or Cologne and then drive for an hour, unless you are landing with a private jet directly at the small Maastricht airport. If collectors have gone to this length, especially if they come from America, they do not want to return home without a trophy.

In every big city, be it Paris, London or New York, an art fair is one of several attractions. But with Maastricht you come because of TEFAF, and that is that. This is the secret of the 'miracle of Maastricht'.

Nevertheless, it took a long time for Maastricht to become this successful. At the beginning of the 1980s everything was still manageable and regional in character. One could be glad to sell to one of the important local collectors, such as Leon Melchior, who owns a large country estate nearby in Belgium and was the benefactor of many an art dealer in the early years. At my first fair in the early 1980s he generously bought a nice large Kangxi *famille verte* plate from me, and gave me the courage to continue in Maastricht. This was still in the small Eurohal, even before the large MECC (Maastricht Exhibition and Congress Center, another lovely acronym) was built and the fair became TEFAF.

During the early years I was one of the first German participants and I had great difficulties with the German art dealers association, which did not approve of Bernheimer's exhibiting there. Scheduled in parallel, in March, there was the Westdeutsche Kunstmesse, which alternated between Cologne and Dusseldorf. Under a bizarre protectionist policy no foreigners were admitted. The Chairman of the German association, Günther Abels, actually verbally attacked me in public at the Westdeutsche Kunstmesse as a 'traitor to the country' because I dared to exhibit in Maastricht.

Thank God times have changed. Today the German contingent is among the most numerous at TEFAF, together with the Dutch and the British. (My long-term work in the Executive Committee has played a part.) There is hardly an important German dealer who is not present; indeed they could hardly afford not to attend today. I have always been partial to the international spirit in Maastricht. I liked that the fair was not just organised by the Dutch, from the beginning it was an international event. Maastricht is still the only

fair I participate in which does not make a difference between 'domestic' and 'foreign' exhibitors. This is very much in contrast, for example, to the Paris Biennale des Antiquaires, where there is still the distinction *Les Français et les Étrangers*.

TEFAF is registered as a foundation under Dutch law, and it is probably now the most powerful art trade organisation of all. It has considerable funds and its main administration is based in its own building. Paul Hustinx has managed the staff of permanent employees for many years. They work highly professionally and very effectively all year round, because as we all know, after the fair is before the fair. Our president is not an art dealer but a personality of European standing. For many years it was Hans König, a great European citizen, long-term secretary of the International Chamber of Commerce in Paris and an important collector of carpets and textiles. Today the TEFAF president is Baron Willem van Dedem, a Dutchman who lives in London and has an important Old Master collection himself. With his diplomatic skill and tall, elegant appearance he chairs the TEFAF Board of Trustees. The board oversees the fair and consists of an international group representing the art dealers, collectors and museum curators. In addition there is the Executive Committee, which is the management board, and two chairmen. At the moment Ben Janssens chairs the Antiquairs and I chair the Pictura. Ben and I have been friends since he worked in the Asian department at Spink & Sons in the early 1990s. At that time I bought several beautiful Indian sculptures for our private collection from him, which we still have.

Even after so many years, TEFAF is exciting every time. After my arrival at the hotel directly adjoining the MECC, I always walk over into the exhibition hall to see how the preparations are going. In the early years we reconstructed Colnaghi's red picture gallery at our

stand, which used to make a big impression. The country house hanging in several rows was equally striking, but perhaps a little too museum-like. Since we moved to the upper floors in Old Bond Street the large gallery is no longer part of our rooms, and so we decided to commission a new display for the fair and reconstruct our picture room with its blue-grey wall coverings and a replica of the mantelpiece. It is a more contemporary design.

Every year the Executive Committee is looking for a new idea to design the entrance to the fair. Together with the interior designer Tom Postma we have come up with, for example, a slightly 'retro' version, a 1970s one, and a futuristic one with enormous light installations. Every year the legendary Dutch flower arrangements change – sometimes there are tulips that have been bred especially for TEFAF, sometimes red roses, sometimes pink carnations. This flower had gone completely out of fashion, but after its appearance at TEFAF it is bound to make a comeback.

There is usually still a lot of chaos when I arrive. The builders are hammering and working everywhere, and then the shippers arrive to deliver to the stands. Large crates are stacked in the aisles, and many a colleague is hyper-nervous and gives hectic instructions. During the years of great catastrophes and crises the tension was always especially palpable, be it during the Gulf War, or in 2011, when the harrowing pictures of the tsunami and earthquake in Japan reached us during installation. These events make the stock markets fall, and the fear is that the negative atmosphere will spread. If there are several stock market crashes and natural catastrophes in the same year, this is also bound to be bad for the art market.

But we usually still succeed in creating an atmosphere at the fair which is completely detached from the reality outside. I once said to a journalist who absolutely wanted a negative comment during a time of crisis: 'Any disasters are to be left in the cloakroom outside.'

There is normally some time left before all pictures are unpacked

Booth at TEFAF

and we begin to hang, and I can go and greet my colleagues. Ben Janssen and I discuss any outstanding questions and problems which need to be fixed, before we meet again at the Executive Committee Meeting a few days later.

My immediate neighbour at the fair is Johnny van Haeften, and he usually arrives one day after me. A few years ago he hung a picture on his central wall that we had bought together: a large scale painting by Frans Francken with a fantastic *Allegory of Man between Good and Evil*. Four of us had bought the picture: Johnny van Haeften, Otto Naumann, Roman Herzig and me. We had paid a world record price at the Vienna Dorotheum. In its second outing we sold it in Maastricht on the opening weekend, to everybody's relief. Now it is hanging in the Museum of Fine Arts in Boston, and it looks so much smaller than on Johnny's stand. On the opposite side from my stand Georg Laue and his colleagues Mehringer and young Benappi from Turin always create their wonderful sculpture and

Kunstkammer display. Next to them Jorge Welsh from Lisbon unpacks his Chinese porcelain. At the opposite corner there are Florian Eitle, owner of the venerable firm Julius Böhler, and my old friend Roman Herzig with Galerie St Lucas from Vienna. He usually arrives when all the installation is done. Not far away there are the stands of Richard Green from London and Otto Naumann from New York.

For many years Johnny van Haeften, Otto Naumann and I have been called The Three Musketeers, because we keep buying important pictures together. We follow the motto: 'One for all, all for one.' It has never been possible to clarify which of us is Athos, Porthos or Aramis. Sometimes there is a fourth, a d'Artagnan so to speak (who, by the way, was killed in Maastricht!). It depends on the amount of money involved, or whether we feel that we need reinforcement, or it may be right for strategic reasons to have a fourth partner.

One of the last great coups of the Three Musketeers was 'the Ter Brugghen deal'. I had long known and admired the painting of a bagpipe player by Hendrick Ter Brugghen in the Wallraf-Richartz-Museum in Cologne. It is regarded as one of the best works by the great Utrecht master, who is considered to be one of the foremost Caravaggist artists of the north. This was a group of artists who travelled to Rome in the early seventeenth century and returned home to Utrecht with new and revolutionary stylistic ideas inspired by Caravaggio. I had never noticed the small label which said 'acquired in 1938', and I had therefore absolutely no idea that there was a restitution claim on the painting. One day I heard that the picture had been restituted to the heirs of Herbert von Klemperer in New York. Johnny entered into negotiations with the family, but they decided to consign the picture to Sotheby's in New York. We expected a very high sale price, and as a single-handed purchase was not possible, the Three Musketeers once again decided to go

The Three Musketeers: Otto Naumann,
Konrad Bernheimer and Johnny van Haeften

into battle with the rest of the world. We had to work on the assumption of a sale price between seven and eight and a half million dollars. We put our respective financing in place and went to the auction on the twenty-ninth of January 2009. We were not sitting next to each other, but we had a line of sight, and Johnny was to bid. The bids rose quickly above the auction estimate of four to six million dollars. Our very determined counter-bidder on the other side of the room was Richard Feigen. I made a sign to Johnny that Richard was probably bidding for a museum; we thought it might be the Getty. As we were at eight and a half million dollars I encouraged Johnny to go

over our pre-arranged limit. Otto had also given us a nod, so Johnny went up to nine million and we got it. Afterwards I went straight over to Richard Feigen and said: 'You have cost us a lot of money!' He had indeed bid on commission, but he did not say for whom. Johnny, Otto and I went around the corner to an Italian restaurant to lick our wounds. Even while we were sitting over pasta, the phones started to ring. Johnny had a collector on his mobile, I had the press, and Otto had Arthur Wheelock, curator for Netherlandish painting at the National Gallery in Washington. Arthur said that Feigen had been bidding on his behalf, and he added: 'We have to have that picture. Could you sell it to us for cost?' We replied in unison: 'Well, that's not really the idea.' Three days later we had come to an agreement. With the help of our friends Greg and Candy Fazakerley, great collectors in Washington, the picture was sold with a small but quickly realised profit for us. The Fazakerleys understood that we dealers not just needed to make a profit but that we had also earned it through our courage, and without their generous donation the deal could not have been done. When the Ter Brugghen was hung in the museum a few months later, the Musketeers arrived, too. Rusty Powell, the director of the National Gallery, gave a great dinner in our honour in the old Mellon boardroom, and we went to spend the weekend with the Fazakerleys in their fabulous house in Virginia – a happy ending for an important art trade deal.

On the Sunday before the fair opens, the final hanging is under way. The first day is usually taken up with the time-consuming and careful unpacking of the pictures, and we therefore only manage to hang about half of them. But on Monday we have to be finished, when the labels go up and the lighting is adjusted.

During the set-up the first members of the Vetting Committee gradually arrive. I tend to have my first conversations with Pete Bowron from Houston, Andrew Robison from Washington and

George Abrams from Boston. I also sit down with Anthony Speelman, who has been the Chairman of the Old Master Paintings Vetting Committee for many years, using his calm temperament with great skill.

Two days before the opening of the fair, the annual ritual of vetting begins, which is the evaluation of the art works on show. During this procedure groups of experts in different categories, who are invited by TEFAF to vet, move from one stand to the next and examine each piece with regard to authenticity, attribution and condition. Vetting is an important element of quality control at TEFAF and provides the greatest possible assurance for the potential buyer. The vetting committee for Old Masters alone has over forty members, everyone an expert recognised in his particular field worldwide. Most of them are curators or directors of great museums, many of them are American. (This also has the advantage that some of them are among our best clients.) A few years ago we decided to split the committee in two, the Northern Committee for Holland, Flanders and Germany, and the Southern Committee for France, Italy and Spain. No exhibiting dealer is on the committee, with one exception: as Chairman of the Pictura I accompany both committees and coordinate the process. Above all, I see it as my role to mediate in problematic cases and calm the waters. It can of course lead to financial problems when a dealer bought the work of an artist at a corresponding price and the committee downgrades it to 'school of ...' or 'circle of ...' And there are regular cases where a colleague is convinced to have made a great discovery but the committee is unable to agree with him.

In my opinion it is very important that neither exhibiting dealers nor auction house staff sit on the committee. The integrity of a vetting process is crucially dependent on the absence of any potential conflict of interest. Of course the verdict of the committee is not always jubilantly received. In that case there is the possibility of an

'appeal'. In front of the entire panel the dealer will have to convincingly defend his attribution to a particular master, which the committee may not have recognised. If he does not succeed he will have to bow to their decision. Most dealer colleagues are very experienced in their area and know exactly what they are doing, however. But everybody can make a mistake sometimes, and then the colleague will have to change his attribution. In many such cases they then decide to take the picture down and not show it at the fair. In rare and extreme cases the committee decides that an object is not to be admitted 'in the best interest of the fair'. It is subsequently removed and must not be shown. All this happens with the greatest possible confidentiality and is not made public.

TEFAF's reputation of the highest standard of quality is not least based on this rigorous and conscientious assessment, which is done with great effort.

Most evenings during the fair we can be found with colleagues and clients at the Mediterraneo, our favourite Italian restaurant in the old centre of Maastricht. This charming little restaurant has been there for over twenty years, and Pino and Angelika have become an indispensable part of TEFAF for us. During the ten days of the fair the restaurant becomes an exhibitors' club, with all tables booked long in advance by the dealers. It is nearly impossible to get a table here if you have not been part of the scene for years. And every year there is a great hullabaloo when we all meet again.

Then the day of the opening arrives. To start with, the press comes in the morning and there are a lot of interviews. Then the collectors arrive and the excitement builds.

We take one last glance at the stock markets. If the markets are up, or the dollar has dropped again, we tell our colleagues, and it puts everybody in a good mood.

One important collector after the other arrives at the stand, some-

times simultaneously. They express their interest in one or the other picture, and if we are lucky there is a sale on the first day. Often everybody clusters around the same paintings. In that case, the one who is quickest to make up his mind carries the trophy home. This has happened to me again and again in the last years, with important pictures by Cranach or Rubens for example.

Over the past few years we had almost ten thousand visitors on the opening day, which was nearly our maximum capacity. The first days are always very crowded, with non-stop talks and handshakes. I enjoy the calm before the storm in the mornings, before the fair opens its doors to the visitors. I try to arrive early and in good time. This allows me to go over my notes from the day before and review who came and who was interested in which picture. As soon as the first big picture sells, the ice has been broken.

The fair is getting better year after year. One reason surely has to be that we keep asking ourselves what else we can improve on. Not a week in the year goes by without me talking to Johnny van Haeften or Ben Janssens about some detail, in addition to the four to six committee meetings per year.

Every year visitors from all over the world flock to Maastricht. Almost every day is fascinating and brings potential new collectors and buyers. The American patrons tend to have the deepest pockets, and many of them come every year. Almost every big museum is represented, sometimes with curators, directors and trustees. There are Germans, Dutch, French and Italians, many Spaniards and quite a few South Americans, and in recent years more Russians and Chinese. The art trade is changing, and new markets emerge, which we also notice at TEFAF. Some time ago the annual 'Art Market Report' published by TEFAF already drew attention to the increasing importance of the Chinese art market. But our plans to establish a new TEFAF fair in China did not materialise. Maybe we were too early.

Almost every year I have bought something for us at the fair, even though our house in Munich, the flat in London and the castle in Marquartstein became so full that we hardly knew where to put new acquisitions. I hear this from clients as well, when they are hesitant about a purchase: 'We really don't have any space left.' I always quote my grandfather in these instances. He used to say: 'A really good object will find its own space.'

Art Dealers vs Auction Houses

*

'We are all prima donnas!'*

(Johnny van Haeften)

T imes change, and the art trade is not immune to this. Recently I have had more and more conversations with investment bankers or fund managers who want to discuss contemporary investment strategies, as more family offices are looking to invest a greater part of their wealthy clients' capital in art. At the same time we observe that many potential investors shy away from giving up their cash positions, due to the generally uncertain situation. This is not entirely logical, but then, what is in the current economic and financial climate? However, clients who buy modern and, even more so, contemporary art do not hold back at all. There are several reasons for this. One reason is that many advisers have little specialist knowledge and simply follow market trends. The mainstream buys contemporary art because it indicates a progressive outlook, and it's all too easy for people to buy 'labels'; they are looking for the recognition factor of an artwork. When friends come to visit they should be able to recognise at once what is hanging on the walls, and if possible what their host spent on it. It is not so easy with Old Masters, where buyers and viewers have to have some historical knowledge, or at least the ability to place an artwork vaguely in the context of art history. Collecting Old Masters is more challenging because it is more than just decorating.

An investment banker asked me the other day how much market share in Old Masters was held by the dealers in comparison with the auction houses. I told him that I believe that the total volume of the

art dealers is still higher than that of the auction houses. This is in contrast to the Impressionists, where the auction houses are certainly much stronger. However, if we include the auctioneers' ever growing Private Sale departments, the trade has long been left behind.

A while ago I read an article by Georgina Adams in *The Art Newspaper*, which not only struck a chord with me, but also pointed towards a surely rather alarming trend. The subject was the role of the big auction houses as dealers. According to the article, Sotheby's and Christie's turned over private sales for a combined total of over one billion dollars in 2011 – a huge sum, considering that these houses used to see their business primarily as selling art at public auctions. In both firms, it said, private sales amount to ten percent of the respective total turnover. These sales, it was maintained, took place mainly in the fields of Old Masters, Impressionist and modern art, but also contemporary art and jewellery. The share of private sales also continues to rise.

This development has several consequences. The boundary between auction houses and traditional dealers has become increasingly blurred. The shift is all one-sided: the auction houses take away business from the trade, but not vice versa.

A big problem is the role reversal with regard to their clients that the auction houses drive ahead. They act more and more on behalf of the buyer, whereas before they acted first and foremost in the interest of the seller, for whose pictures they are intermediaries. In addition, there are a growing number of agents, advisers and consultants. The traditional division of labour between auction houses and dealers is becoming more and more a thing of the past. The dealer who stocks up at auction, researches the pictures, restores them and sometimes also makes discoveries in the process, who then sells to his clients with more or less profit and advises them in building their collections – this art dealer, it seems, is on the retreat.

For a long time great collectors used to rely on their dealers, and the greatest collections were the product of a constructive co-operation between a dealer with great expert knowledge and an ambitious collector. But today there is a new kind of collector, one who no longer relies on the trade's expertise but who rather enjoys going on the hunt himself, seeking the thrill of the open battle at auction. This can work well, but it can also go wrong. Some people have the painful experience of bids being driven up through 'chandelier bids', fictitious bids employed by the auctioneer. The Anglo-Saxon auction houses cover themselves through their conditions of business – they act in the interest of the seller, to drive bids above the minimum sale price, the so-called reserve. An experienced bidder will quickly realise this in the saleroom and will wait until the reserve is reached in order to avoid bidding 'against the chandelier'. But a private client who is bidding on the telephone may hear from the auction house staff on the phone that there is great interest in the room. At the end of the telephone line he cannot see that he may be the only bidder, and he gets a completely distorted view of the sale in progress.

The expression 'chandelier bidding' is said to have come into being like this: an elderly lady wanted to sit in the auction room and bid, but not to be seen doing so. She agreed with the auctioneer that she would bid on a certain lot as long as she was looking up to the chandelier hanging above. The lot in question came up, the bidding began. The auctioneer looked towards the lady, who must have not been looking at the chandelier, and knocked the lot down to another bidder. Upon which the lady shouted angrily and defiantly: 'But I was looking at the chandelier!'

(If it's not true, at least it's well invented.)

On the fifth of July 2011 Christie's Old Master and British Painting sale was about to start at 6:30pm. Even the title demonstrates the

difficulty the auction houses face in sourcing good and important pictures. They mix the offer to fill the catalogues. When the art market still had plentiful supply, both Christie's and Sotheby's had separate departments in London for Old Masters and for British Paintings. There were separate catalogues and the sales took place on different days. Due to the shrinking supply today, the auction houses have to merge their categories and make concessions with regard to the objects' quality and condition. On that day in July the result corresponded: a few good pictures achieved high prices, the rest was soon forgotten. The top lot was a large painting by George Stubbs. It had its own catalogue and a bold estimate of twenty to thirty million pounds. But Christie's risk was limited, since the guarantee which the auction house had given to the consignor had, it was said, been financed by a third party. Had the auction price not reached the guarantee, the guarantor would have become the owner of the picture. It was sold just above the agreed guaranteed sum to another buyer, who was represented by an agent in the room. Rumour had it that it may have been the ruling family of Qatar. In any case, somebody paid a new record price of over twenty million pounds for a Stubbs.

Sotheby's auction on the following day was much more interesting than Christie's. My friend Otto Naumann was able to secure a very good altarpiece by Hans Schäuffelein, painted on both sides, for over two million pounds. Soon afterwards he succeeded in selling it to the Metropolitan Museum in New York. A *Madonna and Child*, attributed to Correggio, which had not convinced me at all, still made a lot of money. But the last lot which was put on the easel stole the show: an unusually large and really excellent painting by Francesco Guardi, depicting the Canal Grande with a view of the Rialto Bridge. Sotheby's Chairman Henry Wyndham, currently the best auctioneer in London, worked his entire charm to drive the bidding to unprecedented heights. In the end it was sold after a long battle

between two telephones – China versus Russia, it was speculated – for over twenty-six million pounds.

Time and again there are exceptional talents among auctioneers. During my time at Christie's the best was Sir Patrick Lindsay, head of Old Master Paintings in the 1970s and a fabulous auctioneer. With an innocent expression he leaned far over the rostrum to call out, as a matter of course, even the most dizzying prices: 'One million pounds, any more?' He did exactly that with a beautiful small gold ground panel by Duccio di Buoninsegna, an incredibly fine Crucifixion which belonged to his family, the Earls of Crawford and Balcarres. The picture from one of the oldest families in Scotland was bought jointly by the National Galleries in London and Edinburgh for one million pounds. In 1976 this was one of the most expensive art works ever sold. Besides, Sir Patrick was also a dashing racing driver. It was a highlight for us boys from the Front Counter when Sir Patrick drove up on Monday morning with a roaring motor in his vintage cabriolet, pulled off his leather cap and threw the keys into the expectant cluster of Front Counter boys. Whoever caught them was allowed to park the car. I never dared.

Often pictures fail at auction because of the high estimates put on them. They are the result of the tough competition between the auction houses, which have to fight for every picture and every collection. Sometimes one house is too aggressive in its promise of high results. Then the other firm, whose turn it is on the following day, is lucky and can use the interval to adjust some consignors' high expectations downward.

But sometimes auctions can also achieve prices that make us dealers shake our heads. This was the case with a sale at Christie's in December 2011. A large picture by Pieter Brueghel the Younger, depicting the *Fight between Carnival and Lent* achieved nearly 6.9 million pounds. It was the son's replica by of a painting by the

father Pieter Bruegel the Elder in the Kunsthistorisches Museum in Vienna. When Johnny had it a few years ago he was struggling to sell it for just over one million. If we dealers demanded such prices in our galleries for the same pictures, the clients would pronounce us insane.

One of the reasons is most likely the fact that the buyers think that with a dealer they do not need to rush. At auction however they have to act immediately, otherwise it is too late and someone else buys the picture. This generates a sense of euphoria in the saleroom, and a buying frenzy that we cannot initiate in our galleries.

At Bernheimer's and at Colnaghi we enjoy the privilege that many collectors and families with important pictures have confidence in our sales successes, our accurate research and our expertise. Consequently, they entrust us with outstanding pictures. We are somewhat less in need of having to fight for the few good pictures at auction than most of my colleagues. The combination of two long-established companies, Bernheimer's and Colnaghi, plays its part. The more important the pictures consigned to us, the longer our research can take. But we need to take the time to put forward conclusive attributions. For big names it is especially important to eliminate any doubts. The picture also has to be presented in the best possible condition. In general, auction houses do not restore the pictures consigned to them. They sell them 'as is', in the same condition they were when brought in. The art dealer on the other hand tries to lift the picture to a higher level, both through research and through restoration. In a way this could be considered to be our *raison d'être*.

In addition, we can be more selective than auction houses, as we are not under pressure to present a well-stocked catalogue at certain predetermined times throughout the year. In front of every picture we can ask ourselves: 'Is this a must-have? Do we really need to

have this?' It is not enough to have a beautiful decorative picture today; it has to be exceptional. It is precisely this search for the pie-in-the-sky which makes our work so complicated, and so exciting. All of us, auction houses and dealers, compete for the same pictures, and so we all contribute to the ever-shrinking supply.

During one of my last flights to New York I read a newspaper article about the Brussels art fair. 'Old Masters sold out!' it said, and that only very few pictures remained on offer. This sounds dramatic. The author would only have to come to Maastricht one month later to see that an entire exhibition hall can still be filled with Old Masters (Brussels is not Maastricht, after all). But it is true that the shrinking supply in our area becomes more and more severe. When I studied Christie's and Sotheby's auction catalogues for the coming sale week during the flight, very little of interest remained. Three of the catalogues I had already left behind. Until a few years ago I had to make a strict selection in New York in order not to risk my 'war chest'. Today things have changed: I do not need to have the very few really good paintings, because the general tendency is that they sell for too much at auction. In addition, the market has become more transparent. Anybody with a little know-how can check on the Internet for which picture sold for how much in which sale, and then tell me how much I want to earn on a painting.

The good old-fashioned system – auction houses as gross dealers and the art dealer as a retail outlet – is a thing of the past. Still, it is always possible to overlook something in a catalogue. Therefore my colleague Tim Warner Johnson and I go to Sotheby's and Christie's auction previews several times to look carefully at the offers. We have some pictures taken off the wall to inspect them in a dark room under ultraviolet light. This is still the quickest method of making restorations visible to the naked eye. We carry very effective black light pocket torches when we go to see the paintings. And after several rounds, and by the second day at the latest, we know which pic-

tures we want to bid on. There are usually only a few. But occasionally there is something really important where we shoot our bolt.

Over the last years Johnny van Haeften and I have often discussed the changes in the market. In times of an economic crisis, the euro crisis, the debt crisis and the slide in the stock markets many potential clients and collectors are uneasy. They prefer to wait for better times, whereas the collectors of contemporary art tend to speculate without restraint and with the mentality of a gambler. Johnny told me that he had heard what his neighbours, the White Cube gallery, have set as a monthly sales target: thirty million pounds! They represent Damien Hirst and others. We are happy if we make that in a year. The Old Master market is much more conservative. We agree on how we see the situation in the market: our clients, the Old Master collectors, have a different buying pattern from collectors of contemporary art. Sometimes we come across a speculative approach directed at value appreciation, but for most of our clients the picture is much more important. They are interested in the art historical context, in filling a gap in their collections. Most of all, they want to live with the picture they purchase. They take great care in selecting the wall or the room in their flat or house where the new purchase will hang. We often do a test hanging. This is rare for contemporary art, where works are frequently bought without knowing where they will go after the purchase. Often the work is sent into storage pending resale – until the increase in value which one hoped for has been realised.

But we should not generalise. There is no typical Old Master buyer and no typical Impressionist, modern or contemporary art buyer. There are only trends, and the buying pattern is different.

We dealers agree on one thing: the rules in the market have changed dramatically. One could almost say there are none anymore. Every day we experience so many irrational moments that it must be hard for everybody to predict results beforehand. This is

because we have more players and actors in today's market who have sufficient funds, but have very little knowledge. Around 1900, when the great American collections emerged, the steel magnates and railway barons did not have the knowledge either, but they relied on good advisers. The best dealers, like Colnaghi, Knoedler and Duveen, advised them and channelled their collecting passions into the right direction. Auction houses are going to hate me for what I am going to say, but I am convinced that most auction house employees today (there are always exceptions) are much more short-term thinkers that we dealers. During a sale in New York I saw a member of an Old Masters department bid on the telephone for a client, and jump from 360 000 dollars to 450 000 dollars in one step. The picture was sold to the client at 450 000 dollars. He may also have gotten it for 380 000 dollars. A dealer would never have done this. We would tell the collector: start with 380 000. For us it is a matter of survival to build up a long-term relationship with a client. And I do not even want to know how many pictures at Sotheby's or Christie's are bought without the buyer ever having seen the original. They bid on the basis of an illustration and the persuasive skill of the department.

What is an appropriate way for a dealer to react to the changing market? Sometimes we wonder why we did not merge several dealers into a large important art trade company, to increase our power in the market. A merger could be the answer to the current market situation. But such plans are bound to fail because the egos of the dealers are simply too big. As Johnny once said during one of these talks, 'we are all *prima donnas*', and we have a hard time finding a consensus. It is never a problem to form a temporary *ad hoc* alliance in order to buy an important picture. But a permanent merger or even a joint company is something altogether different. Maybe the answer is simple: we dealers must work together even more closely.

Dealers and Collectors

*

'I have never bought with my ears,
only with my eyes.'

(Tom Hill, New York collector)

Every year during the last week of January, the entire Old Masters trade gathers in New York for the major sales at Christie's and Sotheby's. Another fixture in the calendar is by now the annual 'Chinese New Year's Buffet' in Richard Feigen's amazing apartment on Fifth Avenue. It is a place to meet not just colleagues but also every important museum curator and director, and many collectors who are clients or whom one would like to have as clients. There is no other art dealer today who has managed to be so successful over such a long time (he is now over eighty), and built such an unbelievable collection. It comprises pictures from early gold ground paintings to Orazio Gentileschi to Turner and Beckmann – it really is incredible. Everything is hung peacefully and most impressively on the walls of his Fifth Avenue apartment. None of us will ever achieve this – tough luck for those who were born too late.

But then there is Fabrizio Moretti, wunderkind of the younger generation of dealers. I am sure that we will hear a lot about him in future. He has certainly managed to position himself at quite a young age as the premier address for early Italian paintings. Apart from his gallery in Florence he has branches in London and New York, where he works with his colleague Adam Williams. Fabrizio always has a very good selection of early gold ground pictures, which currently experience a renaissance (literally). I have never

been able to become passionate about these early pictures; you have to really like them. Once, maybe fifteen years ago, I spent three days in Siena on my own and did nothing all day except study gold ground pictures. Afterwards, I was able to distinguish fairly well between the different masters, which is hard enough, but I was still not feeling very enthusiastic. This has still not changed: I greatly admire the field and the colleagues who really are experts, but it is not for me. Knowledge is one thing, but you also need passion, and I have to admit that I lack that for these early pictures. Fabrizio's gallery is on 80th Street, next door to my friend Otto Naumann and in between Madison and Fifth. Today, Otto is probably the most successful dealer in New York. He has certainly handled the most Rembrandts over the last few years. His walls are covered with great masters. But Otto lives with his pictures as a matter of course, and he conveys the same ease in dealing with masterworks to his clients. On top of that he has a great sense of humour. Over the last years we have successfully done business together many times, never enough, as we always say, but we certainly had great fun together.

Otto's pizza parties in his gallery on 80th Street are legendary. He invites the entire art world that is in New York at the time: colleagues, museum curators, restorers and collectors. It is a wonderful get-together. If there is anybody you have not yet met at the auctions, receptions and dinners, you are bound to meet them here. In addition, the buffet is stocked with the most delicious fine Italian wines in plentiful quantity, and the pizza is freshly delivered every quarter hour from the oven next door, courtesy of the nice restaurant Serafina on Madison Avenue. It is very popular with art dealers. The jeroboams of Sassicaia 2007 that Otto provided one year were not just wonderful, but also wonderfully generous, and the *pizze* were a treat as always. Everybody who is anybody in the art world was there and enjoyed the evening.

Not far away on 71st Street my friend Jack Kilgore has his gallery.

I admire Jack for his salesmanship. He looks like an absent-minded intellectual with his curly hair, round glasses, and inevitable bow tie. But he manages time and again to sell huge pictures, sometimes with peculiar subjects, from the nineteenth century, which I would normally have considered unsaleable. He seems to actually specialise in non-saleability, and he is very successful with it. He has thus earned my greatest respect.

On every trip to New York a visit to the Metropolitan Museum is a both a must and a great pleasure. I went to see the *Renaissance Portraits* exhibition there in January 2011. It was the same exhibition that had created such a stir in Berlin that it was hardly possible to get in. In New York it was not quite as packed. I saw some familiar faces; clearly many European art dealer colleagues who had come for the auction week did not want to miss the exhibition. My favourite painting in the show was Domenico Ghirlandaio's famous portrait of the grandfather with the large rhinophyma on his nose and his grandson. There is no better depiction of an enchanting loving relationship between grandfather and grandson than this picture, which had come from the Louvre. Even though the grandfather does not meet today's ideal standard of beauty.

But on that day I also wanted to look at the new Islamic department at the Metropolitan. I had heard great things about it and it met all my expectations: wonderful presentation, excellent lighting and the collection alone is tremendous! I felt a little as if I was entering an earlier life, since I was still so familiar with the Star Ushaks, the Mamluk carpets, the Isfahans and the Iznik ceramics. All of these were sold at Bernheimer's in the old days, and still in my time.

The best moment on that visit came when I stood in front of the *Commander*, a Rubens which I had been able to obtain for my friend and client Tom Hill. It is a painting of a commander preparing for battle and putting on his armour with the help of servants. Christie's

offered it in June 2010 from the Spencer Collection at Althorp, Diana Princess of Wales's family. It is a great picture. My client and I were equally enthusiastic, and he commissioned me to buy it for him. We were successful and happy that we got it for the low estimate of eight million pounds. Some people had, for whatever reason, tried to badmouth the picture before the sale, saying that the condition was bad and that some experts had not agreed with the attribution. We were unmoved, as we were completely convinced by the picture. When I informed Tom Hill about the rumours before the sale, as I had to, he said" 'I have never bought with my ears, only with my eyes.' I found that a wonderful phrase, and I keep quoting it.

Tom gave the picture to the Metropolitan on loan. When I saw it hanging there, I felt completely and happily vindicated, thank God we never wavered. I also visited Tom and Janine in their apartment, where Tom showed me the wall that he reserved for 'our' Rubens on expiry of the loan to the Metropolitan. It is across from a large Francis Bacon painting of a pope, which is influenced by the Velázquez portrait of Pope Innocent X in the Palazzo Doria Pamphilj.

Over the years it has happened again and again that clients became friends, for example Mo Zukerman and his wife Karen. I will never forget when we invited the Zukermans to a performance of Verdi's *Macbeth* at the Munich State Opera. It was one of the so-called modern productions, and the director had not spared the audience any vulgar atrociousness. Karen, who sat next to me, looked aghast at the stage, and after the performance she just said politely and quietly: 'You know, I don't think this would be possible at the Met.' She was surely right. The Zukermans's apartment on Park Avenue is amazing. One fabulous picture is hung next to the other; with a still very comfortable atmosphere. They live with their paintings, which have been gathered with a highly intellectual approach. Even

though each picture would be the pride of any museum, the overall impression is not museum-like.

During the last annual auction week the Zukermans invited Johnny van Haeften, Otto Naumann, Jack Kilgore and me for a glass of champagne in their home. Afterwards, Mo, Johnny, Otto, Jack and I went to a very nice Italian restaurant called Sette Mezzo around the corner. Otto and Jack very kindly invited us to dinner (I had wonderful *funghi trifolati* as a starter, followed by a masterful *risotto Milanese* with just the right subtle amount of saffron). But above all our friends treated us to a very impressive jeroboam of Bricco dell'Uccellone 2005 from Giacomo Bologna's Braida vineyard in Piedmont. It was exquisite. Although the three litre bottle looked rather big to begin with, it turned out to be no match for our friends in the end. The conversation was at least as captivating as food and drink, and once again it revolved around the subject of auction houses versus the trade. Mo pointed out that for him, as a collector, it was of particular importance that we dealers had simply a different approach. We would form close relationships with our clients, and were 'long-term thinkers'. That, he said, was a crucial difference to most auction house employees who tended to think about short-term success. This is quite understandable, one of us said, since we dealers are liable down to the shirt off our back for what we sell the client. If an auction house employee makes a mistake, at the worst they can be dismissed, but how often does that happen? When we make a mistake, we put ourselves on the line.

Mo Zukerman is a great friend, not just personally, but also spiritually, as it were. He is a friend of the dealers, and we love him for it.

No trip to New York takes place without a visit to the Frick Collection. It is a great joy to see this wonderful collection every time. Many years ago I told the director at the time, Charles Ryskamp, that I would be happy to move in straight away, just with my tooth-

brush, and leave everything unchanged. I once complained to a curator about the constant rehanging of the pictures. Over the years one gets used to the order and knows exactly where one's favourite pictures hang. And then they change everything! When I last visited, Claude Lorrain's large *Sermon on the Mount* was suddenly in the great picture gallery. For as long as I remember it had been in the adjoining small gallery. But I have to admit, it is not in a bad location now. It is in the same place, where for years, Bronzino's marvellously arrogant and blasé-looking young man in a black doublet hung. This picture is a safe candidate for my own *musée imaginaire*.

Whenever I stand in front of the Frick's *Polish Rider* by the young Rembrandt, I remember a story: the picture was 'on and off the list', as at times it was fully attributed to Rembrandt but at others not. For many years it was de-attributed. Then the all-powerful Rembrandt commission revised the artist's oeuvre and the *Polish Rider* was once again fully attributed. When I congratulated the director Charles Ryskamp, saying 'Charles, congratulations, your *Polish Rider* is back', he said, with a little smile: 'You know, we never changed the label.'

There is another picture in the Frick Collection for my *musée imaginaire*: Giovanni Bellini's *Saint Francis*. This is not just because it is one of the greatest pictures Colnaghi ever sold (long before my time), but also because with every visit I am fascinated by this depiction of complete rapture in a fantastic landscape, which even without the enraptured St Francis would appear entirely other-worldly with its cascade of blue shimmering rocks.

Every year the January week in New York flies by. My last New York visit before the flight, if there is still time, is always to a small shop on 62nd Street. There, on the corner of Lexington Avenue, there is the best 'shoe shine shop' I know of. The owners are very nice Mexi-

cans and they are completely dedicated to shoe care. If I moved to New York, I would have to live on the Upper East Side because of this shop alone.

At least once a year I love going to Rome, and there is always an excuse to visit the Eternal City. The exhibitions in the Scuderie del Quirinale, for example, are always worth a trip: *Dürer in Italy* or the great Lotto exhibition, which brought all the important altarpieces by the artist together which you never see otherwise, unless you trawl through all the small towns in the Marche, or go to Recanati, Bergamo and Loreto. Barbara and I usually stay at the hotel De La Minerve behind the Pantheon, and our first port of call is almost always our favourite trattoria, Il Angoleto, *per una piccola pasta*. And we always look forward to seeing our friends Ugo and Chiara Pierucci. It is hardly possible to outdo Roman hospitality. Evenings with Ugo and Chiara are always a great pleasure, both from a culinary point of view and because of the art. One evening there was a hilarious dispute between Ugo and Sandro Bufacchi, both of them great collectors of Italian paintings. They discussed one of the best pictures in the Pierucci collection, a Vanvitelli with a view of the Tiber and the Castel Sant'Angelo. Ugo had bought it in the 1990s from an English collection, with its English frame and clearly never having been cleaned. The wonderful painting had been in England since the eighteenth century, and had accumulated a nice layer of dirt, *sporco inglese*, as Sandro Bufacchi called it. Ugo had always refused to have it cleaned, but Sandro insisted that the picture would benefit enormously. Only then would one see what the artist had intended, with a light blue sky instead of the brown layer which covered it now. Ugo maintained that the *fantasía* would be lost, however. These are two opposing views which often come up when the question arises: to clean a picture or not?

A few weeks after the discussion Ugo Pierucci called me from

Rome; he had finally made up his mind to have the *sporco inglese* removed from his Vanvitelli. Ugo said the result was breathtaking, I would not even be able to imagine how blue the Roman sky now appeared above Castel Sant'Angelo. It had really been very 'English' before. On my next visit I saw the picture in all its new splendour, glowing and fresh, free of its *sporco inglese*.

The highlight and the real reason for one of my last trips to Rome was a visit to the Palazzo Farnese. This incredible building is one of the most beautiful Roman palaces, but it is normally closed to the public, since it is the residence of the French ambassador. This time it was briefly open for an exhibition, and so for the first time we were able to see the fantastic frescoes by the Carracci brothers. The cycle of frescoes in the gallery with the subject of the Triumph of Bacchus is mesmerizing. Of course I knew these masterpieces, but only from books, not least from Steffi Röttgen's magnificent volumes on frescoes. But to stand in the hall, crane one's neck and share the impressions with the others in our small group was an unforgettable experience. Especially when considering that the first time is likely to remain the only one.

Alive with the history and the splendour of the Farnese we then walked over to the Farnesina in Trastevere. This small villa with the frescoes by Raphael and his school, depicting the Triumph of Galatea, are really a triumph of beauty and poetry.

Later, when we crossed the Corso, we came across a horse-drawn carriage. It brought back my mother's stories about her trip to Rome with my grandfather in the 1950s. They stayed (of course) at the Villa Hassler at the top of the Spanish steps, and my grandfather insisted on going around Rome in a carriage, as he refused to get into a taxi. In those days they were small and cramped. In today's insane traffic, a carriage in Rome would not be recommended.

Before leaving Rome we often have a cappuccino on Piazza Navona in the morning. At 9am there are very few tourists. As soon

as it opens, we go inside St Agnese, Borromini's circular church, to see the marble reliefs and altars. It is always wonderful to visit Piazza Navona, with Borromini's curved façade and the three fountains by his arch-rival Bernini. There is the marvellous figure on the fountain that turns away in horror from Borromini's church façade and covers its eyes with its hands, an amusing testimony to the eternal dispute between the two masters.

The last short visit before taking a taxi to the airport takes us to the church of Santa Maria sopra Minerva opposite our hotel, on the square with Bernini's little elephant, *L'elefantino*, carrying an obelisk on its back. In Santa Maria sopra Minerva we advance until we reach the chapel on the right side where there is a very beautiful fresco by Filippino Lippi depicting the Assumption of Mary. The winged angels playing music that carry the cloud on which the mother of God ascends to heaven are of celestial beauty, and they become, it seems, more beautiful with every visit.

Part IV

The Question of Restitution

*

'What was a lost paradise for
my family can become a new paradise
for many children today.'

(From my speech at the Otto-Bernheimer-School in Feldafing)

S everal years ago I received a letter from the elementary school in Feldafing, the village on the Starnberg Lake outside Munich. It had been suggested to rename the school in our former villa after my grandfather Otto Bernheimer, so that it would become the Otto-Bernheimer-Grundschule. I was very pleased about it, even more so as I had been previously upset by the local council. The mayor had written to me about a donation to restore the square in front of the villa, which my grandfather had commissioned in the nineteen-twenties. It had a fountain with a small putto carrying a water-spouting fish, copied after the famous original by Andrea del Verrocchio in the courtyard of the Palazzo Vecchio in Florence. I found the fundraising request rather insensitive and inappropriate. A lack of historic knowledge seemed apparent, and I had told the mayor so at the time.

The request by the school, however, was completely different. With my entire family in tow I went to the official inauguration in Feldafing, having a slightly queasy feeling. It was the first time that I would enter these premises. But the reception was so heartfelt, the children and teachers so kind, that it became a very touching experience. I had been asked to give a ceremonial address, and I used the sentence: 'What was a lost paradise for my family can become a new paradise for many children today.' I was deeply

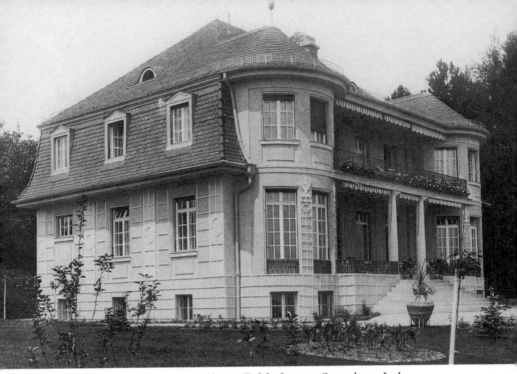

The villa in Feldafing at Starnberg Lake

moved when I later saw this sentence quoted and credited to me on the homepage of the school's website.

Feldafing was Otto and Lotte Bernheimer's summer residence. After their marriage in 1905 they had decided to have a house in the country, and in 1912 they bought the beautiful villa with a great view of Starnberg Lake, above Rose Island. Entry to the park was through the gate of a chauffeur's lodge. At the beginning of every summer my grandmother moved to the lake with the children, my uncle Ludwig and my father. In the autumn they returned to the large flat on Lenbachplatz. The two boys must have had a very happy childhood there. Summer was spent on the lake and in the mountains. When the golf club was founded in 1926, my grandmother was one of the few ladies among the founding members. My father also became a passionate golfer in his youth, until the family was excluded from

membership in the 1930s. After the arrests during *Kristallnacht*, the family were forbidden to return to the villa in Feldafing. Together with the other property holdings, the estate was lost in the process of the emigration negotiations. The Nazi party passed the villa to the Feldafing local council, which set up a school there.

When my grandfather returned to Germany, the villa was restituted to him. His wife was dead and his sons had remained in Venezuela, however, and he did not want to return to the place where he had spent so many happy years with his family. He therefore decided on a generous gesture. Directly after restitution he donated the villa to the Feldafing council. The elementary school was to still have its home after the war. Not everyone in the family could follow him in this generosity.

Even if he never set foot in the villa again, Feldafing remained one of my grandfather's favourite places. When we were children we spent several summer holidays in a small chalet next to the Forsthaus am See, a pleasant small hotel and day trip destination, where my grandfather often joined us for lunch. He came out from Munich but never stayed overnight. We often dined at the hotel Kaiserin Elisabeth above the golf course. He always wanted to sit beneath the portrait of Empress Sisi, whose large marble sculpture stood in the garden. In July 1957 he celebrated his eightieth birthday there. I was seven and remember the event well, with my beautiful mother being the radiant centre of attention among the guests. At least as a proud son I saw it like that. Of course we children sat at grandfather's table. Each guest received a present of his *Memories of an Old Man from Munich* in a limited edition with a precious binding and real black and white photographs. Flicking through it brings back many of my own memories.

It may sound surprising, but my grandfather never made any restitution claims for objects lost during the Nazi period, whether they were expropriated or the subject of a forced sale. What mattered to

him was that we were back, that unlike many other families we had been fortunate in being able to emigrate, and that everybody in the family had survived. From the moment he returned to Munich his attitude was to look ahead and not back. He wanted to rebuild his hometown together with his fellow citizens.

Therefore it has never been an issue for me to look for objects that may have been subject to a forced sale during those years and claim restitution.

My grandfather's generosity was by no means the exception. A while ago I read the book *The Hare with the Amber Eyes* by Edmund de Waal. It describes the extended history of the Jewish Ephrussi family and their passion for collecting throughout the periods of political turmoil in the nineteenth and twentieth centuries. It moves from Odessa to Paris, Vienna, Tokyo and finally London, and follows the history of a collection of Japanese *netsuke*, which is passed on within the family. But the book is also about the generosity of Jewish families, who felt the need to give back something of their positive experiences to the countries they lived in. They proved to be great philanthropists.

My grandfather would have been justified in making a number of claims. He sometimes mentioned the sword of Cortés, which the Nazis confiscated under the pretext that Jews were not allowed to own weapons. Later he heard that foreign minister Ribbentrop had presented the Spanish conqueror's sword to Generalissimo Franco during a visit as an official gift from Hitler. There were also the Dürer sheets which had vanished from the safe when he returned from Dachau. He told us about much more which had been lost forever.

Another great loss we suffered was the sale of the Otto Bernheimer collection by the Weinmüller auction house in December 1960. In a certain sense it was also a forced sale, but for different reasons.

After my grandfather's death we did not have enough cash to pay the inheritance tax and for my Uncle Ludwig's inheritance claim. As my grandfather had fallen out with Ludwig, we had to pay him out. Otherwise we would have had to pay him with additional shares in the firm, which would have been even more against my grandfather's wishes. On the advice of our family lawyer Dr Leibrecht, my mother reluctantly decided to give up the private collection. The auctioneer was the young Rudolf Neumeister, and the sale of the Bernheimer collection was his first great success, which launched him.

The introduction to the sale catalogue for the ninth and tenth of December 1960 was written by a close friend of my grandfather's, Theodor Müller, director general of the Bavarian National Museum. He wrote that the Otto Bernheimer collection had been 'the quintessence of the life of the great merchant'. He said that he had never forgotten how 'from the cellar to the attic the Consul had been present in every single room of his house, which were all filled with a vast array of objects'.

Even as a small boy Otto Bernheimer begged his father for the small bronze figure of Bodhisattva, which he kept all his life and which even accompanied him into emigration.

I can confirm Theodor Müller's recollection of my grandfather's home; from today's perspective I would describe the incredibly cluttered interior as *horror vacui*. His flat was filled to the rafters with sculptures, objects, showcases and textiles.

The sale of the Consul Otto Bernheimer collection was a great success and realised over two million marks, which was an enormous sum at the time. The top lot was a picture by Carl Spitzweg with the title *This Is Your World*. It depicted an eccentric scholar or alchemist in his study, with a stuffed crocodile above his head, and sold for one hundred and twenty-two thousand marks. Fortunately a few things remained unsold or were withdrawn by the family, such as

The small Chinese Bodhisattva

Olaf Gulbransson's portrait drawing of my grandfather, which hung on the wall of my *Herrenzimmer* together with the other family portraits. The beautiful velvet on the cover of the catalogue was also not sold, and we had it at Marquartstein. It is a large piece of red Florentine velvet brocade with gold and silver embroidery in a pomegranate pattern from the early sixteenth century. I remember it well on the walls of my grandfather's flat.

There is one object among the losses to which I am very partial. Should I ever come across it, I would like to buy it back. It is a bronze head of the winged Hermes. It stood on my grandfather's television set, and even then it was an object of desire for me. Will I

ever find it again? Maybe today's owner will read this book and will recognise the illustration – *on peut aider la fortune, n'est-ce pas?*

Some time ago I received a letter from Bernhard Maaz, director of the Gemäldegalerie in Dresden. He expressed his gratitude for the return of a small painting by Jan Brueghel the Younger, which had been in the Dresden State Collections before the war. It had been lost in the war and, as so often in these cases, it is not clear how it went missing and who might have taken it. In any case, it resurfaced later in a Belgian private collection, and about twenty years ago it was offered to me for sale.

At that time there was little awareness of problematic provenances and resulting restitution claims. When we bought the little picture we had no reason to doubt the provenance provided by the sellers: according to them the painting had been in the family for a

Bronze Hermes head

long time. Quite soon afterwards we sold the picture to very good clients. Several years ago they decided to consign some of their paintings and artworks, which they had purchased over the years, to auction. To everybody's surprise the Brueghel was confiscated and handed over to the police. The Dresden Gemäldegalerie had put forward a claim. I compensated the family immediately and took over the picture myself. Now the buck stopped with me. Several expert reports and investigations followed in order to clarify if this really was the picture the Dresden museum had lost, or possibly another version, which is not so far-fetched. We know that Brueghel often painted several almost identical versions of the same subject. In addition, the Dresden painting was documented only by a bad black and white photograph from before the war. The affair took its time. I began to realise that it would never be completely resolved, since neither side was able to put forward conclusive proof. So I decided to cut the Gordian knot. As a gesture of goodwill I gave up my own claim and handed the picture over to the Gemäldegalerie without compensation.

My first encounter with Bernhard Maaz led to a friendship and collegial cooperation. He is now the director general of the Bavarian Staatsgemäldesammlungen, the Bavarian State Painting Collections, and in charge of both Pinakothek museums, which have been part of my life for as long as I can remember.

My Father

*

'*Dios me perdone!*'

(From Kurt Bernheimer's last letter)

In the summer of 2010 we had to say goodbye to my sister Maria Sol. She fought her illness bravely until her final days, but she lost the battle in the end.

We had planned a big party to celebrate my sixtieth birthday months before, and many friends from America, England, Italy, France and, of course, Munich had been invited. When it became clear in the spring that my sister's cancer had returned, we discussed cancelling the party, but my sister would have thought straight away that we did it because of her, and it would have been a depressing signal. All of us so wanted to stay positive and hope that she would conquer her disease.

We visited her in her house in Munich a few times in August. We saw her become weaker and weaker, but she always stayed optimistic and did not lose her sense of humour. Then she was taken to hospital. We drove to Munich to see her. I could see at once that the time had come to part. For hours I stayed at her bedside and was able to say goodbye. On the following day my sister died.

It took a year before I was able to remove the placement cards for the birthday party from the table of the library in the castle. I could not do it before.

Sadly, none of us can be buried in the Bernheimer family grave in the Jewish cemetery in Munich, since we are no longer Jewish in the orthodox sense. This is a pity, as it is probably the most beautiful grave of all there. It is designed like a wonderful *hortus conclusus*,

surrounded by a low wall with its own small bronze gate and narrow paths between the graves. The great-grandparents Lehmann and Fanny Bernheimer are in the centre, surrounded by the graves and memorial plaques of my grandfather Otto, his brothers Max and Ernst and their wives Karoline and Berta. Great-uncle Ernst is buried in Havana, so he has only a memorial plaque. There are two more for my father and my grandmother, who are buried in the cemetery in Rubio, the village where we lived in the Andes of Venezuela.

When several friends died some years ago, I began to think about buying a grave. After a lot of deliberation I was able to buy a very nice family grave in the North Cemetery, right opposite the Jewish cemetery. My family teased me a little about it, and I did of course hope that the roses I had planted would have to wait a very long time for one of us. But I found the thought comforting that the family would not have to start looking for a grave if the worst came to the worst.

I miss my sister Maria Sol very much, now that I try to remember details for this book. In our family it was she who kept our memories of Venezuela and our father alive. Many of my own memories of early events, and also about our grandfather, were hers. Her stories were so vivid that they became my recollections. In addition, I have a tendency to idealise, especially where my grandfather is concerned. But my sister always put me right with her stories of real episodes. Above all, she had many more memories of our childhood in Rubio than the rest of us. In a certain sense she was the most 'Venezuelan' among us siblings.

Our Venezuelan relatives refer to us to this day as *los Alemanes*. My father was German, we speak German among each other and we live in Germany after all.

But the Venezuelan element has remained alive. My sisters and I grew up bilingual in Venezuela. This had the advantage that other

languages became easier to learn later. As far as I am concerned, I live with and in several languages – not just in conversation but also in my thoughts and even dreams. German is for me something like my *langue littéraire*, in which I think and dream most often, and in which I count. But it depends also on where I am, since my 'professional' language is English. Occasionally I also count in English, dream in English, and of course I read English every day. Since my childhood, Spanish has been the language of emotions and spontaneous outbursts. When I hurt myself, my 'ouch' sounds more Spanish than German. I also taught myself Italian and French and speak it quite a lot with our French and Italian friends and clients.

As I get older, I feel oddly closer to being Jewish. This could also be because Barbara, who comes from a strictly Catholic family, has developed great sympathies for everything Jewish. We love travelling to Israel and have wonderful friends there. Ideally we would go several times a year, so much do we enjoy the life there with its climate and the vitality of the people. In the past, I must admit that I never paid any attention to our family's Jewish roots. Of course there was the family tradition, but there was little personal identification. It certainly played a role that my mother was Catholic and that my upbringing had been Catholic.

I was essentially first confronted with Jewishness at my grandfather's funeral, and that was an almost disturbing experience. The speech at the grave was given by the abbot of Kloster Ettal, who put the greatest emphasis on being there as a personal friend and not as a Catholic dignitary. The Jewish community certainly took considerable offense and suddenly remembered that my grandfather had not paid church taxes for years. There was a steep posthumous payment to be met.

I think it was some time in the 1980s when I left the Catholic Church. I am a believer at heart, just not in the Catholic sense.

Today, I feel more Jewish than Catholic. But many would say I am not, since my mother was not Jewish, while others would say I am a Bernheimer and therefore Jewish by definition. I fall in between, as in my nationality. I am *'el Aleman'* for my relatives in Venezuela, and for everybody else I am a peculiar mix of Bavarian and Venezuelan. I see myself more as a citizen of the world, but with several distinct deep roots. The deepest are perhaps in the Chiemgau region, in Marquartstein, but there are also some deep ones in the little Andes village of Rubio.

After my sister's death my niece Daniela told me that as she was tidying up she had found letters in her mother's estate – letters from my grandfather and from my father. She wanted to hand these over to me, now that I had begun to write the family history. My sister Iris, who had looked through the papers together with Daniela, told me that the content would be hard for us to bear. These were my father's suicide notes, which we had never known existed. Our mother had obviously kept them and never told us about them. When Maria Sol had cleared out our mother's flat she had taken the letters, but she too kept quiet about them. Only shortly before her death had she told her daughter Daniela about the existence of these letters.

I wanted to save reading the letters for the right moment as I felt that it would not be easy. They were my father's suicide notes after all. This was the final confirmation that my father's death had not been an accident, as I had always suspected.

It was several months later when I finally had the courage to read them: firstly, my father's suicide note to my mother. These were harrowing lines. My previous ideas about my father were completely overturned. When I had thought again and again about my father's suicide over the years, I had come up with my own plausible version. But this letter, and the others I held in my hands, changed everything.

In his last letter to my mother, my father said goodbye in heart-breaking words. He wrote that he was very ill in body and mind. His nervous system was shutting down, due to a quickly deteriorating nervous disease that impaired him more each day. He was already blind in one eye, and would be completely blind in the near future. He was no longer able to drive and had already caused several accidents. It was clear to him that he would soon have to live in a sanatorium, helpless and with dementia. He could not do this either to his beloved wife or to his children. For the last weeks he had put up pretence in front of her and the entire family, but due to his worsening condition this was no longer possible. He was unable to imagine living in this terrible condition while his wife, his children and his father were around. At the end he said goodbye *con tanta tristeza*, with so much sadness. He had to leave his children, he said, who had been his greatest joy. My mother would have to be brave and look after the children so that she would not fail them as he had done. *Dios me perdone*, may God forgive me.

Then there is the suicide note to his brother Ludwig, which to my surprise was also written in Spanish and not in German. Had Spanish become the language the two brothers used? Was this another hint that my father wanted nothing more to do with Germany, that he corresponded in Spanish even with his own brother?

In the letter to Ludwig he also asked his father not to judge him harshly, but to forgive him. He repeated in this letter that he was suffering from an incurable nervous illness, and that his strength was failing. He had become incapable of taking any decisions at work. He had turned blind in one eye and could no longer drive. He had become generally unfit for achieving anything at all. At the end he asked his brother to take care of his wife and the children, and to ensure that they could go on living in their house and would be sent to good schools. For the children his brother should keep the mem-

ory of their father alive. He said that he had told his father that he could not come to Germany. At the end he wrote: *'padre, porqué me dejaste solo?'* ('Father, why have you abandoned me?')

My niece Daniela later made a valuable point: while the letter to Ludwig was written in Spanish, it was not on headed paper and not in Kurt's handwriting. As it was in my mother's estate, my niece suggested that Ludwig or someone else had translated the letter for her. I think this is quite likely.

At that point I also wanted to speak with my cousin Fanny, Ludwig's daughter, about my father's death and about the rift in the family. It mattered to me how she would see things from her perspective and from her side of the family, and I wanted to know what her parents had told her. I was sure that my perception of Uncle Ludwig and Aunt Elizabeth would be different from hers.

When she came to Marquartstein at Christmas, we withdrew together with my sister Iris after lunch and sat in the *Herrenzimmer.* What had my cousin known about my father's death? And where did she see the reasons for the disastrous quarrel in the family? She could not add anything new. My father's death was also never mentioned in his brother's house. Her parents had told Fanny that my father had committed suicide, but she was ordered never to mention it since we, the children, knew nothing about it. Her family had also never discussed the reasons for the suicide. Fanny did not believe that the relationship between the two brothers had caused the family dispute, but rather the difficult relationship between the father Otto Bernheimer and his son Ludwig. Ludwig had apparently come to the conclusion that our grandfather had become senile in his final years and was no longer able to run the business. I can easily imagine that this led to a final rift between the two. No father likes to hear that he is senile, and least of all Consul Otto Bernheimer, who never knew or tolerated opposition. But Ludwig may well have been right. As

much as I adored my grandfather, he was sometimes confused in his later years and began to make mistakes at the firm. And the influence of my grandfather's girlfriend Erna Imfeld may also have played a part. In his final years, my grandfather listened to her more and more, and her influence was not always beneficial for the family. She may have added fuel to the quarrel between father and son, rather than tried to mediate between the two. But all this is conjecture.

I kept thinking about the conversation with my cousin. I was really glad that we had spoken so openly. It was a new discovery for me that the dispute between two brothers, as we always imagined it to be, may not have existed. Fanny seemed to be quite sure that the family quarrel was based first and foremost in the rift between her father and our grandfather. It could perhaps even be understandable that, having been disinherited, Ludwig projected the outcome of the dispute onto us, our grandfather's sole heirs. But was this inevitable? We don't know, and we will probably never find out about the real reasons for the quarrel.

Fanny told us that Ludwig had also not really wanted to return to Germany, which was news to me. He had only done it because there had been nobody else in the family to take on the management of the firm. After my grandfather's death in 1960 he went back and forth several times between Munich and Venezuela. It was only in 1963 that he moved to Munich for good and settled with his wife Elizabeth and their daughter in a house in Rottach on Lake Tegernsee. But he wanted to go back soon, said Fanny; he never felt quite at home in Munich. In any case, Ludwig's return to Germany was short-lived, since he died of cancer in 1967, at the age of only fifty-eight.

Aunt Elizabeth had invited my mother and us children to the funeral. I was impressed at the time by the easy familiarity in the graveyard, since we had had no contact at all until this time. The day of Uncle Ludwig's funeral was the first day of the end of the family

quarrel. In the following years my mother and Elizabeth visited each other more and more often, and today Fanny and I share a very warm family friendship. Thank God we are living proof that family disputes do not need to become a legacy.

My father's illness and the worsening dementia which he experienced in full consciousness must have been terrible for him. When I re-read the letters, it made me think about his severe breakdown in 1948, when he had come back to Munich for the first time for a brief visit. At the time he was taken to a Swiss sanatorium. My mother and Maria Sol both mentioned several times that he suffered from a very bad back. We know that he must have been severely physically abused both in the concentration camp at Dachau and in the notorious Gestapo prisons in the Munich Gestapo headquarters at Wittelsbach Palais. His periods of depression, his taking refuge in his books, which sometimes made him oblivious of his surroundings, may possibly also be explained as late consequences of the torture to which he must have been subjected. I cannot imagine it otherwise. I keep coming back to my grandfather's awful story about meeting his sons in Dachau, when they were named during roll-call and realised that father and sons had been standing next to each other without mutual recognition.

I spent several hours in my library in the hope of finding old letters or documents in folders and boxes. In a folder together with payment instructions from the early post-war years I did find a number of letters which I had never looked at before. This was one of my grandfather's files from his personal safe, which I had taken in 1987 when we moved from Lenbachplatz to the castle. Ever since the documents had been stored in a cupboard in my library, and in the last twenty-five years I had completely forgotten about them.

What I found was harrowing. There were condolence letters to my grandfather relating to my father's death, from Ludwig and

Elizabeth, from Erna Imfeld, from Aunt Blanca's husband Uncle Wolfgang Kopecky, from Werner Hornung, who had been our neighbour in Rubio, and from Aunts Carmen and Blanca. All the references to my father's death confirm what I now know: my father had clearly acted in a severe phase of depression caused by a debilitating illness. Everybody around him seems to have been completely taken by surprise by his suicide, especially as my father had never breathed a word about his illness to anybody, not even my mother.

I spent many long hours over the letters. There is the first letter from Ludwig and Elizabeth to my grandfather after my father's death. Nobody had known about Kurt's condition, it said, it was inconceivable for everybody. From a letter by Erna Imfeld I see that my grandfather had flown to Venezuela in August, a few weeks after my father's death, to visit his son's grave and to prepare everything for our move. She also welcomes my mother's decision to come to Munich: 'To stay in the surroundings where she had spent so many happy years with Kurt is unbearable, and above all one has to get the children out of the atmosphere of mourning, otherwise they will suffer.'

I also found the obituaries:

> *As a result of a car accident in Rubio (Venezuela) our beloved*
> *Kurt O. Bernheimer*
> *died on 24 July 1954,*
> *shortly before his move to Munich.*

I found an offer from a local travel agent in San Cristóbal dated April 1954, addressed to my grandfather, for tickets from Caracas to Munich – return tickets! They were to be issued in the names of my father, my mother, Aunt Carmen (it seems that she was to join from the outset) and for my sisters and me. Return tickets, mind you, since my father was only coming for a few months to begin with.

And then everything changed. I have found no indication why the family decided directly after my father's death never to mention it again and to pretend that it was officially a car accident. It seems that the pain and the incomprehension about my father's desperate act had been too much for all involved.

Much has become clearer, and about much I will continue to reflect. My father's destiny fundamentally changed the course of my own life. Had he not died, we may only have come to Munich for a short time to visit my grandfather. I would have grown up in Venezuela, and I would certainly not have been sitting in the castle in Marquartstein and thought about my life as an art dealer. Fate just took its course, and it has to be accepted.

But I am now certain about one thing: my father's death was a result of his ordeal in Dachau and the Wittelsbach Palais. My father never got over the physical and psychological consequences of his experiences and his suffering.

When walking from Brienner Strasse to the Pinakothek, I had recently started to take a shortcut through the courtyards of the headquarters of the Bavarian Landesbank. Once I had read about my father's imprisonment in the notorious Gestapo prisons in the former Wittelsbach Palais, I realised that whenever I crossed the Landesbank courtyards I was exactly in this place. When the ruins of the Wittelsbach Palais were pulled down, the new building had been erected precisely on this site. My initial reaction was to find a different route to go to the Pinakothek. But one day, when I walked across Karolinenplatz while consciously avoiding the Landesbank courtyards, I asked myself: what are you doing? I had never thought about the Gestapo before when looking at the Landesbank, and now that I am over sixty it starts bothering me? Like many of my contemporaries I have repressed many things all my life, including my

father's tragic story. It is not as if the documents and letters which I read had not existed. I just never took an interest. But to repress something does not mean that it vanishes, at some point everything that has been buried and sunk rises back to the surface. To overcome it is a different matter, and I begin to do so by writing down our history.

Of course the Bernheimers are a family of victims and not of perpetrators. For the children and grandchildren of the latter it can be equally painful to understand the fathers' and grandfathers' history, once the decision has been reached to no longer repress the past. But in the end there is no alternative, everything is bound to surface again, whether we want it or not.

My family serves as an example that there is not just the silence of the perpetrators but also the silence of the victims.

There have been recent publications about families and companies who face their past and document their involvement during the Nazi period. Of course nobody is to blame for the crimes of a father, or a father's acquiescence or inactivity. Most of the children of such fathers were too young or not even born. They are 'fortunate in having been born late', as Helmut Kohl memorably put it. But everybody shares a responsibility to keep history from repeating itself. Those who know that their families have been guilty, and who try to deny this even after so many years, who refuse to face up to a historic truth, are in danger of becoming personally liable. Through the denial and repression of the past they may even unwittingly contribute to history repeating itself.

When my brother-in-law Jobst cleared my sister Maria Sol's cupboards, he found another stack of documents and gave them to me. This time I wanted to tackle them without delay, and spent many hours studying them in the library. There was a letter of appointment, making 'Kommerzienrat Otto Bernheimer' a 'lifelong

member of the Deutsches Museum committee' in 1929. There was also a condolence letter after the death or Ernst Guttmann, my grandmother's brother who had fallen in Reims just before the end of the war in late September 1918. He had volunteered for a night-time mission! There is also the document about the military decoration with the cross of merit with crown and swords, dating from January 1915.

There is a lovely letter from my father to his parents from November 1925 where he thanks them for the many presents he received for his fourteenth birthday. He says he was spoilt! He had received books by Kleist and Jean Paul, an elegant suit, an alarm clock, a history of literature. And he had been especially pleased about an innovation: instead of fourteen candles he had had fourteen new coins on his birthday cake. He reports what he did on his birthday. In the morning he was at the synagogue until 11am. Then there had been visitors, his cousin Franz and the Rheinstroms, and the afternoon had been spent in Oberföhring with Uncle Ernst's family. His parents Otto and Lotte must have been travelling.

Then there is a charming letter from my grandmother to my father on his eighteenth birthday, in verse:

> 'Once our little one you were,
> you are now a grown-up sir!'

She advises him to study hard for his *baccalauréat*, after which the world would be open to him, and she offers him as presents that he will get 'on *Maman*'s return' an entire new wardrobe, starting with a suit and hat and ending with a golf bag.

These are the only documents I have about my father's happy childhood and youth.

Then things become serious again:

Ludwig wrote to my father from Munich to Rubio in May 1954. Ludwig had travelled to Munich with Elizabeth and little Fanny to join my grandfather for the celebrations on the ninetieth anniversary of the firm. He describes the situation in Munich as he found it for his brother. He tells his brother, who in accordance with our grandfather's wishes was about to follow soon and move with his family to Munich, that he should have no expectations of anybody finding a flat for him in Munich, he would have to do that himself. It would not be easy to find one. The same was true for domestic staff, he said, maybe a charwoman could be found for a few hours. As grandfather was not willing to transfer them money, they would also have to think about how to finance the move and the search for a home. Kurt would have to take care of this himself. Then there are a few details about new fertiliser that one could try on the hacienda, and finally he urges Kurt once again to discuss the details of the trip and the living conditions in Munich with his father. In case Kurt was really planning to move, Ludwig demands that the firm in Venezuela be handed over to him completely.

This was not a very encouraging letter to my father, who was already doubtful about travelling to Munich and only considered it for the sake of his father. Handing over his share in the hacienda to Ludwig would effectively have blocked his return to Rubio. This does not sound as if the two brothers had a close relationship.

In the end I found the last two letters from Otto to his son Kurt. The first dates from the fifth of June 1954. My grandfather begins by describing the strenuous anniversary celebrations with the great exhibition *1500 Years of Textile Art*. Ludwig and Elizabeth had left, he wrote, and would return to Venezuela after a stop in Switzerland. He continues to write how much he is looking forward to Kurt's arrival. Ludwig had sadly not shown much ambition to work in the firm, and so all hopes rested on Kurt. Of course he would do everything

– 277 –

possible to make him and his family feel at home quickly. There was much to do, and he himself was overworked. Kurt would have to support and manage the business together with him. He suggests living in a small bed-and-breakfast in Munich to begin with until the right home could be found. He did not want to start searching without him, as Kurt would be in a much better position to choose for his family's needs.

Then he wrote that he was about to take the waters at Bad Kissingen to recover from the stressful period.

The second letter from Bad Kissingen is hand-written. It must have been written shortly after the first one, in June 1954, just after Otto had heard about the death of Don Daniel Uzcátegui, my mother's father. 'I am deeply shaken by the death of my dear Don Daniel, whom I regarded as my best friend from the moment I arrived in Rubio and saw him first', my grandfather wrote, and he is saddened by the great gap that Don Daniel's loss would leave in the lives of many people.

He was greatly benefiting from his cure, he wrote, walking had become much easier, and the chronic pain was eased. He wanted to stay until the middle of July, and he would see 'the Ludwigs' in Munich before their return to Venezuela. The letter ends with the words: 'I so much look forward to your arrival in Munich, which hopefully will be soon … Dear Kurt, you will find a great and interesting job awaiting you, the entire staff is waiting for you and is looking forward to your assistance. The business is doing well, and with a little effort it will be possible to expand the firm and increase profitability … Write very soon when you are coming, I am very impatient already.'

The next news Otto Bernheimer had from Venezuela announced his son's death.

I only found out the truth about my father's death while I worked on this manuscript. Writing about it has been liberating. My whole life had been overshadowed by my father's death and the disaster of the family repressing it. The intensive investigation into my father's death and the process of writing about it has helped me come to terms with it. Today, I can think more neutrally about my father and talk about him more openly, which has been truly cathartic.

Venezuela

*

'Coffee should be black as night,
hot like fire and sweet like love.'

(Proverb)

I often think of Venezuela, our village with the beautiful name Rubio, our coffee plantation, the house, my mother – in this wonderful land that is going through such difficult times due to the unfortunate politics of President Chávez and his successors.

In the old days the entire village life revolved around coffee. My mother's family, the Uzcáteguis, had made a living from their coffee plantation for several generations. My mother's father, Don Daniel, had created economic success at 'La Palmita', the hacienda situated above Rubio near the Columbian border. Like my grandfather Otto Bernheimer, he had been born in the late eighteen-seventies. He inherited some land from his ancestors and accumulated a lot more. With 'La Palmita' and the additional satellite estates in the surrounding valleys, he became one of the biggest and most respected landowners in the area. Apart from their houses on the haciendas the great families owned 'townhouses' in the centre. Most of them were located on our street, Calle 10, which led directly down to the main square of Plaza Bolívar, where the church stood. These townhouses were all built in the Spanish colonial style around one or more patios. They were not decorated in a luxurious way, but provided every comfort. Even in the nineteen-twenties the Uzcátegui's house had several bathrooms *en suite* with the bedrooms. The hacienda was somewhat more rustic. I remember a bath which consisted of a small tub in the floor, into which a water chan-

nel ran. It was fed by one of the streams on the hacienda, which effectively created running water.

Don Daniel and his wife had nine children, and one stillborn. When the eleventh child was born, the grandmother died together with her last grandchild. My mother Mercedes was the youngest but one, and she was not yet two at the time. Blanca, the youngest, was just one year old. The eldest daughter Maria Teresa was already married, and so the second daughter Carmen was tasked with looking after the father, the household, and the younger siblings, especially the youngest, Mercedes and Blanca.

Don Daniel could easily feed his large family with the earnings from the hacienda, and he could even finance his sons' university studies. The oldest, Daniel, was even allowed to go to Europe. He studied law in Geneva and Paris, and after a brief diplomatic career he became a successful lawyer and businessman in Caracas. Luis, the second son, was chosen to follow in his father's footsteps on the hacienda. (Today Luis's son, my cousin Luis Hernando manages the hacienda. Everybody calls him LH or Don Luis.) The third brother Leonidas, known as Leo, who looked like Anthony Quinn in the role of Alexis Sorbas, also became a businessman in Caracas. And the youngest, Erasmo, who was a few years older than my mother, stayed in Rubio and became a pharmacist. He was in Marseille a few times as Venezuelan consul, however, whenever his party was in government. As soon as they were back in the opposition after the next election, he returned with his family to Rubio and his pharmacy. He went back and forth like this several times.

The next sister is *tia* Emilia, a wonderful woman who was married to a charismatic man, José Manuel Medina. He was the nephew of General Isaías Medina, who was president of Venezuela during the war. *Tia* Emilia was always very proud of having been led to the altar by the *Présidente de la República* at her wedding. José Manuel looked like Clark Gable's twin brother, and he had his

foibles. He could be very generous, but he also had a violent temper. I remember when we came to Rubio for our first visit after we had moved to Munich, and I was fourteen. I said at the table: *'Tengo hambre!'*, I am hungry. He practically exploded. *'En nuestra familia nadie tiene hambre, quizás apetito, pero jamás hambre!'* 'In our family nobody is hungry, maybe you have an appetite, but you are never hungry!' I have never forgotten this sentence.

There is another scene which I have never forgotten. My mother once said she would love to have a pineapple, since they were so hard to get in Germany. It is hard to imagine today, but in the 1960s pineapples were rare and expensive in Germany. As soon as José Manuel had heard that, he went outside without a word. After a while he came back with a huge sack over his shoulder. He emptied it out with a flourish in the middle of the patio. Dozens of pineapples rolled out, and he shouted: *'En ese país de m... no hay piña? Pues*

On horseback at the 'Palmita'

aquí tienen piña!' 'There are no pineapples in this f'ing country? I give you pineapples!' For a few days we ate nothing else.

One day he insisted that Maria Sol and I should ride out on horseback with him on the hacienda.

Maria Sol got the relatively docile Yegua, and I was supposed to get on to the livelier Caribú. Our uncle rode a beautiful black horse. Before we knew it we were no longer on the hacienda, where we had ridden several times, but on the path down to Rubio. Once we had arrived in the village he took us to the Uzcáteguis house. He rode through the entrance, where he wanted to show my horrified mother her children on horseback. Then we continued to the Plaza Bolívar. He led us around in a circle while he greeted the people. He called out to everybody, whether they wanted to hear it or not: 'These are the children of Mercedes! Finally they are back!' Since he enjoyed it so much he took us around the square another time, before he directed us past the *mercado* back to the Avenida, shouting all the while. Then we went back to the Palmita. We were not used to riding, and my bottom hurt for days after this outing over several hours.

Blanca was my mother's youngest sister. She was as pretty as my mother, and she also married a German, Wolfgang Kopecky from Hamburg. He had come to Venezuela for entirely different reasons in the 1930s. As a young man he could no longer bear to live in the Hamburg quarter of Fuhlsbüttel. At night in the harbour he stowed away on the next ship with a far-flung destination, and found himself on a banana carrier on the way to La Guaira, the harbour of Caracas. On arrival he settled in Caracas and the harbour town Puerto La Cruz, where he founded several business enterprises and became very successful. Uncle Wolfgang and Aunt Blanca often visited us in Rubio with their daughters Rosi and Lissy; we grew up like siblings until we moved to Munich. After my father's death uncle Wolfgang became the most loyal and reliable support for my mother, and he became an important father figure for me.

Our house in Rubio is an oasis of calm and quiet, with its patios, its *corredores* with the various groups of chairs and hammocks. My sister Iris was determined to get married to her husband Dale Goodman in Rubio – a lovely idea. The wedding took place in 1987 in the house of the Uzcáteguis, with our Venezuelan cousins and South American music. During the party I heard from my Aunt Blanca that the house opposite was for sale, a beautiful family home in the Spanish colonial style. Without further ado we decided to buy the house, and when we began to renovate it my mother stayed to oversee the work. She turned out to be a brilliant project manager. Afterwards she only returned to Munich from time to time, until the mid-1990s when she gave up her flat in Munich altogether. She now lives in Rubio permanently. For several years she has been suffering from severe dementia, and it is heartbreaking that nothing can be done about it. She is well cared for, I do not have to worry about that, but it is irritating and painful to know her in this condition, especially as it has unfortunately been getting worse in the last years. My sisters used to go there regularly, in order to be with her as much as possible. Since Maria Sol died, it is doubly hard for my sister Iris. Every year in January she spends a month in our village. Emma, who has cared for our mother for many years, says she sometimes smiles. But can she still understand who talks to her? Does she understand anything at all? We don't know.

All her life my mother believed that she had to keep our father's sad fate from us. She alone carried the weight of the terrible decision to bury our father's desperate act once and for all. She made everybody who knew about it promise never to mention it again. The 'official' version became the car accident. And she could never talk to us about our father's death, not even mention a word about his illness.

Today, knowing the terrible secret my mother kept from us all her life, her own suffering appears even greater to me. In the early

stages of her dementia she often had moments where she desperately realised that she could no longer tell us something. It was clear that she registered her own condition and her mental decline, and was so inconsolable that she could only cry. I am certain now that in these moments she also thought about our father's death.

My cousin Luis sends me regular reports about our hacienda. These are not good reports; Venezuela is really not in good shape at the moment. Chávez, and now his successor Maduro, have managed to ruin the country in every possible sense through their fundamentalist-socialist policies. Luis sends me newspaper articles that document the increasing perfidy of government policy in recent years, and the widespread corruption, even in the coffee trade. Until a few years ago coffee export was still an important economic factor for the country; similar to neighbouring Colombia, the life of the rural population of the Andes is not imaginable without coffee. The plantations created jobs, income and security. In a region that was industrially underdeveloped, they were the most important employers and centres of the community. My mother's family is a good example. Since the mid-nineteenth century it has been a traditional family who employed many people on their large and intensively farmed agricultural estate: entire villages in the surrounding countryside were populated by employees, hundreds of families lived on the work the plantations provided. At harvest time the number of employees multiplied. During the harvest they were housed for several weeks in separate buildings and received a hot meal three times a day. Cooks were employed for this purpose. Many seasonal workers who moved from village to village, depending on the timing of the harvest, had been coming to us for generations.

But everything changed with Chávez. The plight of the coffee plantations in Venezuela began with the setting of fixed sale prices for green coffee. Prices were no longer determined by the market, as had been the custom. In a functioning market prices self-regulate

according to supply, demand and quality. The prices on the great international coffee bourses were used as guidance. I remember that years ago we benefited from a frost in Brazil, which had destroyed half the harvest there. Our prices rose in turn. Then there came a phase of constantly falling prices, due to an overproduction in Vietnam, which had become the second biggest coffee exporter after Brazil. They began to flood the market with cheap *Robusto* types. It did not help that we produced top quality *Arabica* beans in the highest, gourmet class. The prices for *Arabica* were also caught in the general downturn. And just as prices began to recover, Chávez started to regulate the market in his own way.

Prices were dictated to us. They were usually so low that they were below the import prices for low quality coffee from other countries. They were far below those that comparable *Arabica* made in neighbouring Colombia. We were forced to sell our valuable production for low prices to local buyers, who in turn probably just shipped them over the open border to Colombia to resell for much higher prices. We could not afford to do this. Once you were caught, the government had a welcome excuse to expropriate the estate. The regime was waiting for it. We are now the only one of the old families who still run their coffee plantation. But we do not give up. We have seen many crazy dictators come and go, I said to my cousin; we said goodbye to this one too, and now he is gone. Unfortunately his successor Maduro is not much better, but there is always hope that one day the country will return to a more sensible political situation.

In 1988 a television crew for the Bavarian broadcaster produced a documentary about us that was directed by Erika Reese. The journalists accompanied me over the Andes passes. Together we tracked the route the Bernheimers had taken in 1939 with all their belongings to the small village in the Andes, though I don't know how many days they needed from Caracas to Rubio. The team were filming

in the house, on the hacienda and in the village, as well as in the beautiful landscape in the surrounding mountains. Our three grown-up daughters were still little at the time, and Felicia was not yet born. I remember a particularly nice scene: when the team wanted to film our patio, my mother intervened, who had always been especially proud of her flowers and plants. The hibiscus plants, which framed the patio in large pots, did not have enough flowers, and this would not do at all. Quickly she took flowers off some other plants and let the children stick them in the patio pots. And indeed: Teresa can be seen in the background, putting flowers in pots!

The occasion for the film was the sale of the house on Lenbach-platz, and so the end is a little sad. One of the heavy bronze doors is seen closing, and they closed forever.

Munich and the Highlights

*

'On the way to becoming a national institution.'

(*Süddeutsche Zeitung* on the Highlights Art Fair)

When Bernhard Purin, the director of the newly opened Jewish Museum in Munich, first came to me with the suggestion of creating an exhibition in the new museum about the history of the firm and the Bernheimer family, I was taken aback. The idea that an entire exhibition would be dedicated to our family history troubled me. At the same time, I felt honoured, especially as our exhibition would be one of the first in the new Jewish Museum of the City of Munich. Purin introduced me to an excellent curator, Emily Bilsky, who soon set to work. Together with her colleague Juliette Israël she came to Marquartstein to discuss a selection of loans. The catalogue for the exhibition was very well researched and illustrated with many photographs from our family albums. There were loans not just from our family, but also from museums. The Swiss Landesmuseum sent the fragment of a famous tapestry depicting a so-called wild man and woman, made in Basel around 1490. The Württembergisches Landesmuseum in Stuttgart lent a twelfth-century aquamanile from Lorraine. Both pieces had been in my grandfather's collection. The Deutsches Museum in Munich sent several clocks and other objects, which my great-grandfather had donated for its inauguration. The Lenbachhaus lent the oil sketch for our portrait of Lehmann Bernheimer, of which I had not even been aware. There was a group of beautiful Art Nouveau vases from the Bavarian National Museum, and the Munich City Museum sent parts of the original choir stalls from the city's

Frauenkirche, by the workshop of Erasmus Grasser. My grandfather had bought them from the collection of the artist Eduard von Grützner and had donated them to the City Museum in 1958. It was very moving to see all these museum objects united in the exhibition, but it was equally poignant to see the family 'treasures' that we kept in the castle, and with which I as well as our daughters grew up, as part of the museum exhibition and outside their usual domestic context. These included the large Art Nouveau column made from translucent alabaster and gilt bronze, which my great-grandfather had bought at the World Exhibition in Paris in 1900. It also included our famous Buddha, and the Holbein chair on which Pope John Paul II had once sat.

For the opening of the exhibition Bernhard Purin asked me to give a speech and talk about the family history. I was happy to oblige, but I had not expected so much interest. For the duration of the exhibition I had to repeat it several times, always in front of a full house. This gave me the idea that one day I would write down all the stories whose sum is my family history, so that they would not become lost.

Our family history is closely tied to Munich, from my great-great-grandfather's days until today. Over the past few years I have often been asked why we never moved to London for good, since it was so much more important for us from a business perspective. This may well be the case, but I answered that working in London and living in Munich was a wonderful combination. But of course it is much more than that. I grew up in Munich, and I am attached to the city. I have been able to live a very happy life in the city. And, like so many Bernheimers before me, I am a citizen of Munich.

When we discussed the importance of a really high level art fair among German art dealers, it became clear that the site of the

country's most important art fair would also be the most important art trade centre in Germany. As a staunch Munich citizen I was determined that this should be Munich and no other German city.

In addition, it had been none other than my grandfather who had founded the first German art fair in 1956. At that time he was president of the Federal German Art Trade Association, and the fair had taken place in the Haus der Kunst in Munich. For me, as well as for many of my art dealer colleagues in Munich, there was therefore only one possible fair venue, the Haus der Kunst. In 1956 the first fair had taken place at a time of great uncertainty. The Western world was convinced that the Hungarian Crisis could start World War III and the Cold War had reached a new high. Shortly before the first German art fair was due to open, Russian tanks had invaded Budapest, and many people were convinced that the Russians would shortly arrive in Munich. My grandfather stuck to his plan, but in order for the fair to take place at all he had to personally guarantee the sum of eighty thousand marks, which was a large amount at the time. In the end the income from the fair covered all costs incurred, so that his guarantee was not needed. I remember the inauguration ceremony for the fair very well: as a six-year old grandson I was allowed (or obliged) to attend the formal event by my grandfather's side, and I sat in the front row between my grandfather and the Mayor Alois Hieber.

But the sense of uncertainty was all-pervading, and as a consequence sales were disappointing. Every day my grandfather took a tour of the fair with me holding his hand, and he asked every exhibitor how business was going. Everyone complained: 'Very badly, Herr Konsul, very badly!' Then my grandfather bought something from every single dealer, saying: 'Well, why don't just you send this over to Lenbachplatz.' In return he was nominated as the 'Virgin of Mercy of the Art Trade', which he endured with a wry smile.

Over the years the Munich art fair had its ups and downs. A decline began in the early 1990s when the fair had to leave the Haus der Kunst. Afterwards it moved several times, from the old fair grounds behind the Bavaria statue overlooking the Theresienwiese, where the annual Oktoberfest takes place, to the new fair grounds at the site of the former airport, far outside the city centre. This did not do the fair any favours, and together with several colleagues I pulled out at the time. Instead we came up with the Munich Highlights, a coordinated exhibition to which the art dealers based around Brienner Strasse would invite their colleagues from the Federal Republic. Our gallery alone presented ten colleagues. For several years this 'street fair' was a great success. But we all agreed that it could only be a placeholder until we could return in triumph to the Haus der Kunst.

Finally we succeeded. It had not been easy to convince the director Chris Dercon that an art fair had to take place in the Haus der Kunst. There were a lot of reservations, not all of which could be explained with scheduling difficulties. A traditional distaste for trade and commerce was palpable. The Bavarian Minister for Arts and Science, Wolfgang Heubisch, realised that our art fair was not only an important cultural event for Munich, but would also strengthen Munich as an art trade venue. He had been one of the first German politicians to visit Maastricht, where he could clearly see the importance of the European art trade. He was also able to recognise the European standing of the German art dealers who exhibited in Maastricht, and in particular the dealers from Munich. From then on Wolfgang Heubisch became a staunch supporter of Munich as an art trade venue, and of the idea to bring the art fair back to the Haus der Kunst, where, from our point of view, it had its historic home.

The first Munich Highlights Art Fair took place in October 2010 in the Haus der Kunst. Fifty-two art dealers participated. From the beginning my most important ally was my Munich colleague Georg Laue. Georg has for many years been one of my most successful younger colleagues, who has created a renaissance in collecting *Kunstkammer* objects. His concept of *Naturalia, Mirabilia, Artificialia and Scientifica* has been popular especially with younger collectors who often started out with modernism. As he says: 'Miracles are something to collect.' I envy him this phrase. Georg is a colleague who cooperates very well with our art fair team, and he shoulders more and more work for me. Raffaela von Salis is an excellent fair manager. My financial director Daniela Dölling takes care of our calculations and ensures that the Highlights, too, do not run out of money. Thomas von Salis looks after the design and the technical installations. He is an irreplaceable team member and everything would grind to a halt without his tireless efforts.

In spite of some initial difficulties the new fair shows excellent development. We had set a high standard, and both the public and the press really appreciated it. The daily *Die Welt* reported in 2011 that the second edition of the Highlights surpassed all expectations: 'Unanimous enthusiasm.' The *Frankfurter Allgemeine Zeitung* wrote: 'The second edition of this compact fair with its international flair and supreme level of quality confirms its position as the foremost German art fair', while the *Süddeutsche Zeitung* even said that we were on the way to becoming a 'national institution'.

However, the third fair in October 2012 heralded the end of this brief and happy revival of the old tradition. To our great surprise the management of the Haus der Kunst decided to reduce the exhibition space for the fair by almost a third, while at the same time a large hall stood empty, which we had been able to use the previous year. After some discussions with the ministry we eventually came to the conclusion that we would have no future in the Haus der Kunst, also

in view of an impending renovation which would create a building site over several years. This outcome, as well as the fact that the art dealers had been made to feel like paying but unwanted guests, led to the Highlights leaving the Haus der Kunst.

A great and long-held dream was shattered, which was all the more painful since it had started so well. But my colleagues and I agreed that we would not want to give up and would look for another, possibly even better venue in Munich.

After a few weeks we were indeed able to come to an agreement with the President of the Bavarian Schlösserverwaltung, which administrates the former Royal palaces, Bernd Schreiber. The art fair will now have a long-term future in the Munich Residence. At the joint press conference the President described the Highlights fair as the 'proud flagship of the art trade' and as the ideal partner for the Residence. It turned out to be a perfect move.

Blanca and Her Photo Gallery

*

'Now my father listens to me.'

(Blanca Bernheimer)

From 2005 my daughter Blanca very successfully established a new department for photographs in our gallery in Munich. She had one exhibition after the other, and more and more often my Old Masters and I had to give way, but when I complained, Blanca told me that for the Old Masters I still had Colnaghi in London, too.

There is a story behind the foray of our Munich gallery into this new area. The starting point was an encounter with the famous photographer Lucien Clergue in Arles during a bullfighting *feria*. The great master and doyen of French photography, who had been a friend of Picasso, is a fascinating character. Only when we had lunch at his house did I really understand how close his relationship with Picasso had been. His great bullfighting photographs were on the walls, interspersed with Picasso. I suddenly had the idea to ask him for a selection of his bullfighting photos for an exhibition in Munich, provided that I would succeed in also getting a complete set of both Picasso's and Goya's *Tauromachia*. (NB There is only one Goya edition which was created during his lifetime, the three others are posthumous and the fourth one only dates from 1911.) He agreed, but he clearly did not think that I would manage to do this.

But I did, and so we had the exhibition *Toros and Toreros*. To my surprise, and that of Barbara – who told me: 'But you are the only aficionado in Munich!' – it became an exceptional success. Not only

did the complete cycles by Picasso and Goya sell immediately, but also almost the entire bullfighting photographs by Lucien Clergue.

The whole thing may have remained a one-off, had I not had a call from Blanca. At the time she lived in Berlin and was thinking about opening a gallery for photographic art together with a partner.

I told her that I would be very happy if she took this route. But since she was only twenty-three, I suggested that she might want to learn about running a gallery from the inside, especially with all its economic factors, before she became independent. And where better to do this than with me? No outsider would give her so much insight. We both enjoyed working together from the outset, and over the years the cooperation developed in a harmonious and fruitful way.

Blanca says that I had told my daughters from a very young age that I would not force them to join the business. They would be able to take up any profession they wanted, as long as they did it well. I had held this opinion from the beginning, since as a child I had been under great pressure myself to take over the firm one day. My daughters were not to feel this pressure; they should be free to make up their own minds.

Blanca was familiar with art and the art world from infancy. When she was little, she came to the Pinakothek with me and her sisters, just as my grandfather had taken me. She studied literature and philosophy before she joined the firm at twenty-three to establish the department for photography. She once said in an interview that it had been very important for her to assert herself. She now enjoys it that I pay attention to her and that she can explain aspects of photography to me that I was not aware of. She says that she likes it when I listen to her. In another interview she described me as 'authoritarian but warm-hearted, a man of the world as well as a Bavarian'. She also says that it is very important in our successful co-operation that we can laugh with each other and about each other. I can only confirm that.

Blanca has built up a large circle of clients over the years, and she has established working relationships with many excellent photo artists, and over time she has developed a handsome portfolio. She has a particularly good eye when selecting her artists, which she mostly credits to the school of seeing she attended in our family.

She has developed a programme which she seems to carefully pursue: on the one hand the gallery exhibits 'classical' black-and-white photographs of the twentieth century, such as Lucien Clergue, Horst P. Horst, Irving Penn, Jeanloup Sieff and Robert Mapplethorpe. On the other hand she selectively focuses on young artists such as Veronica Bailey, Mat Hennek, Guido Mocafico, Jan C. Schlegel, Silke Lauffs and Christopher Thomas, who she discovered for herself and who she has gradually helped to establish. As far as these are concerned, she wants to 'grow with them'. The decisive factors for her are not just the concept of the image and the artistic content, but also the perfect mastering of the technique and the photographic skill.

I am delighted that Blanca has found an area where she can continue the family tradition of dealing in art. She is entirely part of the tradition and of the firm, because in every generation the Bernheimers have moved with the times, and dealt in something which had relevance for the current generation. Each generation of the family opened a new chapter and found their own territory, from my great-great-grandfather's textile trade to my great-grandfather's interior decoration and furnishing fabrics, to the development of an antiques business under the sons Max, Ernst and Otto. And finally in my time there was the move to dealing in paintings. The only generation who did not have the opportunity to make their mark was my father's, due to the Nazi period.

Blanca is the first gallerist in a family of art dealers, this is new. By definition a gallerist works with living artists, as opposed to an art dealer. I have to say that from the beginning I have greatly

enjoyed the encounters with Blanca's artists. They are inspiring. They are for the most part highly interesting, fascinating personalities, and meeting them has enriched my life, too. My artists are evidently all dead, and sadly I cannot meet a Lucas Cranach or a Peter Paul Rubens. So I can understand very well why from the point of view of her generation Blanca prefers contemporary photography to Old Masters.

In October 2011 there was a marvellous exhibition entitled *Passion*, which was shown in the church hall of the Bavarian National Museum. It included a series of very impressive photographs by Christopher Thomas, which he had taken during the Oberammergau Passion Plays directed by Christian Stückl in 2010. The opening night was very busy, and we had to move to the adjoining Mars-Venus Hall for the speeches. The director general Renate Eikelmann explained how she had been initially very sceptical when Blanca suggested the exhibition. She knew neither Christopher Thomas nor his work. But when she saw the book with the images of the *Passion* she immediately recognised their high quality. She also had the vision of contrasting these compelling images with the great late medieval sculptures in the Sculpture Hall of the National Museum. She sent Blanca, Christopher and his curator Ira Stehmann to inspect the Sculpture Hall, and when they returned it was clear that this was to be the venue for the exhibition. The ensuing dialogue between the *Passion* images and the altarpieces was very powerful and compelling, and worked in both directions, by the way. The experience of the sculptures was different in the context and in dialogue with the *Passion* images. The museum also benefited, since we found that many visitors had never before, or not for a long time, been either to the Bavarian National Museum or the Sculpture Hall.

After the opening, a small group had dinner in the museum restaurant. It was an unusual experience to have many of the actors

from the *Passion* photographs with us. With short hair and 'in civ-
vies' they looked like any typical Bavarian regulars. Christopher's
photographs showed very impressive Old Testament style heads. Of
course costumes, beards and long hair assist in the transformation.
The actors, who all have to be born in Oberammergau, could not get
their hair cut for over a year. But this is not the only reason.
Christopher has a special ability to transform and create art. I sat
with the Oberammergau people for a while and talked with the two
who played Jesus, and (we were wondering about the plural for
Jesus – Jesuses? Jesi?) Barrabas was there, Joseph of Arimathea as
well as the very striking Judas. I told them about my first visit to
Oberammergau with my grandfather in 1960. At the time we stayed
at the Hotel Alois Lang, which was owned by the actor playing
St Peter. In that year, Jesus was played by the owner of the Gasthof
Post, Anton Preisinger. As a small boy I could not believe it that
Jesus would pass through the restaurant and personally ask the
guests if they were happy with their meals. I was even more shaken
by Alois Lang, who had also played Jesus in the past. He now was an
old man. He had long hair and a long white beard, and when my
grandfather and I passed the bench in front of his hotel where he sat,
he rose and came towards us. 'Look there, it is the Almighty!' I
shouted loudly and full of emotion to my mother, and of course I did
it in Spanish: *'Mira, Papa Dios!'*

Conclusion

*

'Things could have been worse.'

(One of my favourite phrases)

For one of my last birthdays I received a very nice present from my sister Iris, it was a tattered album with photographs from our childhood that she had found. Some of them showed Maria Sol's First Communion. They were taken in the Hotel Königshof, which my grandfather loved solely because of the view out of the windows over to Lenbachplatz. In the photos there are 'Papa Otto', my mother and my sisters, and there is also the present that my grandfather gave me on the occasion of my sister's First Communion: a bronze figure of Bodhisattva.

I can be seen in the picture proudly carrying my present. I was entirely conscious of the special significance of this 'family relic'. My grandfather had received the Bodhisattva from his father when he was six years old, and it had accompanied him all his life. When I was six, my grandfather gave it to me, and the bronze has also been with me all my life. It was both a talisman and a symbol of a long tradition. When I started my family I kept saying that my first son would inherit the bodhisattva from me. My daughters teased me a bit when I finally declared that my first grandson would one day become the proud owner of the Bodhisattva. When it became clear that Teresa would have a son, the promise caught up with me. Neither Barbara nor my daughters missed any opportunity of reminding me. My grandson is not yet six years old, and when I came to Marquartstein my Bodhisattva was waiting for me in the *Herrenzimmer*. But the day will come when we have to part, and

when I think about it, I feel a small pang. Is this the pain of separation? Or is it the recognition that as a grandfather I have to slowly let go of the things that I have been fond of all my life? It may be a bit of both. In this respect, Barbara is much more relaxed than I am. When our daughters were on the hunt again in Marquartstein for furniture and objects for their homes, she said we should give 'with a warm hand', before we are dead and gone. And of course she is right.

On the day of Maria Sol's First Communion

The days that I love best are those when all of our daughters are around. This is usually either on Barbara's birthday, which we celebrate with a small family trip together, or in the summer holidays, or at Christmas.

Teresa teaches Early Islamic History at the London School of Oriental and Asian studies (SOAS). Her husband Kaspar is a television executive in Munich, and he is increasingly successful in his career. We see them as often as possible, and we are the happiest grandparents in the world.

Isabel lives in Berlin. Having worked in Munich at the Haus der Kunst and later with dealers such as Hauser & Wirth, she became Chief Registrar at the Martin-Gropius-Bau and was responsible

Barbara Bernheimer

for set-up and dismantling, loans and shipping of great science exhibitions. I used to see our third daughter Blanca most often, as she was working with me in the gallery. After her marriage she set up with her husband in Lucerne and opened her own gallery there.

Our youngest daughter, Felicia, finished her BA in European Studies with particular focus on political science very successfully at the University of Passau. Her studies helped her in expanding her interest in international political organisations. She is enthusiastic about her involvement with Model United Nations (MUN), a working group for students from all faculties, who come together to discuss current affairs in global politics. For international conferences they represent individual countries and take on the roles of diplomats to recreate United Nations committees. In this way international issues are analysed from the perspective of the younger generation, and solutions are discussed. Feli has already represented the Egyptian cultural minister and Swiss delegates, for example. Recently she took part in a conference in Canada about security issues in North Korea. This is an excellent training for a later career in an international organisation, which seems to be what Feli imagines. Now she will start her master's degree in Public Policy at the Hertie School of Governance in Berlin.

The birth of our first grandchild was a very emotional event. It was so touching to see the delightful small person for the first time, to hold him in our arms with his little head on our hand, see his tiny nose, eyes, small feet and tender down of the eyebrows. And how moving it was to see Teresa and Kaspar as happy parents. Alive with this first encounter, we happy grandparents and proud aunts returned to Marquartstein, but we could not wait to go back to the clinic the following day and see how our grandchild had developed after its first night on earth. I have to admit that I was at a loss for

words for the first time in my life. I could not describe what we felt, the emotion was too great.

It is hard to believe, but it is really true that a newborn changes every day. The features begin to emerge, the eyes are open more often, and there is the sense that it reacts to its surroundings in a more immediate way. But in any case, we are so blind with love and devotion that we find everything about him beautiful. Of course it was the same with our four daughters, although I was more concerned about the mother at the time.

When Teresa and Kaspar brought the little prince to Marquartstein for the first time, I had the castle bells rung to welcome the new family member. I was allowed to carry my new grandson over the threshold and into the rooms upstairs. I took him to the *Herrenzimmer* straight away to introduce him to the family portraits, my father, my grandfather and the great-grandparents. Then I realised that my father is already the great-grandfather of the small boy, and as far removed as Lehmann Bernheimer had been for me.

A few days later after dinner Teresa gave me a present: the little wristband with his name which the clinic had tied to my grandson when he was born. I was very touched when I held the band. I took Teresa to the *Herrenzimmer* and put the small band with the Bodhisattva, which now belongs to my grandson. I am sure that my great-grandfather and grandfather would be happy to see their talisman handed to the next generation.

Whenever Teresa and Kaspar leave with little Samuel, as when I opened the castle gate and they drove off, there is a moment of sadness. Barbara and I stand and wave for a while. So far, my suggestion of living in shared accommodation has not been taken seriously.

Even if this is not going to happen, the relationship between the generations seems to have intensified with the arrival of our grandchild. And from personal experience I know that the influence of grandparents should not be underestimated.

But the role of grandparents has changed, which is also true for my family. My daughters' grandparents died too early. They only know my father from a few stories (they will know a little more when they have read this book). The other grandfather, my father-in-law, was a kind and forgiving family man and medical doctor, but he died of lung cancer when he was only sixty-four. Teresa met him when she was a small child, and Isabel had just been born when he died. The grandmothers left a stronger impression. My daughters remember my mother from visiting her. They called her 'Nita', and she was popular because of her cakes and biscuits. They associate her with the house in Venezuela, the annual summer holidays with my mother in Rubio and on the coffee plantation – happy and carefree weeks, which shaped our daughters' childhood, until the country's increasing instability put an end to our travels to Venezuela. Sadly this is the reason that my daughters have not been able to see my mother during her final years.

The other grandmother, known as 'Oma', usually arrived like a whirlwind for a brief stay before she departed like a whirlwind again. I have to admit that as a son-in-law I found it exhausting, although she always had the best intentions. Maybe my daughters felt differently.

I think that the role of grandparents has really changed in my family, after my daughters grew up. Now that there will – hopefully – be more grandchildren, only the future can tell how they will see us one day. But from my personal experience and my relationship with my grandfather Otto Bernheimer I know how important the influence on grandchildren can be, even in their first years. In my case the influence was surely exceptional. My grandfather died when I was only just ten years old, and he has still had a bearing on my entire life.

Every art dealer is also a collector; it cannot be otherwise. How can one convince a client to collect if you do not carry the collecting gene yourself? Although one may not want to compete with one's business, it must be said that the best dealer's collections were created in their respective professional fields. Examples are Ernst Beyeler, Heinz Berggruen and Richard Feigen, and of course Otto Bernheimer.

I have often said that by the end of my life I will have built up three collections. The first one is by now rather impressive and comprises every picture and object which has passed through my hands in my life as a dealer. The second collection is rather less important, but nevertheless means a lot to me: these are the objects that we have personally collected and kept during our lifetime. The third collection is also considerable, but above all painful: these are the missed opportunities, those pictures and objects which I did not buy, for whatever reason.

Like most other people's, my life has been a sequence of triumphs and defeats, of great hopes and disappointments. My family's history may seem incredible at times, and when I let it pass before me it amazes me, too. But it is especially important in difficult times to have a happy family life and a happy home, and for this I am very grateful to Barbara and my daughters.

I finally found the book again for which I had been looking for so long: I could not remember whether it had been by Camus or by Sartre, but it was about the ancestors of the living protagonists discussing their actions and character strengths and weaknesses. By chance I recently came across it; it was by Sartre, with the title *Les Jeux sont faits*, and published in English as *The Chips are Down*. It is actually a screenplay, and when I re-read it I found that my memory had rather deceived me: there is just one scene in the book where it says that the blasé young man's ancestors were following

every step of his, that they observed him constantly and were only waiting for him to die so that they could tell him what they thought about him. In my imagination I had expanded this idea of the dead conversing about the living in the afterlife, whereas Sartre had only touched on it briefly. I had imagined entire conversations in my mind, as I was fascinated by the thought of how the dead would criticise or quarrel over the behaviour of their living descendant. None of this was in Sartre's book, so reading it again after such a long time was a sobering experience. At the same time this proves once again that the best books spring from one's own mind. I only needed to take a seat in the Marquartstein *Herrenzimmer*, surrounded by the family portraits, and close my eyes. My ancestors soon began to speak with each other. All my life I have imagined conversations with my father and grandfather, I even became obsessed by them. Even now that I have written down the history of the family, some things remain opaque or at least elusive. I believe I have found the answer to some questions, but many remain unanswered.

After so much travelling and the constant commuting between Munich and London it was a blessing to sit peacefully in my comfortable Marquartstein *Herrenzimmer* and read the newspaper under the family portraits. Then there was usually one more very important task awaiting me, to select the wine for dinner.

I would choose a lovely 1999 Saint Emilion from the winery of our friend Stephan Neipperg, Canon La Gaffelière, and a white Clos Marsalette 2006, also made by Stephan, to start with. In the meantime, Barbara and Feli were preparing a delicious veal ragout with Persian rice and fried courgettes. I was home again.

When the weather was warm, I sat on our balcony overlooking the valley and the surrounding mountaintops. Whenever I knew that I would not be able to be here for some time I felt rather homesick even before leaving. I also looked forward to the quickening heart-

beat when I was on the way back. There were wonderful sunsets, and the birds were singing their hearts out in the treetops. No place could have been lovelier and more peaceful.

When I left the castle again, I looked out over the bridge when I opened the gates. I saw the great lime trees and ash trees lining the road up to the castle chapel. Below the chapel I took the path to the garages and entered the real world again. We seemed to be protected from the outer world in the enclosed peace and quiet of our castle, and I only wish that my parents and grandparents could have experienced the same serenity.

My family

Finale – for Now!

*

'Exceptional things never happen
in comfort zones.'

(Said my daughter Felicia recently)

eli mentioned this sentence to me and suggested that it was a good quote, and I liked it so much that I used it as the title for my final chapter. It says a lot about what has been on my mind for a while; What is a comfort zone, really? Comfort food is usually associated with too many calories and carbohydrates, comfortable eating that is easy to prepare, enjoyed by all and fattening. The comfort zone, however, does not have negative connotations; it is more about a place of comfort, of cosiness, a place where one feels at home either geographically or mentally. In such a situation exceptional things may well never occur, because it is too tempting to stop thinking creatively, when everything around one is so nice and comfortable. Is being comfortable the same as being conservative? Surely the need to change is much smaller when one is moving comfortably, and in every respect in a 'green zone'.

In the area of the art market that we call Old Masters, we have certainly long left our comfort zone, or rather, we were forced to do so. We did not give up our positions voluntarily, in many respects we were pushed aside.

At least ten years ago Souren Melikian wrote that in his opinion the market for Old Masters was endangered, it was shrinking on the side of supply as well as demand, and a shrinking market was not an attractive market. For many years Souren Melikian was the author of

the *International Herald Tribune*'s Saturday pages on the art market, and in this capacity he also reported on Maastricht every year. He always wrote about the international art market in a very ambitious and intelligent way.

I have to admit that I was amongst those who did not want to hear this pessimistic prognosis, and that my incurable optimism led me to believe that the 'grand old man' of arts journalists took a much too gloomy view and was as usual doing his tour of the fair in a bad mood, while trying to uncover any mistakes made by us dealers.

Today, I must admit that he was right to be pessimistic, and that he predicted our future almost prophetically. As mythology demonstrates, nobody wants to believe a bad-tempered Cassandra. Souren Melikian had foreseen a development that has actually happened. In the past few years it has really become more and more difficult to find good pictures, and we found ourselves in an ever-tougher competition with the auction houses. Even when we found good and interesting Old Masters, we were still struggling to sell them. One might think that in times of shrinking supply the demand increases, but this has not been the case.

It is worth remembering an old adage of the art market, which says that without a steady and significant supply in a collecting area, interest will waver. This is exactly the reason that has led to a change in taste in the younger public, away from Old Masters and towards contemporary art. There are not enough good Old Masters in the market to kindle interest, whereas there are new works by Warhol, Jeff Koons, Gerhard Richter or Baselitz more frequently. As contemporary art is so present in the perception of the public, and it gets so much attention, this helps to create the desire to own it. Old Masters, on the other hand, are still considered art history's greatest achievement, but younger art enthusiasts describe them more and more often as pictures for a museum, and not to live with. We dealers had either not seen this development coming, or we had turned a

blind eye. Today's art market is only for trophies, really significant paintings by great names, and this category is increasingly hard to find. And should a picture from this category appear the probability is that it will go to one of the global auction houses, and that the price will be so high that we dealers do not stand a chance. Even though from time to time we manage to snatch a picture from under the nose of the auction houses, this is becoming increasingly rare.

At TEFAF in March 2015 it became obvious how much the Old Masters market is under pressure. *The Art Newspaper* even entitled their TEFAF Special Report: 'Old Master Dealers Feel the Pressure'. A number of reasons were given for the decline in turnover, such as the volatile euro, the shrinking supply, and the Internet, which publicises a dealer's purchase prices for all to see. At first I disagreed about the volatile euro, since for Americans or any other collector calculating in dollars the prices would have dropped, as long as the dealer had not increased his euro prices. In view of the weak market this did not seem likely. Had there perhaps been fewer Americans, and if there were, why did they not pounce? Other visitor groups such as Chinese or Russians had not been seen at all, which is understandable in view of their respective economic situations. But as we analysed the results more closely we found that those areas that used to have a more difficult time at TEFAF than the Old Masters, i.e. seventeenth and eighteenth-century European decorative arts, had had great successes. Money had been spent, just not so much on Old Masters. Was there a change in taste after all?

Of course the Internet is an important factor. A potential buyer can always check on Artnet or another database how much a picture has cost and how high the seller's mark-up is.

A change in taste can no longer be ignored, and it became apparent in the German collector community years ago. In this country it is

now possible to count collectors of high profile Old Masters on one hand, whereas contemporary art is collected with growing enthusiasm. Consequently, I have reduced exhibitions with Old Masters in my Munich gallery, as there were fewer sales compared to years before. It seemed only logical to offer more space to my daughter Blanca for her photo exhibitions, which have achieved pleasing results. In autumn 2014 I also gave the gallery space over to my daughter Isabel for the exhibition *Vanitas*, showing a group of works by the young artists she handles, and it was a great success.

Recently I have been heard to say a few times that I was quite happy to be reaching my retirement age of sixty-five in 2015. What I was trying to say was that I would have been much more nervous about the art market changing ever more quickly, if I were ten or fifteen years younger. At sixty-five, even an art dealer is allowed to consider his future. An art dealer does not really 'retire', but he can consider downsizing. My London partner Katrin Bellinger has taken a first step. A while ago she had told me that she wanted to leave as partner of Colnaghi at the end of 2015. She has now decided to focus on the activities of her Tavolozza Foundation as well as her commitments in the museum world. After many very successful and harmonious years of collaboration, I will miss Katrin as the most friendly and charming partner, always reliable and with her distinct eye for the highest quality. This was the moment, I thought, to find younger, capable partners who could lighten my load, give their own active input and facilitate a gentle transition to the next Colnaghi generation.

I used to joke that the search for the next Mr Colnaghi was similar to the search for the next Dalai Lama – he lives and walks the earth, but he does not know yet that he will be chosen.

Far be it from me to compare the role of a Mr Colnaghi with the

personality and position of a preeminent religious leader in the world. But I am responsible for the legacy of Colnaghi, for ensuring that the oldest art dealership in the world is ready for the future.

There are very clever heads among my younger colleagues, who certainly also have the necessary enthusiasm. Working with younger colleagues will surely also give me new momentum, and for them the name Colnaghi will be a challenge as it had been for me, and help them on their way to an international clientele.

It seems that we are well on our way to finding a very good solution for the future of Colnaghi, and I look forward to the day when we can announce a new partnership.

And then there was another decision to take: the sale of Marquartstein Castle. When we bought the castle in 1987, we said that it would not become a 'family relic'. I actually said that one day we should be ready to sell the castle as quickly as we had bought it. But now we have been there for thirty years, our children grew up there, and we have grown to love it. We were never able to live in the Chiemgau region full-time, since I travelled too much, especially with my weekly trips to London. Essentially, we have spent Christmas, Easter and part of the summer in Marquartstein, and sometimes the weekend. We also found that the castle was less suitable at our age; too much up and down on staircases. And if you want to downsize and reduce business activities, everything needs to be reviewed. Life in a castle as a weekend and secondary home is only possible with a large-scale business operation and a matching income. With the decision to downsize the Munich gallery, we therefore had a classical conundrum: trying to work less means potentially a smaller income. The clear and sensible answer was that having both the gallery and Marquartstein were incompatible.

After many discussions with friends and family we came to the rational but emotional decision to part with the castle and its entire contents.

Over thirty years much had accumulated. We had bought a lot over the years, and as the castle was so extensive, there was never the need to sell anything. This included the contents of the Bernheimer house on Lenbachplatz when the building was sold in 1987. At the time I had not felt up to selling the contents as well as the building. I wanted to take the 'Bernheimer spirit' with me, and keep the ambience of the collections. The Marquartstein castle with its many rooms and endless attic space allowed me to do exactly that. Many, many lorry loads went up the hill, and the old walls took everything in. The house filled to the rafters with art works, rare furnishings and memorabilia, a *lapidarium*, that is a collection of stones, fountains, capitals and columns which is hardly ever seen these days, and an attic which is brimming with eccentric objects.

Our rooms were furnished in such a comfortable style that the resulting atmosphere became special and unique, and enchanted every visitor.

I also realised that I was the last in my family who still knew the origin and the history of the many objects and artefacts, and that it therefore would have to be me who dissolved the large collection.

We asked both auction houses, Christie's and Sotheby's, to assess, catalogue and value the entire contents. In this process we saw many familiar items with new eyes. We also began to realise the sheer size of the collection. The initial idea was to have a sale of the contents in the castle itself, as a 'house sale'. But after the first proposals from both firms we soon came to the conclusion that a single owner sale in London was the better choice. The centre of the art market would be a more suitable venue for an international collection. Both firms' specialists explained that for all the enthusiasm for

the collection, it might be difficult to attract the right as well as important buyers to the Chiemgau. Of course this meant the enormous effort of shipping everything to London, right up to the contents of the attic.

Once both houses had presented their valuations and their proposals, the moment came for the difficult and important decision which of the two we would choose. If there is just one painting or object to sell, the decision can be hard enough, but the criteria are manageable, and sometimes personal preference or the personal relationship with a specialist in one of the firms tips the scales.

In our case it was really difficult, since it concerned our entire collection, a vast quantity of objects from many different specialist areas, great artworks, but also a group that the English charmingly refer to as an 'attic sale'. But then I had also decided to downsize the Munich gallery, which meant selling the Munich picture stock, and concentrate my Old Master activities in Colnaghi. We knew that both auction houses would do everything possible to make the sale a success. Both proposals were comparable, and during the days when the respective teams of experts visited the castle we had developed a very good and friendly relationship with both. We knew that the decision would be hard, but it had to be made.

In autumn 2015 the great Bernheimer collection sale will take place in London at Sotheby's, and the castle will be sold in parallel.

Of course we will keep those things which are close to our hearts, and that we could never sell, such as the family portraits, and last but not least my great-grandfather's narwhal tusk!

In spite of the pain of separation we know that we have made the right decision. It was time to cast off ballast and explore new avenues. And for Barbara and I this means that we will have the freedom to travel, which we never had because we felt the obligation to drive down to Marquartstein whenever we had the time.

Surely we will find a weekend home again, maybe once again in the Chiemgau, but this time it will not have to be a castle!

The new strategy for Brienner Strasse will keep us busy, Old Masters will be offered only in London, and I will keep just an office in Munich. I much look forward to a new era for Colnaghi.

Life should remain interesting!

Appendix

Historical Chronology of the firm
and the family of Bernheimer

*

Mid-19th Century Stall no 298 in the 2nd row at the Dult fair, Munich: Meier Bernheimer, from the Swabian village of Buttenhausen, offers 'Silks, shawls and fashion wares' at the biannual fair.

1864 Foundation of the firm of Bernheimer's.
On 10 May 1864 Lehmann Bernheimer acquires the insolvent Robert Warschauer textile firm on the corner of Promenadenstrasse and Salvatorstrasse, and founds his own business for fashion fabrics and finished fashion.

1868 The range is expanded to include furnishing fabrics and 'all manner of carpets'.

1870 The business premises are extended and moved into Kaufingerstrasse no. 17, the prime retail street in Munich at the time.
Wide selection of silks, cloth, and shawls. Lehmann Bernheimer begins to bring back carpets and *objets d'art* from his travels, especially to the Orient. Initially these are only used to decorate the shop. Encouraged by the interest from his clients, in particular the painter von Lenbach and the architect Gedon, the range of goods changes to include more art and decorating objects.

*

Franco-Prussian War 1870/71, 'Gründerjahre'.

*

1873 Purchase of the building at Kaufingerstrasse no. 17, which from that time becomes the family home a well as business premises.

1876 Expansion to become a 'fashion business, supplying a rich selection of everything from the simplest to the most elegant style'.

1882　King Ludwig II appoints Lehmann Bernheimer 'Supplier to the Royal Bavarian Court'. He maintains a close relationship with the Bavarian Royal family, supplying furnishing fabrics for the royal residences as well as other Wittelsbach castles.

1884　Lehmann Bernheimer is appointed as the first holder of the title 'Royal Bavarian *Kommerzienrat*'.

1886　(June) King Ludwig II drowns in Lake Starnberg. Bernheimer's supply the fabrics for the catafalque.

1886–1887　Lehmann Bernheimer appoints the architects Friedrich von Thiersch and Martin Dülfer to design a prestigious residential and commercial building in the former grounds of the Englisches Café on Maximilianplatz no. 1, later known as Lenbachplatz.

1889　Completion of the building and festive inauguration by the Prince Regent Luitpold in the presence of members of the court and the high nobility. Important commissions, such as the furnishing of several rooms at Villa Hügel in Essen, home of the industrialist family Krupp, and aristocratic clients like the German Kaiser, Russian Grand Dukes, and famous personalities such as the painter Wilhelm von Kaulbach soon make the business Germany's leading firm.

1893　Lehmann's sons Max, Ernst and Otto Bernheimer join the business.

1897　(February) A fire in the building destroys part of the stock. The support of friends and clients ensures that the business can reopen already in May. The Prince Regent offers an infantry barracks building on Hofgarten as a free temporary storage facility.

1900　Lehmann Bernheimer plans the procession for the Centenary celebrations on the occasion of the turn of the century in Munich.

1907–1910　The building is expanded through the purchase of the residential houses in Ottostrasse nos. 13 and 14, which are added to the building on Lenbachplatz no. 3.
Friedrich von Thiersch is again employed for the project, and also for designing the 'Italian courtyard'.

The courtyard in the style of the Italian Renaissance is to be filled with objects that Otto Bernheimer gathered over the years on his trips to Italy. It is designed to set the tone for the wide range of Italian Renaissance art on offer; Otto Bernheimer manages the building project.
Festive inauguration of the finished building, once again by the Prince Regent Luitpold.

1904–1914 Regular purchases of valuable carpets in Constantinople and Smyrna.

*

First World War 1914–1918

*

1918 (May) Death of the firm's founder Lehmann Bernheimer; his sons Max, Ernst and Otto take over of the business.

*

Inflation until 1925, World Economic Crisis

*

1920s The difficult economic climate at the time forces the company to sell some valuable tapestries at Christie's in London, including a famous tapestry woven in 1520 after a design by Jan van Eyck. (It was bought by Price Paul of Yugoslavia for his brother, the King of Yugoslavia, and achieved the sensational price of 350 000 marks). The sale proceeds permitted a refurbishment of the stockroom after 1925.

*

1933: Hitler becomes Chancellor, 'Third Reich'.

*

1935: 'Nuremberg Laws'

*

1938 (November) During the *Kristallnacht* the Bernheimer building remains mostly untouched, on the orders of Hermann Göring. The male members of the Bernheimer family are taken to the Dachau concentration camp. After the intervention by Mexico, which had been represented by Otto Bernheimer as Consul for a number of years, they are allowed to return to Munich, but they are forbidden from entering their own business premises.

1939 (November) The firm is taken over by the 'Association of Artists'. Their president is the Munich Gauleiter and state minister Adolf Wagner, while the furniture producer Robert Scherer is the executive director and fiduciary. They are a front for Hermann Göring.

1940 Expropriation of the family and emigration. Max Bernheimer's family emigrates to the United States. Ernst Bernheimer emigrates to Cuba, and Otto Bernheimer and his family emigrate via London to Venezuela, where they had bought a coffee plantation.

*

1945: End of World War II and of the Nazi Era

*

1945 Otto Bernheimer returns to Munich.

1948 Following lengthy negotiations with the American occupying authorities and the new German authorities, restitution of the – partly damaged – building and of the objects that had been stored in convents. Resumption of business, first focusing on the textile and furnishing departments, but soon the demand for art and antiques resumes.

*

1949: Foundation of the Federal Republic of Germany

*

1949 Reopening of the great tapestry hall.

1954 (May) Exhibition *1500 Years of Textile Art* on the occasion of the ninetieth anniversary of the firm in the Haus der Kunst.
(July) Tragic 'accidental' death of Kurt, Otto's favourite son and designated successor.
(September) His widow Mercedes and the children Maria Sol, Iris and Konrad move from Venezuela to Munich to be with the grandfather, Otto.

1955 Great Bernheimer carpet exhibition in the Haus der Kunst.

*

1956: Russian Tanks Move into Budapest

*

1956 Opening of the first Munich Art and Antiques Fair in the Haus der Kunst, founded and led by Otto Bernheimer as president of the Federal Association of German Art dealers.

1960 (June) Otto Bernheimer is awarded the golden citizen's medal of the city of Munich, in recognition of his having 'established the reputation of Munich as the centre of the art trade in Central Europe' (Mayor Dr. Hans-Jochen Vogel).
(July) Otto Bernheimer dies.
(December) Spectacular auction of Otto Bernheimer's private collection at Weinmüller's, with the young auctioneer Rudolf Neumeister.

1961 Otto's eldest son Dr Ludwig O. Bernheimer takes over the management of the firm.

1964 One hundred year anniversary of the firm with a festive ceremony at the Hotel Regina.

1967 Dr Ludwig O. Bernheimer dies. His cousin Paul, Ernst Bernheimer's son, becomes chairman of the firm. (He had emigrated to Cambridge, Massachusetts and founded his own business.)

The management of the firm is initially handed over to Prof Bruno Taussig, and after one year to Kurt Behrens. The textile and furnishing departments are the core of the business.

1977 Konrad O. Bernheimer, Otto's grandson, returns from London, where he had worked at Christie's for a year. He becomes chairman and takes over the management of the firm.
Gradually the firm's focus shifts towards the art and antiques trade.

1984 Exhibition *Art and Craft on the Silk Road* on the occasion of the 120th anniversary of the firm.

1985 (September) First participation in a London art fair, Burlington House Fair, and in the following years at Grosvenor House.
(November) *Bernheimer Fine Arts, Ltd.* opens in 32 St George's Street, Mayfair, opposite Sotheby's.

1986 Exhibition *The Nanking Cargo*, with Chinese porcelain from a shipwreck.
With the closure of the textile and furnishing departments, the firm becomes an art and antiques dealership.

1986 For the first time, Bernheimer exhibits at the Antiquairs International & Pictura Fine Art Fair in Maastricht's Eurohal.

1987 The Bernheimer family decide to sell the building on Lenbachplatz and to liquidate the family firm; Konrad Bernheimer pays out all family shareholders.

1988 (March) The Maastricht fair is renamed *The European Fine Art Fair* (TEFAF) and moves into the newly built Maastricht Exhibition and Congress Center (MECC).
(October) Konrad O. Bernheimer takes over the London firm *Bernheimer Fine Arts, Ltd.*
(November) Founding of the new firm *Konrad O. Bernheimer Kunsthandel* and opening of a new gallery on Promenadeplatz no. 13 in Munich.
Purchase of the castle in Marquartstein in the Chiemgau region as a family home with spacious exhibition rooms.

1989 125 years of Bernheimer's in Munich and celebration of the first anniversary of the new Bernheimer firm with the exhibition *Art and Tradition – Masterpieces with Important Provenance*, with seventy-eight participating international art dealers.

1992 Konrad Bernheimer becomes a board member of TEFAF (The European Fine Art Foundation).

1998 Move to the gallery space in Brienner Strasse no. 7, with a focus on Old Master paintings from the 16th, 17th and 18th centuries.

1999 Exhibition *Apollon and Dionysius* in conjunction with David Cahn.

1999 Member of the TEFAF Executive Committee.

*

11 September 2001: Attack on the World Trade Center in New York

*

2002 (January) Takeover of Colnaghi's.
Exhibition *Cranach, Brueghel & Co – Old Masters at Bernheimer's*; exhibition *The Pfeiffer Collection* in conjunction with Arnoldi-Livie.

2002 (September) Appointed Chevalier des Arts et des Lettres by the French cultural minister at the Palais Royal.

2004 Exhibition *Toros y Toreros. Goya, Picasso, Clergue*.

2005 Blanca Bernheimer joins the Munich firm and establishes the department for Fine Art Photography.
Exhibition *Moment and Eternity*, in conjunction with David Cahn, Basel.

2005 Chairman Pictura at TEFAF.
Exhibition *In the Company of Old Masters* at Colnaghi's.
Exhibition *Music & Art* in Munich.
Exhibition *Joseph in Egypt*, in conjunction with Heribert Tenscher, Munich.

(October) Founded the *Munich Highlights* – International art dealers and collectors meet in Munich.

2006 Opening of a gallery at the Hotel Schloss Fuschl.

2007 Exhibition *The Art and Antiques Firm Bernheimer* at the Jewish Museum in Munich.

2008 Exhibition *Frans Hals – A Lost Masterpiece Re-discovered.*

2009 *Cranach: Mythological Works – Devotional Pictures – Weibermacht Paintings – Portraits.*

2010 Colnaghi's 250 year anniversary is celebrated with a large reception at Spencer House, London.

2012 (October) First participation in the Frieze Masters fair in London.

2013 (December) Blanca Bernheimer opens her own gallery for Fine Art Photography in Haldenstrasse 11, Lucerne.

2014 (July) Isabel Bernheimer founds her own artist agency, as *Bernheimer Contemporary – Art Solutions & Projects.*

2014 (September) First exhibition of Bernheimer Contemporary in Brienner Strasse: *Vanitas,* a great success for Isabel and her artists

2014 (September) For the first time, Konrad, Isabel and Blanca Bernheimer exhibit together at the Munich art fair Highlights, combining Old Masters, photography and contemporary art.

2015 (April) The Bernheimer family decide to sell Marquartstein, their home in the Chiemgau region. Large parts of the collection are consigned to Sotheby's to be sold in London.

2015 (July) Isabel Bernheimer opens an extensive space for exhibitions and events by Bernheimer Contemporary in the Berlin district of Mitte, vis-a-vis the Museum Island, with the exhibition 'Who Cares? Social Responsibility in Contemporary Art'.

2015 (November) Sotheby's in London sells 'The Bernheimer Collection' over two days.

2015 (December) The Bernheimer Gallery in Brienner Strasse closes. Konrad Bernheimer moves his Old Master paintings business entirely to Colnaghi in London.

Acknowledgements

*

Firstly, I would like to thank my publisher Thomas Ganske. From our initial conversation his reaction was very positive, and he supported the project from the outset. The first conversation took place in passing while he visited my stand at the Maastricht art fair, and afterwards the project advanced every time he invited me for a wonderful lunch at the Anglo-German Club in Hamburg. In my opinion, Thomas Ganske has been 'the publisher with an unfailing appreciation of art' ever since. I instantly felt that I was in the best of hands with his company, especially with Constanze Neumann and Markus Klose, who shall stand in for all the staff at the firm who kept encouraging me with their enthusiasm for our project.

I am much indebted to Rainer Wieland, who was a fabulous editor and helped me to structure my thoughts and turn my notes into a book. At the same time, his sensitive and gentle approach was that of a careful editor who did not want to become a ghost-writer.

Meanwhile, the second German edition is on the market, and my thanks go to Philip Werner and his team who took care of my second German edition.

This first English version of my book is published at Hatje Cantz, also owned by my friend Thomas Ganske. I would like to thank Cristina Steingräber, Julika Zimmermann, Charlotte Neugebauer and their colleagues for their help and support.

But above all, I would like to wholeheartedly thank my excellent translator Susanne Meyer-Abich who understood immediately my way of expressing myself and has created the right tone and the same kind of flow as in the original German text.

I am grateful to my colleagues at the Colnaghi gallery in Old Bond Street, London, for their unfailing support, most of all Katrin Bellinger, who has been and still is a wonderful partner at Colnaghi, my efficient Gallery Manager Sarah Gallagher, my successful and ever reliable Director of Sales Tim Warner Johnson, and Jeremy Howard, our 'professor' and Head of Research, who supplies us with writings on a sound art historical basis.

In Munich I would like to thank first and foremost my faithful and long-term team member Eva Bitzinger, who organises the Munich gallery with the support of Sabine Eidenschink and Verena Greimel, and of course my daughter Blanca, who was responsible for the Fine Art Photography department at Brienner Strasse, and who took my usual place at gallery meetings more and more often and as a matter of course.

I am grateful to my financial director Daniela Dölling for taking the entire load of the financial management of my galleries, for pointing out the right way in a trustful manner, and for taking over many tasks of my everyday jobs, both in London and in Munich, in particular regarding the less appealing sides of our business.

I would like to express my gratitude to the loyal caretakers of our castle in Marquartstein, Wolfgang Hanisch and his family. They are most reliable and have always managed to give us the impression that we have not been absent for long, regardless of how long it had been.

Thanks are due to my art dealer colleagues, and most of all to Johnny van Haeften, Otto Naumann and Roman Herzig. I am grateful for many years of friendship and co-operation, which has brought repeated success to all of us.

My colleagues in the organisation of Highlights, or Munich Art Fair, have been indefatigable in their work, especially Raffaela von Salis with her team, Georg Laue, my colleagues in the management team, and Thomas von Salis, without whose input on design and technical matters nothing would move at the fair.

At TEFAF, I am especially grateful to our wonderful Chairman of the Executive Committee Willem van Roijen who keeps us *prima donnas* all under control, to my Co-Chairman on the Antiquairs side, Ben Janssens, but also to the established team in the TEFAF administration under Paul Hustinx. And we are all looking forward to continuing our work with our new CEO, Patrick van Maris. I would like to take this opportunity to thank everybody for their fabulous TEFAF organisation. All of us art dealer colleagues who have been exhibiting for many years know how much work is needed year round to set up this most important and successful art fair every year in March. And of course I am deeply grateful to my clients and collector friends for making me feel that the hunt for new and exciting pictures is worth it every time.

Last, but by no means least, I thank my family, because I am fortunate in being surrounded by a wonderful and happy family and I know that this cannot be taken for granted.

My sister Iris has been a loyal presence at my side all my life, and I am grateful that she looks after our mother during her visits to Rubio. She is carrying this load on her own since our sister Maria Sol died, as I have proved entirely incapable of dealing with our mother's dementia. I am all the more indebted to my sister and to our faithful Emma, who has looked after our mother in the house in Rubio for twenty-five years. I would like to thank my cousin Luis Hernando Uzcátegui for his courageous support of our coffee plantation, in spite of the difficult political situation in the country – sometimes it feels like fighting windmills. I have especially missed

my sister Maria Sol during the time it took me to write this book. She could have given me many important suggestions. Her daughter Daniela pointed out essential details for me, and she and my brother-in-law Jobst Brey brought me important documents from my sister's estate while I wrote this book for which I am thankful. I am also very grateful to my sister Iris for helping me compile the family photographs.

I dedicate this book to my Barbara and to our daughters Teresa, Isabel, Blanca and Felicia. While I wrote the book and during the conversations we had in our family about it, it has become clear that our daughters were not aware of much of our history. In particular our youngest daughter Felicia had never heard some of the details. We must have simply assumed that she would somehow become aware of them, like her older sisters had.

All of them contributed important advice during the final manuscript phase, and they helped me greatly with the final version. I am especially grateful to my daughter Teresa and her husband Kaspar for many suggestions and for encouraging me to shorten the manuscript, which had been too long in parts. My youngest daughter Felicia compiled our family tree together with her sister Teresa.

This book is dedicated to all of them, and to our grandchildren.

My greatest thanks go to Barbara. We had the good fortune to meet early in life and to commit to each other immediately. We grew up together and came a long way together, and in every phase of our life Barbara has been a loving wife and strong partner, who did not just support our life choices but shaped them significantly. At every point she has helped me, in good times as well as in less good times. (She will say that I have not listened to her enough, and that the most nonsensical decisions were my own.)

Barbara is most of all the beloved centre of our family, which she has always been for me, for our daughters and also, as we can see now, for our grandchildren.

Index

*

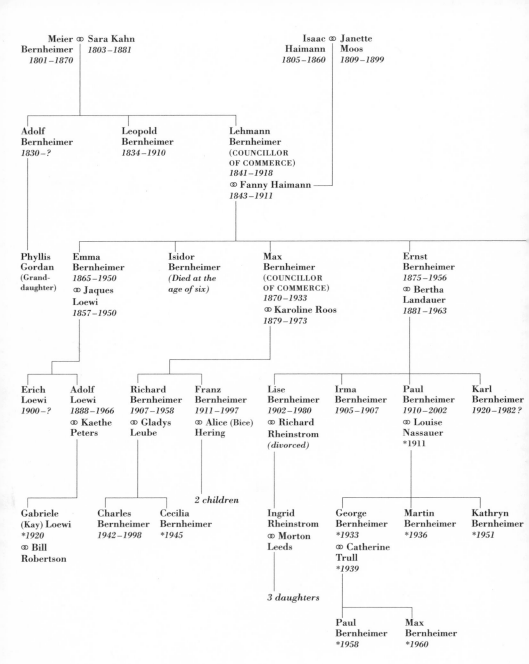

Meier ⚭ Sara Kahn
Bernheimer *1803–1881*
1801–1870

Isaac ⚭ Janette
Haimann Moos
1805–1860 *1809–1899*

Adolf
Bernheimer
1830–?

Leopold
Bernheimer
1834–1910

Lehmann
Bernheimer
(COUNCILLOR
OF COMMERCE)
1841–1918
⚭ Fanny Haimann
1843–1911

Phyllis
Gordan
(Grand-
daughter)

Emma
Bernheimer
1865–1950
⚭ Jaques
Loewi
1857–1950

Isidor
Bernheimer
*(Died at the
age of six)*

Max
Bernheimer
(COUNCILLOR
OF COMMERCE)
1870–1933
⚭ Karoline Roos
1879–1973

Ernst
Bernheimer
1875–1956
⚭ Bertha
Landauer
1881–1963

Erich
Loewi
1900–?

Adolf
Loewi
1888–1966
⚭ Kaethe
Peters

Richard
Bernheimer
1907–1958
⚭ Gladys
Leube

Franz
Bernheimer
1911–1997
⚭ Alice (Bice)
Hering

Lise
Bernheimer
1902–1980
⚭ Richard
Rheinstrom
(divorced)

Irma
Bernheimer
1905–1907

Paul
Bernheimer
1910–2002
⚭ Louise
Nassauer
*1911

Karl
Bernheimer
1920–1982?

Gabriele
(Kay) Loewi
*1920
⚭ Bill
Robertson

Charles
Bernheimer
1942–1998

Cecilia
Bernheimer
*1945

2 children

Ingrid
Rheinstrom
⚭ Morton
Leeds

George
Bernheimer
*1933
⚭ Catherine
Trull
*1939

Martin
Bernheimer
*1936

Kathryn
Bernheimer
*1951

3 daughters

Paul
Bernheimer
*1958

Max
Bernheimer
*1960